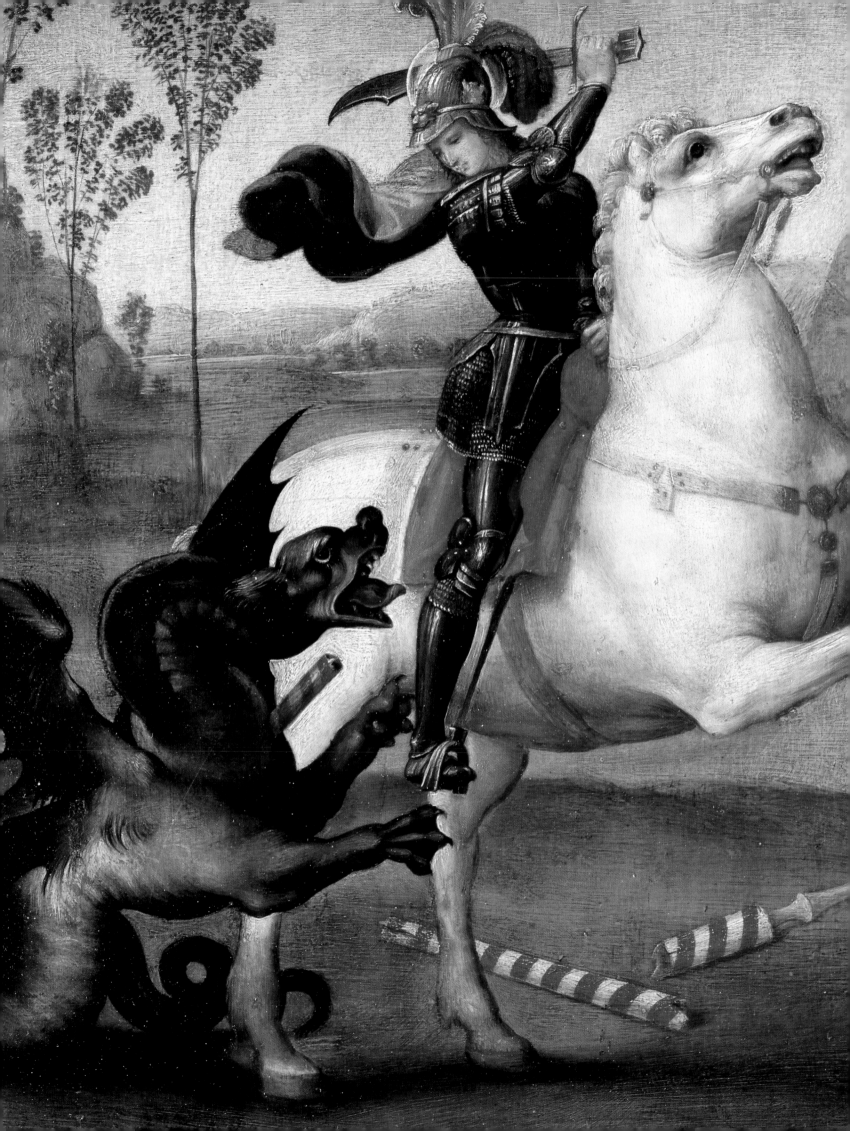

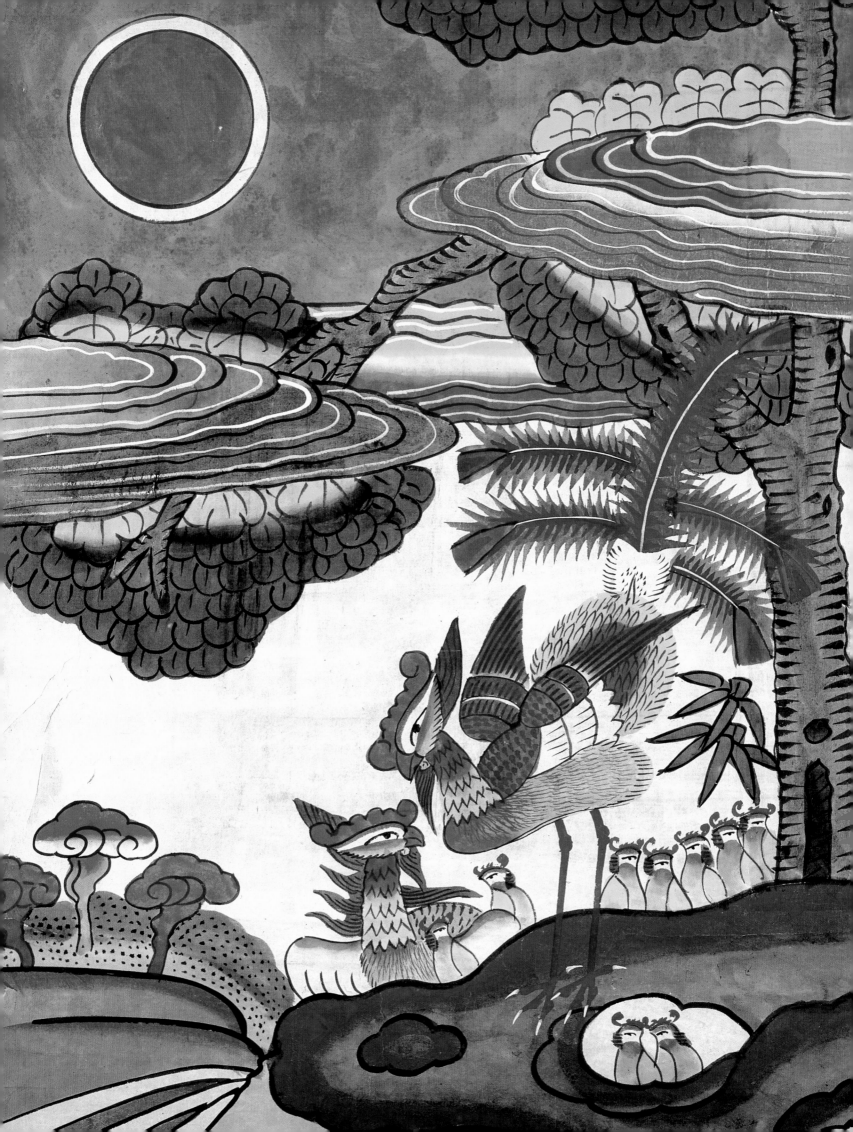

HERE BE DRAGONS

A Fantastic Bestiary

Ariane Delacampagne and Christian Delacampagne

PRINCETON UNIVERSITY PRESS

Princeton and Oxford

Front cover: Paolo Uccello (1397–1475), *Saint George and the Dragon* (detail), c. 1455–60. Oil on canvas, 22¼ x 29⅛ in. (56.5 x 74 cm). National Gallery, London. Photo: © National Gallery, London

Spine: Stylized man-jaguar, Ancient Tolima period (1st–5th century A.D.) (plate 27)

Back cover: Unicorns from a manuscript of Marco Polo's *Book of Marvels*, c. 1410 (plate 55)

Page 1. Raphael (1483–1520), *Saint George Fighting the Dragon*, c. 1505. Oil on wood, 11⅜ x 9¾ in. (29 x 25 cm). Musée du Louvre, Paris

Page 2. *Couple and Brood of Phoenixes in a Landscape* (detail). Watercolor on paper, 35 x 19⅞ in. (91 x 51 cm). Korea, end of the Yi dynasty (19th century). Musée National des Arts Asiatiques–Guimet, Paris

Page 3. *Faun*, attributed to the workshop of Alessandro Allori (1535–1607). Detail from vault 39 of the eastern corridor, Galleria degli Uffizi, Florence

Originally published as *Animaux étranges et fabuleux: Un bestiaire fantastique dans l'art*
Copyright © Editio-Éditions Citadelles & Mazenod, Paris 2003
33, rue de Naples, 75008 Paris

English-language edition published by Princeton University Press, 41 William Street, Princeton, New Jersey 08540
In the United Kingdom: Princeton University Press, 3 Market Place, Woodstock, Oxfordshire OX20 1SY
www.pupress.princeton.edu

Translated from the French by Ariane Delacampagne

Designed by Studio Chine, Marc Walter
Adapted from the French edition and composed by Tina Thompson

Printed and bound in Spain
10 9 8 7 6 5 4 3 2 1

Library of Congress Cataloging-in-Publication Data
Delacampagne, Ariane, 1959–
 [Animaux étranges et fabuleux. English]
 Here be dragons : a fantastic bestiary / Ariane Delacampagne and Christian Delacampagne.
 p. cm.
 Includes bibliographical references and index.
 ISBN 0-691-11689-X (cl : alk. paper)
 1. Animals, Mythical, in art. 2. Animals—Symbolic aspects. I. Delacampagne, Christian, 1949– II. Title.
N7745.A5D4313 2003
700'.474—dc21 2003051741

CONTENTS

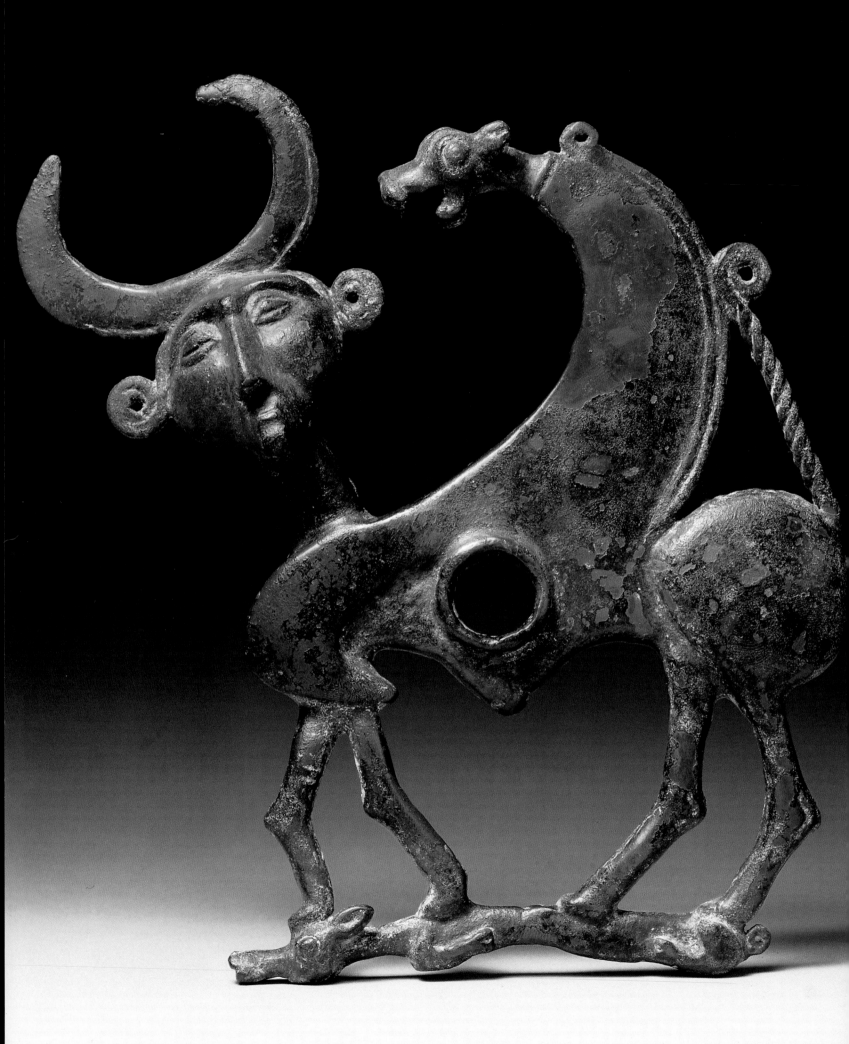

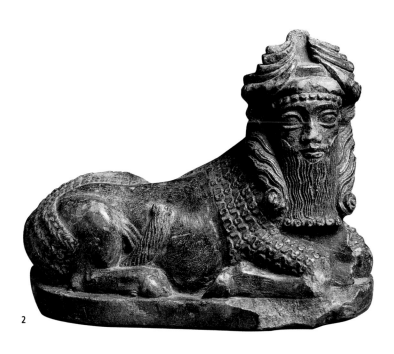

1. Opposite: Horned spirit trampling an ibex. At the end of its wing is the head of a wild beast. Luristan (Iran), 8th century B.C. Bronze horse bit, 7 x 7 in. (18 x 18 cm). Musée du Louvre, Paris

2. Left: Reclining human-headed bull, wearing a tiara. Mesopotamia, Neo-Sumerian period (c. 2150 B.C.). 3⅞ x 5½ in. (10 x 14 cm). Musée du Louvre, Paris

2

INTRODUCTION

BESTIARY: In the Middle Ages the term referred to a kind of edifying compilation, written in verse or prose, in which the moral characteristics of the most diverse animals, real or imaginary, were highlighted.

With the passing of time, this once-flourishing literary genre eventually disappeared. And for good reason: after the Renaissance our vision of the world profoundly changed. We started distinguishing science from sermons, and we stopped equating animals that could be observed with those only dreamt of. It would be a mistake, however, to believe that the former managed to eliminate the latter. Whereas animal painting in the realistic sense of the term became a genre only in the seventeenth century—a genre exemplified by minor painters such as Paulus Potter—the world of fantastic animals has been an endless source of inspiration for major artists from all eras and all countries.

Sphinxes, hydras, chimeras, dragons, unicorns, griffins, mermaids, centaurs, tritons, harpies, phoenixes: from Greek vases to Hollywood movies, from Hieronymus Bosch, Francisco de Goya, and Pablo Picasso to comic strips, advertising, folk art, and self-taught art, these imaginary creatures and their many variations continue to haunt us, just as

1

3. *Below:* Composite animal. Miniature from Mughal India. Musée National des Arts Asiatiques–Guimet, Paris. This type of mythical animal, assembled from multiple other animals, became fairly common in Persian culture, starting in the sixteenth century. The same type of composition by assemblage was illustrated in Europe by Arcimboldo's work.

4. *Opposite:* The Sun, the Moon, the Morning Star, and the Thirteen Birds (The Hours of the Day), from the *Codex Borgianus,* fol. 71. Mexico, Mixtec civilization (1200–1350). The Vatican Library, Vatican City. The Mixtec civilization, which reached its apogee in the region of Oaxaca, was later absorbed into the Aztec Empire.

they haunted our ancestors. Neither the progress of science nor the deluge of mass culture has managed to chase them away. Jorge Luis Borges's *Book of Imaginary Beings* (1967) lists some 120 fantastic animals that have been kept alive to the present day, whether in literature, folklore, or ordinary language. And such beings proliferate in even larger numbers on the numerous Web sites that currently bring lovers of fantastic zoology together in cyberspace.

Offering a general view of such a bestiary or even just suggesting an itinerary through this supernatural universe (one itinerary among many other conceivable ones) becomes a daunting task. In this journey through five thousand years of art,

no matter how hard we try not to overlook anything essential, there will always be gaps. Some of these are inadvertent omissions. Others are related to the impossibility of reproducing certain works of art that we would have liked to have included. Finally, others can be explained by our obligation to make choices—choices that are necessary because not everything can be told in two hundred pages. Such choices are always difficult and debatable. We hope the reader will forgive us.

IT IS IMPORTANT to limit our vast subject by defining the meaning of "fantastic animal" as precisely as possible. This is not easy. For example, just

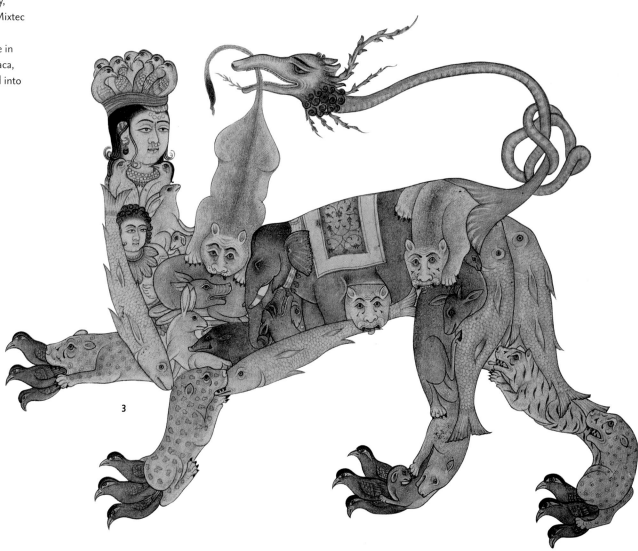

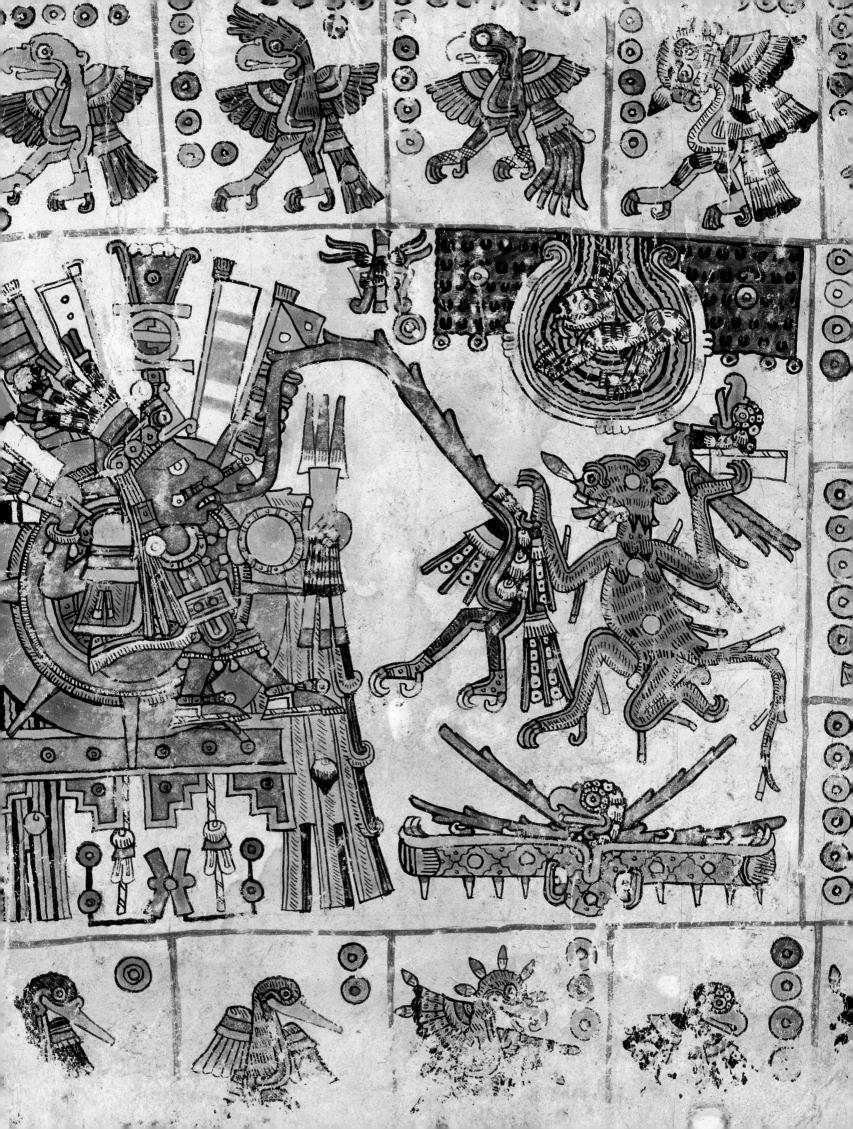

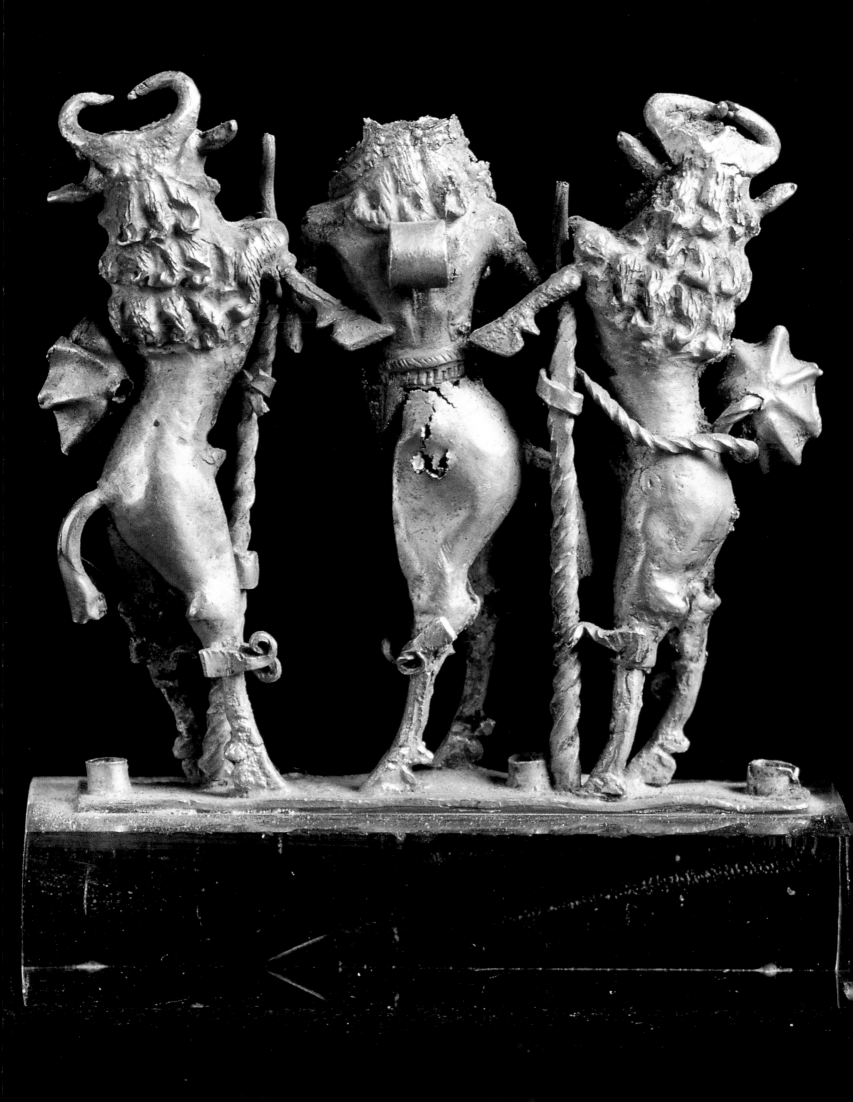

scrawling on a piece of paper some beast not resembling any known animal does not make it fantastic. So how can one define the very idea of "fantastic"? This concept, whose appearance in aesthetic theory is linked to the Romantic movement of the nineteenth century, is elusive, especially because it relates to various forms of artistic expression. One can talk about fantastic literature as well as fantastic painting or fantastic cinema, but only at the risk of forgetting that each medium has its own specific characteristics. Moreover, it is difficult to draw a line between the concept of fantastic and other related concepts, such as abnormal, strange, marvelous, prodigious, supernatural, dreamlike, legendary, and mythical. And it would be a lost cause to try explaining what distinguishes an entertaining or even an amusing fantasy from a disquieting or a downright frightening one, even though we are all perfectly capable of distinguishing the feelings inspired by Snoopy from those inspired by King Kong.

Perhaps the difficult notion of fantastic will become clearer through this inquiry. In any event, since we need a starting point, we will assume that the animals that constitute our subject belong to one of the following three categories. They are either monsters that can be linked to a given species but present a serious anomaly with regard to the "normal" appearance of that species (for instance, an eight-legged horse); or, hybrids resulting from the combination of two or more characteristic elements from different species (for instance, a winged horse). Or they may be composites of the two types, being monstrous and hybrids both, in varying proportions.

Among fantastic beings with both human and animal features, we will discuss only those whose general appearance is undeniably animal rather than human. Such distinctions are essentially intuitive, but we can establish some practical guidelines. First, we will omit representations of monstrous or wild human beings, whose human nature prevails over their animal nature. For the same reason, we will also leave aside most Egyptian and Hindu divinities. Next, we will leave out animals that have a normal appearance but are depicted as taking part in an abnormal, amusing, or unusual activity. These include the animals in Jean de La Fontaine's *Fables*, Charles Perrault's *Tales*, Grandville's caricatures, and Walt Disney's cartoons. These various creatures generally seem to be intended to entertain or amuse rather than to transport us to a truly fantastic universe. Finally, we will set aside the vast world of angels and winged genies that are simply men with wings (just as *The Victory of Samothrace* and other figureheads are simply winged female figures), as well as representations of the devil or demons in which human features prevail over animal ones. This is the case, for example, with the Erinyes (Greek infernal divinities, characterized by wings and snakelike hair) as well as with most Christian representations of the devil during the first millennium A.D.

Throughout this book, the reader will be able to see that the universe of fantastic animals is not only extraordinarily rich but also incredibly complex, and for good reason: it communicates with the world of the unconscious—the dream and the nightmare. To shed light on this complex world, which defies easy analysis, we will examine it from three different angles, exploring the following themes:

- The symbolic or religious function of fantastic animals
- Their genesis and their formal transformations
- The ambiguous relationship between man and animal

These themes are certainly not the only conceivable ones. But we hope that they will help us clarify the enigma that the fantastic continues to present, even today, for aesthetic theory.

5. Opposite: The man-bull Enkidu holding two human-headed bulls (detail, seen from the back). Mesopotamia, Sumerian period (early 3rd millennium B.C.). Gold pendant, height 1¼ in. (3 cm). Musée du Louvre, Paris

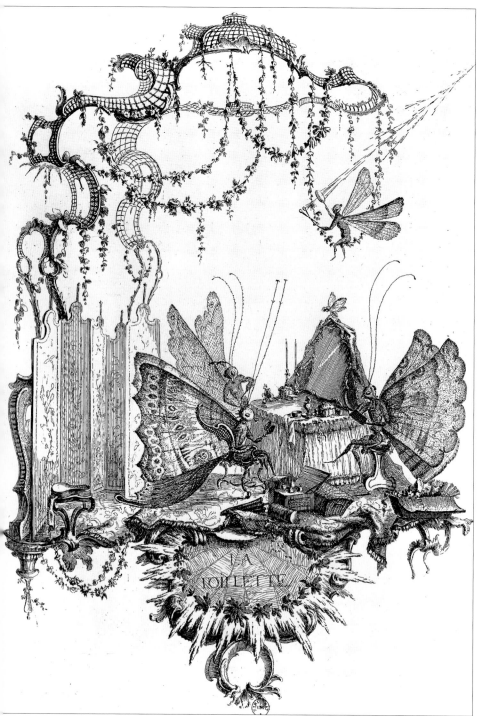

Contrary to what most nineteenth-century Romantic artists believed, the fantastic does not exist in the physical world. It is in our mind. It is, in fact, one of the mind's most sophisticated productions. As proof, let us open the great book of world art.

6. Left: Charles-Germain de Saint-Aubin (1721–1786), *La Toilette,* c. 1756. Etching. Bibliothèque Nationale de France, Paris. This curious phantasm, from a series of plates entitled "Essais de papillonneries humaines," is by a French painter, designer, and engraver who was famous as much for his taste for extravagance as for the delicacy of his brushstrokes.

7. Opposite: Gustave Moreau (1826–1898), *The Fantasy.* Sketch for the frontispiece of La Fontaine's *Fables.* Watercolor, 11 x 8¼ in. (28 x 21 cm). Musée Gustave Moreau, Paris

6

7

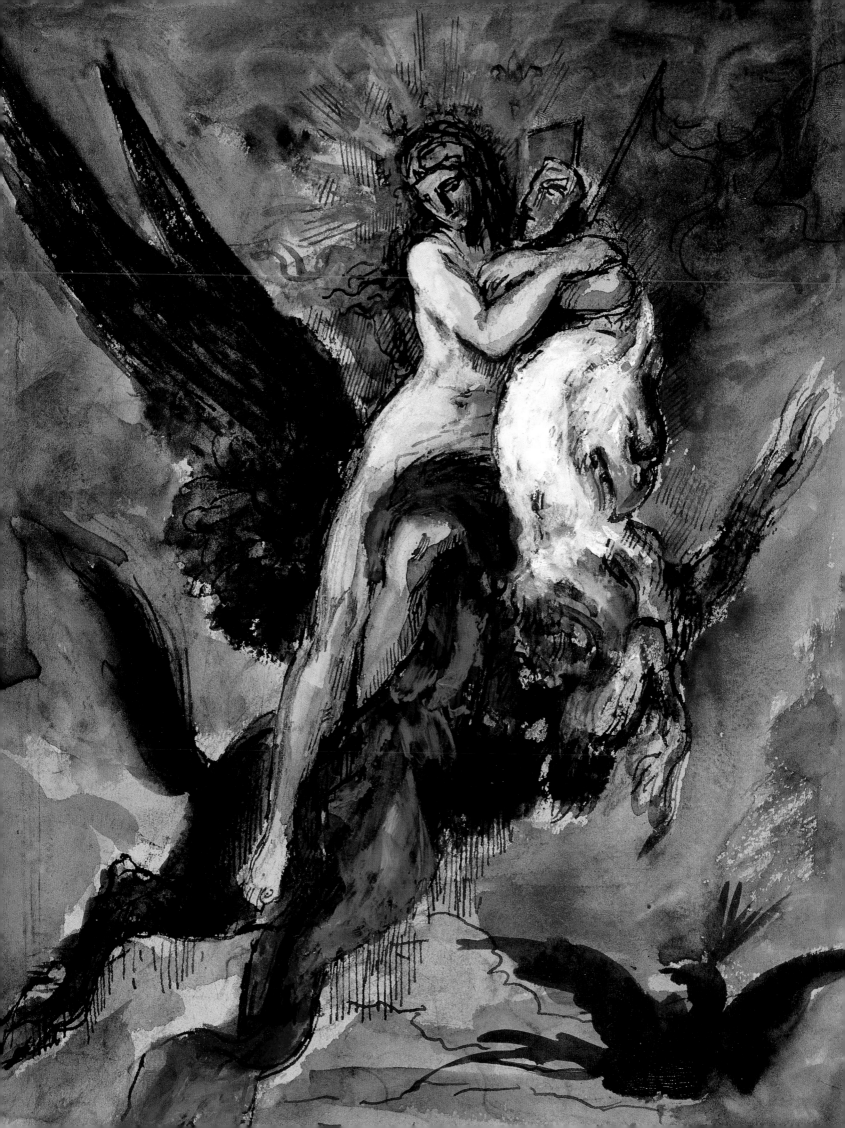

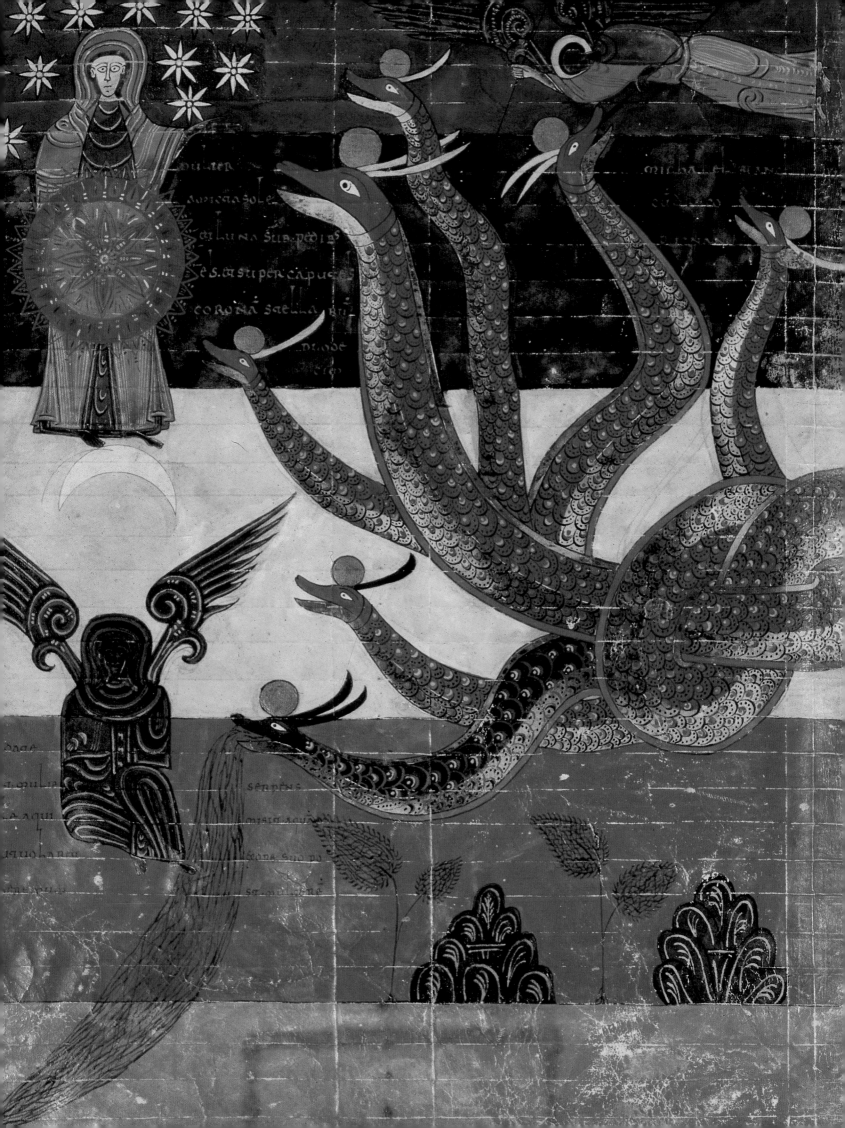

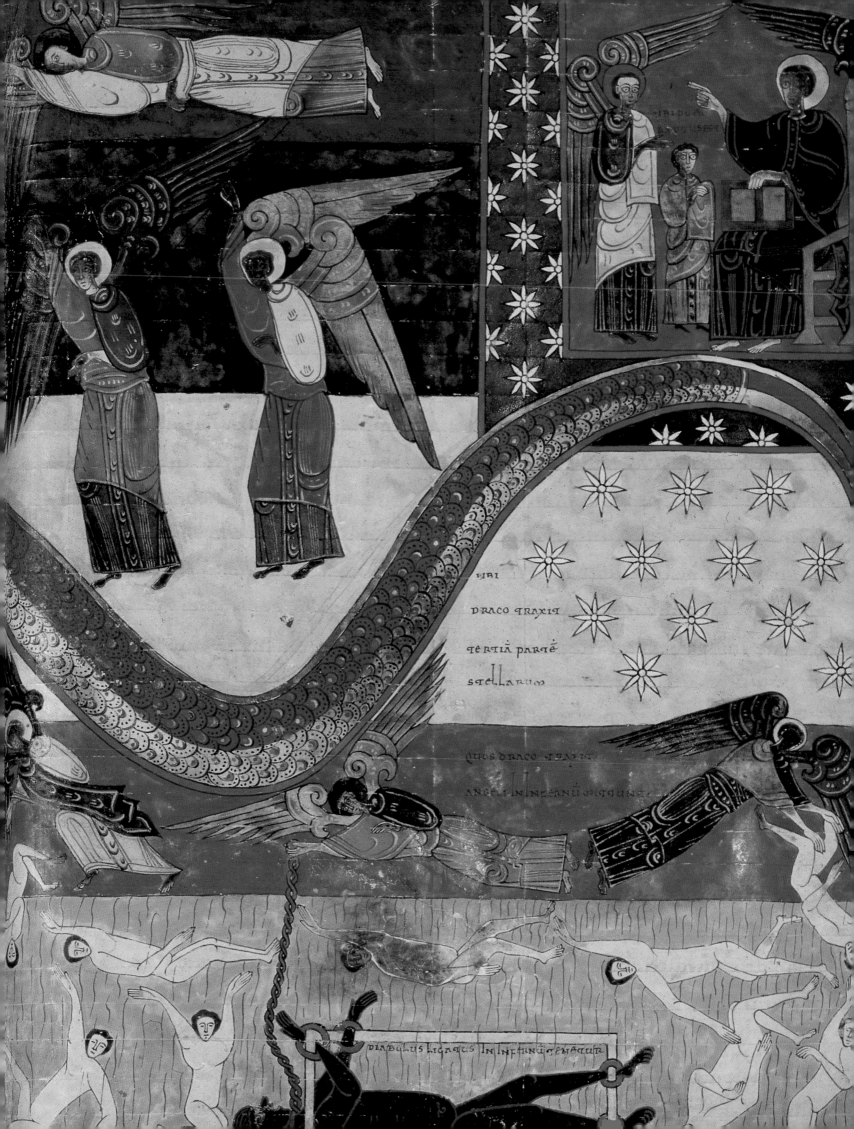

UBI

DRACO TRAXIT

TERTIÃ PARTE

STELLARUM

QUOS DRACO TRAXIT

ANGELI IN INFERNI MITTUNT

DIABOLUS LIGATUS IN INFERNO CRUCIATUR

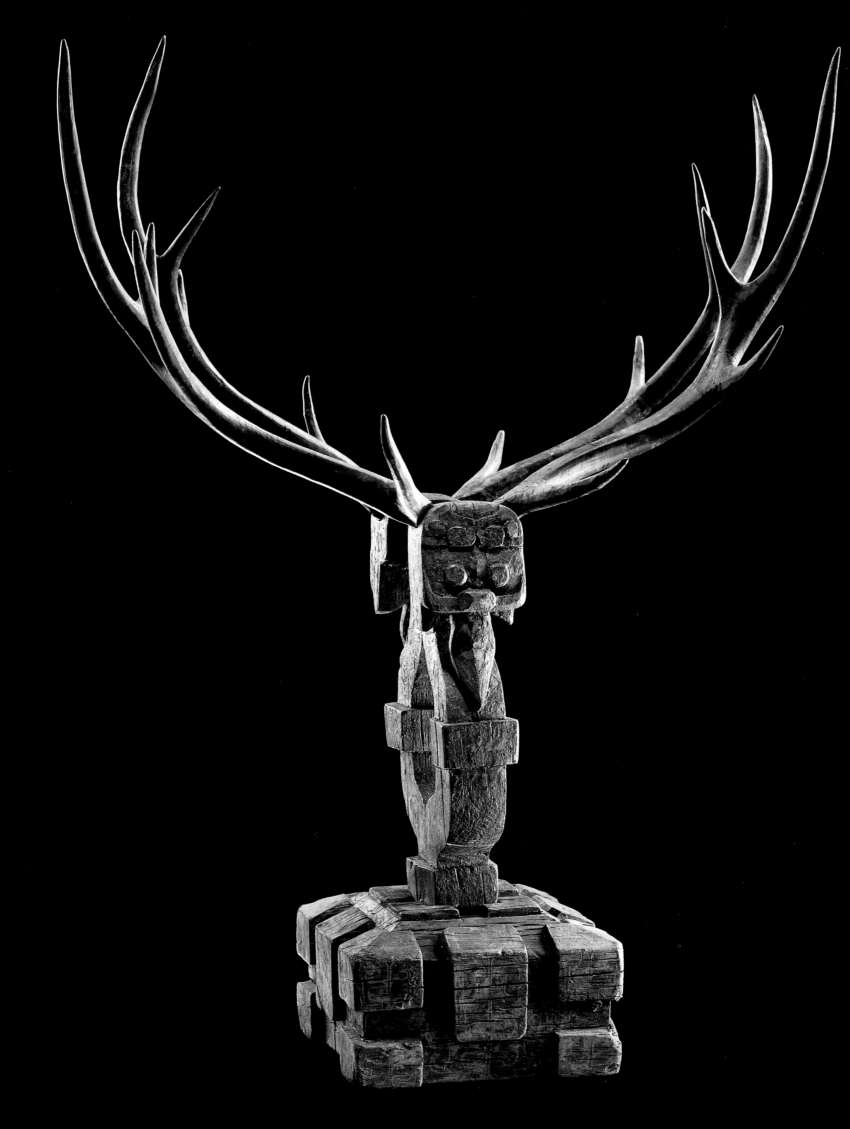

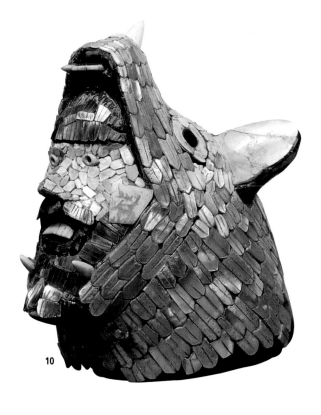

10

8. Pages 14–15: The Seven-Headed Dragon, from the Book of Revelation. Biblioteca Nacional de España, Madrid. The Commentary on the Apocalypse, written between 776 and 784 by the Spanish monk Beatus of Liébana (d. 798), was copied in a number of richly illuminated manuscripts, most from the end of the tenth to the end of the eleventh century. They vividly illustrate the travails that the Church would have to endure on Earth before its ultimate triumph.

9. Opposite: Tomb guardian with two faces. China, Warring States period (5th–4th century B.C.). Wood and deer horn. Musée Barbier-Mueller, Geneva

10. Above: Human head rising from the jaws of a coyote. Tula, Hidalgo (Mexico), Toltec civilization, Post-Classic period (900–1200). Terra-cotta, covered with mother-of-pearl mosaic, height 5⅛ in. (13 cm). Museo Nacional de Antropología, Mexico City

CHAPTER ONE
Symbols, Dreams, Religions

THE FACT THAT fantastic animals are ubiquitous in art proves one thing right away: fantastic animals play a crucial role in the collective imagination.

What role? To find an answer, let us consider the following long list: sphinxes and sacred animals in Egyptian sculptures; the Mesopotamian storm god represented as a lion-headed eagle; man-headed bulls on Akkadian cylinder seals and in Assyrian bas-reliefs; centaurs on Roman sarcophagi; *divs* in Indian miniatures; al-Buraq in Persian miniatures; tomb guardians from northern China; guardians of the law in Tibetan Buddhism; Quetzalcóatl, the Aztecs' plumed serpent; the Peruvian Indians' anthropomorphic feline; the figure in the shape of a dog-medium from Africa's Loango Coast; the turtle-man of the Cenderawasih Manokwari Bay; the monsters of Nias Island; the ancestor effigies in Vanuatu; the Zuni Indians' kachina dolls; the lion of Saint Mark and the ox of Saint Luke; the dragon slain by Saint George; and the marvelous inventory of diabolical creatures in the Book of Revelation. All these diverse animals obviously play a symbolic and, more precisely, a religious role.

Whether they are terrestrial, aquatic, or aerial, whether they have human features, and whether they are considered good or evil, the fantastic animals just listed all have a religious meaning, either

11. Right: Figure in the shape of a dog-medium. Vili sculpture collected by Joseph Cholet at the end of the nineteenth century. Loango Coast (Congo), end of 18th–beginning of the 19th century. Wood, nails, and blades of wrought iron, 16⅞ x 34¾ in. (43 x 88 cm). Musée de l'Homme, Paris (on loan to the Louvre). The magical function of this type of object seems to have been linked to conflict resolution as well as to the keeping of promises: each nail pounded into the wood corresponded to an oral contract, of which this nail was both a witness and a guarantor.

12. Opposite: Koma-Inu, guardian lion-dog or "Korean Dog." Japan, 19th century. Wood and glass, 9⅜ x 3½ in. (24 x 9 cm). Musée National des Arts Asiatiques–Guimet, Paris. These types of dogs were used as guardians of temples, always in pairs, to ward off evil spirits. There were no lions in the Far East, so this animal (which is horned, like the horned lions of the Achaemenid dynasty) is probably Persian in origin.

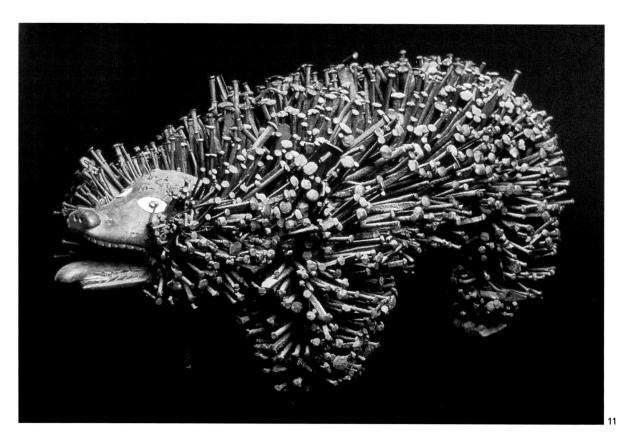

11

because they personify a divine or sacred being (a devil or a demon, a genie, a hero, a deified chieftain, or an ancestor), or because they constitute the traditional attribute of such a being. In any event, they must be taken seriously, either because they are embodiments of the sacred, or because they are intermediaries whose function is to help humanity communicate with the sacred.

Before going further, we need to try to define two crucial words—*religion* and *sacred*—both of which are laden with meaning and ambiguity. Lexicologists disagree about the etymology of the word *religion*: some believe it derives from the Latin verb *relegere* (to gather, to assemble) and others, from the verb *religare* (to connect). According to the first hypothesis, religion is what gathers humankind together, the bond that gives cohesiveness to a community; according to the second, it connects humans to what is beyond their realm—in other words, to the sacred. These two etymologies are not incompatible. It is because members of a community have the same way of connecting to the sacred that they feel connected to one another.

Thus, *religion* is simply the name of our relationship to the sacred, a relationship that, in each culture, passes through a specific set of beliefs, rites, images, objects, and so on—in short, through a coherent set of symbols that we, like historians or anthropologists, are in a position to study in a thoroughly impartial manner.

The word *sacred*, however, raises more complex issues. Unlike the word *religion*, it does not refer to any objective reality: anyone who shifts from one religion to another will realize that what is sacred here is not necessarily sacred there, and vice versa. Thus the word *sacred* can refer only to the constantly changing object of a subjective feeling; this feeling is widespread, since nothing is easier to observe, in all parts of the world, than external manifestations of the sense of the sacred, the sense that there is another world beyond this one. At the same time, nothing is more difficult than defining its characteristic features. Sigmund Freud insightfully viewed it as a kind of "oceanic feeling," and that phrase captures the blend of terror and respect that we feel toward whatever

12

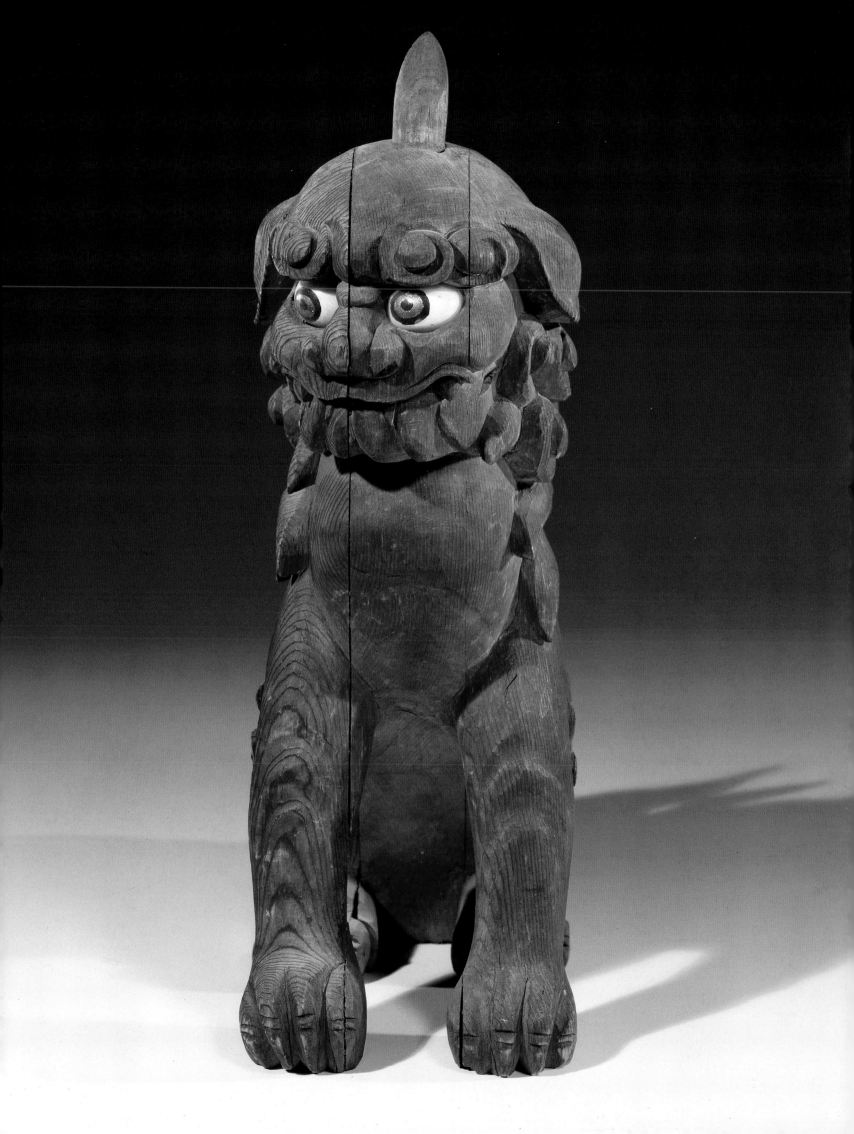

overwhelms or surpasses us, toward what we would be willing to let ourselves drown in, if we succumbed to the spell of our emotions.

It may be true that this feeling has no rational basis, that it reveals nothing except the persistence, in us as adults, of childish apprehensions and inspirations, that the object of our veneration is only a product of our imagination, but saying this is not terribly useful. No matter how much one scorns the sacred, or pretends not to believe in it, the fact is that in all civilizations there is a more or less strong (and contagious) sense of the sacred. And it inspires the most diverse and frightening forms of expression (whether individual or collective)—the trance or state of possession that the Greeks used to call "enthusiasm" being the most famous among them.

Everywhere, the notion of the sacred seems to be tightly linked to a danger threatening those who find themselves in its presence. When confronted with the energies released by such a presence, the individual or group seeks protection. Most human societies entrust the task of manipulating these energies to specialists, whether called shamans, priests, or wizards. In an effort to control the energies, these specialists hasten to lock them in places that are difficult to penetrate—the depths of caves during prehistory, brick or stone sanctuaries in the Sumerian and Egyptian civilizations.

In short, the relationship between religion and the sacred could be interpreted as follows: religion is the positive, socialized, and institutional aspect of the sacred; the sacred is the dangerous force that religion tries to define or contain. The sacred is the invisible cause; religion is the visible effect. In the endless conversation between religion and the sacred, the former tries to appease the latter without really succeeding in doing so, whereas the latter constantly forces the former to transform itself. Religions exist in order to channel the sacred and to prevent it from overflowing and thus disrupting social life. But since nothing (no dogma, no rite, no cult) manages to contain the

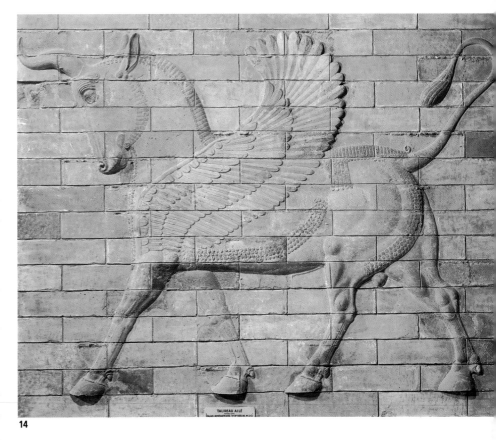

14

sense of the sacred, religions must continuously evolve in order to adapt to the constantly changing manifestations of the sacred. Religion strives to ensure the cohesiveness of the group, whereas the sacred surreptitiously tries to dismantle it. This is why no society, during any period of history, has managed to survive without religion. The cult of the "Supreme Being" in Robespierre's France and that of the "Father of the Peoples" in Stalin's Soviet Union filled the vacuum left, in both cases, by the authoritarian expulsion of Christianity.

After these preliminary thoughts, we still need to determine the role played in religious activity by imagery in general and by representations of fantastic animals in particular. But first we should examine some specific examples.

13. Opposite: Vulture-headed guardian. Banteay Srei (Siemreap, Cambodia), Angkor period (c. 967). Sandstone, 33¾ x 20⅜ x 18½ in. (86 x 52 x 47 cm). National Museum, Phnom-Penh, Cambodia. This sculpture, which is representative of the classic period of Khmer art, comes from a temple built by King Rajendravarman (944–968).

14. Above: Winged bull. Susa (Iran), Achaemenid period (5th century B.C.). Terra-cotta, rectangular brick panel, 63¾ x 75⅝ in. (162 x 192 cm). Musée du Louvre, Paris

FANTASTIC ANIMALS AS EDUCATIONAL

Let us start with a familiar example drawn from European Christianity in the Middle Ages. Christianity

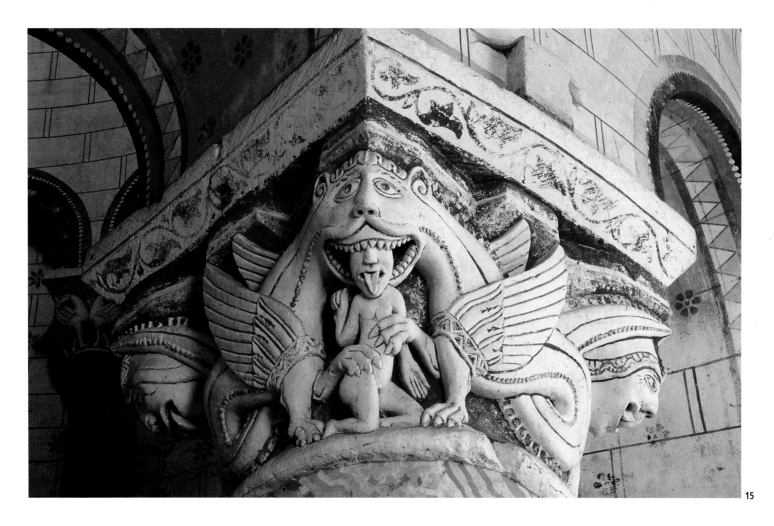

15. Above: Two winged dragons devouring a naked figure. Detail from a 12th-century stone capital by Gofridus. Collegiate Church of Saint-Pierre in Chauvigny, France

16. Opposite: Two illustrations from the Book of Revelation. Top: *The Scourge of the Locusts*; bottom: *The Woman with Twelve Stars Hands Over Her Child to the Angel*. Twelfth-century frescoes from the porch of the abbey church, Saint-Savin, France

in Europe is based on a compilation of texts—the Old and New Testaments—in which animal symbolism is all-pervasive. Metaphors from the zoological world—whether the serpent in Genesis, the golden calf in Exodus, or the dove in the Gospels—provide potent illustrations of moral issues and the presence of the sacred. This is not surprising, given the fact that biblical texts are the product of rural civilizations in which animals were such familiar beings.

The Gospels, in particular, resort to this rhetorical device so often (with the parable of the birds of the air who neither sow nor reap, the naming of the Christian community as Christ's flock, his role as sacrificial lamb, and so on) that the animal kingdom ends up being the preferred source of symbols for the Christian vision of the world. Such a vision, by definition, has no regard for the criteria of scientific rationality; this is why it accepts fabulous animals as easily as real animals.

Let us now move to the representations inspired by these texts, especially from the moment churches started being built all over Europe, at the turn of the second millennium A.D. A modern-day traveler to Poitou, a French region that was one of the birthplaces of Romanesque art, will be struck by the profusion of fantastic animals decorating religious edifices. As examples, let us briefly mention the Collegiate Church of Saint-Pierre in Chauvigny and the Saint-Savin abbey church.

In Chauvigny, the visitor's attention is instantly grabbed by the marvelous capitals on top of the columns in the choir, which are arranged in a semicircle around the main altar so that they are visible throughout the church. By viewing this sequence of capitals from left to right, one discovers the following themes on the eight capitals:

1. Satan, seated on a brazier, is flanked by two winged demons, each seizing its human prey.

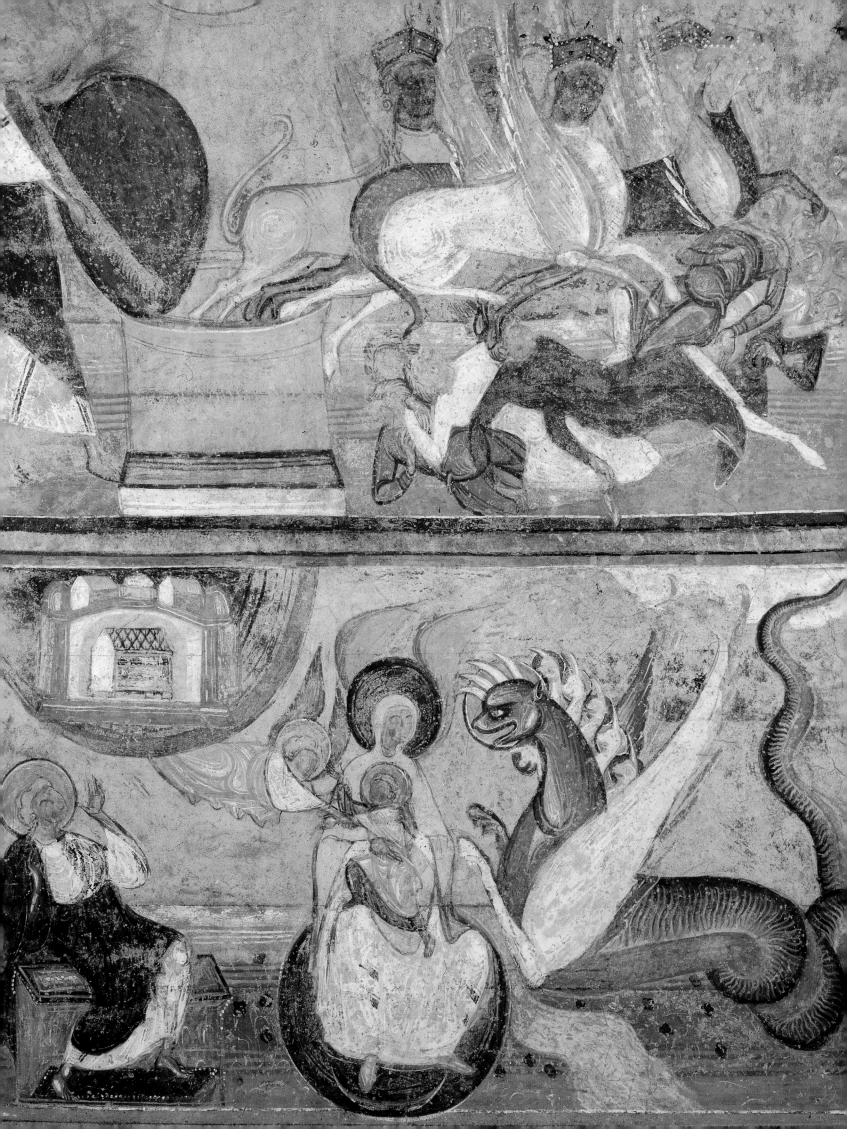

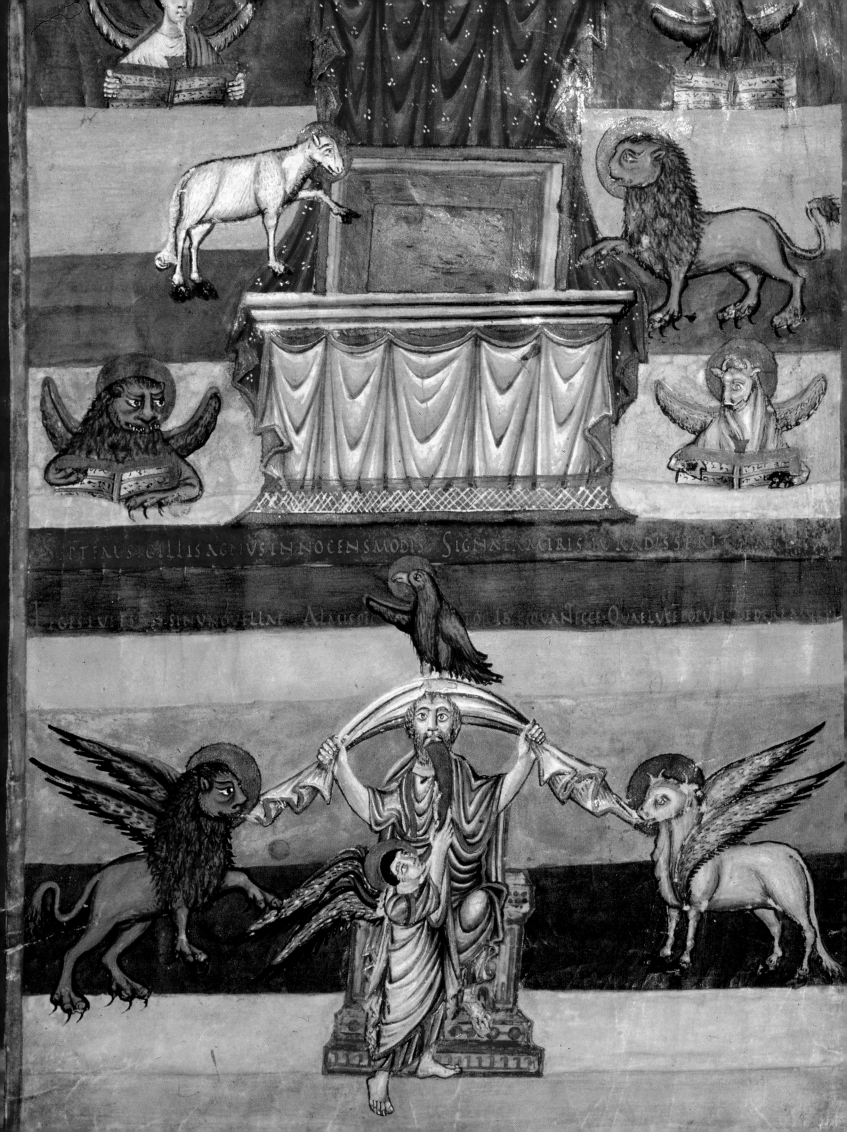

SEPTEM SIGILLIS AGNUS INNOCENS MODIS SIGNATA MIRIS IO RADIS SERIT MAT

EGIT VT ES SIVNDVELIN ALMVCON ... IE COVANICCI QVAE LVE LOPVLI IECTA ...

2. Animals with lion bodies and bird wings face each other (we can perceive them either as griffins, sphinxes, or varieties of manticores—a kind of fabulous tiger often described by ancient and medieval writers).

3. A different scene appears on each of the four sides of this capital: An amphisbaena (a dragon with a second head at the end of its tail, which allows it to move in both directions) clutches a ball representing the world dominated by the forces of evil; two lions also clutch a ball with their paws; birds with bearded male heads surround a normal bird; and a man (probably the prophet Daniel) moves among lions.

4. Two female faces, furrowed with wrinkles and with their hair falling loose (two signs indicating lust), are being slapped by hands attached to the ends of the tails of two winged lions.

5. Four different scenes from the life of Christ appear on this capital: the Annunciation (Luke 1:26); the Adoration of the Magi (Matthew 2:11); the Presentation in the Temple (Luke 2:22); and the Temptation in the Wilderness (Luke 4:1).

6. Four winged dragons, facing each other, devour two naked figures with anguished expressions, who represent the souls of the dead (plate 15).

7. Four different scenes are paired so that (2) is opposed to (1) and (4) is opposed to (3): (1) Babylon, city of sin and exile, is depicted as a whore (Revelation 17:3–5); (2) A man (probably a prophet) is meditating on the fall of Babylon (Revelation 18); (3) Archangel Michael weighs a soul that the devil tries unsuccessfully to pull toward himself; and (4) "An angel of the Lord" announces to two shepherds that the savior is born (Luke 2:8–12).

8. Two birds of prey dismember two naked figures, representing the souls of sinners doomed to perpetual punishment.

18

Without lingering on the details of this iconographic program, let us focus on the general meaning of this remarkable group of capitals, which were sculpted at the beginning of the twelfth century by a certain Gofridus (who, uncharacteristically for the era, signed his work). These images depict the fight between good and evil, which takes place not only in the world at large but also within the soul of each human being. Indeed, each soul is torn between the temptation to succumb to bad instincts and the efforts that it makes—with God's help—to overcome them. This fight can result in salvation only if the sinner has chosen to entrust himself to Jesus Christ and the church; otherwise it leads to eternal damnation. This is a standard Christian lesson, especially in Romanesque art. But the strength of the Chauvigny choir resides in the way this lesson

17. Opposite: Frontispiece from the Book of Revelation, from the Moutier-Grandval Bible, fol. 449. Tours school, c. 840. Illumination on parchment, 20 x 15 in. (51 x 38 cm). British Library, London. Below, the symbols of the four Evangelists: the winged lion (Mark), eagle (John), winged ox (Luke), and angel (Matthew).

18. Above: The Scourge of the Locusts, from the Apocalypse of Saint-Sever, lat. 8878, fol. 145v. 11th century. Bibliothèque Nationale de France, Paris

19

19. *Above:* Winged deity. Urartu, 8th century B.C. Bronze, ivory, and stone, with traces of gold leaf, height 6¼ in. (16 cm). State Hermitage Museum, Saint Petersburg. This figurine was discovered during excavations of the Urartu kings' residence, on the heights of Topakh-Kalé (Turkish Armenia).

is administered, and the expressionist way of depicting the devils or monsters that are meant to strike salutary terror in the believer.

Catching a glimpse of hell should inspire the worshiper to avoid going there: that is the message the Saint-Pierre canons seem to have wanted to convey when they commissioned Gofridus to carve this series of capitals. The educational function of the sculptures was all the more essential because they were destined for an illiterate audience that could not read the scriptures themselves and therefore had to learn everything from images.

In Saint-Savin (a village some thirteen miles away from Chauvigny), the Benedictine abbey church, also built at the beginning of the twelfth century (on the spot where, according to tradition, the remains of Saint Savinus were discovered), boasts a set of frescoes that are unrivaled in all of Europe. These monumental frescoes, which cover the ceiling of the nave and also the internal walls of the porch, the gallery, and the crypt, can easily be read by a spectator some forty-five feet below. They present an illustrated summary of the main episodes of the Old and the New Testaments. Not surprisingly, one finds monsters among them, and more appear on the church doorway.

The frescoes inside the porch illustrate the Book of Revelation, vividly depicting the travails to be endured by the community of believers. Among the noteworthy episodes, one can see, in the middle register on the left side of the entrance, the Virgin entrusting to an angel the infant Christ, who is being threatened by a winged dragon (Revelation 12:1–6; plate 16, bottom), and, in the upper register, the devastation of the earth by a swarm of locusts, represented here as human-headed horses (following Revelation 9:7–10, where they are described as battle horses with human faces and women's hair; plate 16, top).

One might wonder why this cycle of frescoes right at the entrance starts with the last (and last written) of the books forming the New Testament.

Once again, the aim is to inspire a salutary terror in the straying soul—a terror that will turn the soul back to God. The iconographic program at Saint-Savin—a sweeping depiction of salvation history, from Genesis to the Last Judgment—greets the visitor with a reminder that he will have to join the Church's fight against evil. And this fight starts at the western entrance, since medieval Christianity believed that the west was the direction of evil, darkness, and hell; and the east (facing Jerusalem), the direction of good, light, and paradise. Most European travelers, Christopher Columbus included, placed paradise at the extreme eastern end of the world—"Ex oriente lux" (Light comes from the east).

Here, as in Chauvigny (but on a larger scale, since the abbey was intended to receive crowds of pilgrims), the representation of fantastic animals serves a specific educational and even, one could say, therapeutic function: the aim is to elicit fear in the visitor, in order to inspire him to repentance and faith.

This program, stemming from the church's desire to assert control over society, broadly reflects Catholic iconography until the Counter-Reformation. Its invention can no doubt be credited to eleventh- and twelfth-century clerics: it was during this era that the production of manuscripts linked to the Book of Revelation, such as the commentary attributed to the monk Beatus, developed in European monasteries. These manuscripts were decorated with splendid and sometimes terrifying illuminations (plates 17 and 18) that

20. *Below:* Tracing made c. 1883 by the archaeologist Charles Lameire (1832–1910) of a sphinx drawn in the Assyrian Hall of the Musée du Louvre. Pounced and pricked drawing, with lead pencil, gouache, and charcoal, 34⅛ x 46⅜ in. (87 x 119 cm). Musée d'Orsay, Paris

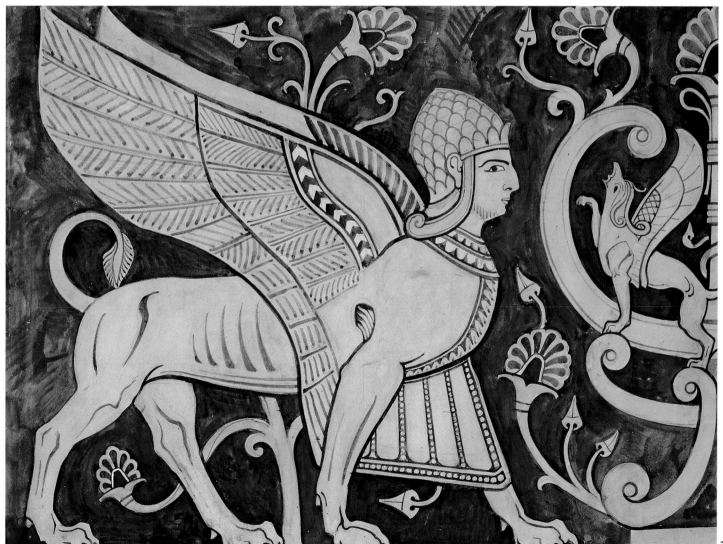

20

21. Right: *Harlot Dressed in Purple, Sitting on the Scarlet Beast Having Seven Heads and Ten Horns*, from *Beatus of Liébana's Commentary on the Apocalypse*, lat. 2290, fol. 142. France, end of the 12th century. Bibliothèque Nationale de France, Paris

22. Opposite: *The Prophet Mohammed and the Archangel Gabriel Arrive in Front of the Angel with 70 Heads and 70 Tongues (the Angel of Prayer), Then in Front of the Prophets Yahya (Saint John) and Zachariah*, detail from the *Mir'âj Nâmâ of Mîr Haydar*. Herat (Afghanistan), 1436. Gouache, ink, and gold on paper, 13½ x 10 in. (34.3 x 25.4 cm). Bibliothèque Nationale, Paris. This Persian-style painting allows us to admire al-Buraq, the prophet's mount.

would later resonate, at the end of the fourteenth century, in the famous *Apocalypse of Angers* tapestry (now in the Musée des Tapisseries, Angers, France).

FANTASTIC ANIMALS AS MAGICAL

Let us now consider some non-Christian cultures—Islam, Tibetan Buddhism, pre-Columbian civilizations, traditional cultures of Africa and of Oceania—in order to include, without any pretense of being exhaustive, several different regions and to expand the scope of our inquiry.

The last, chronologically speaking, of the three main monotheistic religions, Islam seems, from its inception, to have been a particular case. Like Judaism, but contrary to Christianity (which, on this specific point, rapidly freed itself from the laws transmitted by Yahweh to Moses), Islam conforms, for the most part, to the Second Commandment: "Thou shalt not make unto thee any graven image, or any likeness of any thing that is in heaven above, or that is in the earth beneath, or that is in the water under the earth" (Exodus 20:4).

The justification for this commandment (given in Deuteronomy 4:15) is simple: Yahweh, on the Sinai, did not show himself. He made himself heard, not seen. Thus Islam, like Judaism, does not allow representations of God, nor does it allow representations of human beings, since giving life is a prerogative that belongs only to God.

Theoretically, there should be no fantastic animals in an art that is, in principle, devoid of human beings and animals. But reality does not always conform to principles. Like any growing religion, Islam underwent some transformations in order to integrate itself better into the existing cultures of the peoples embracing it. Likewise, as with any other religion, it evolved over time. Large sections of the Muslim world have, at various points in their history, accepted as normal the representations of human beings (and even of partially naked women, as one can see in some of the frescoes of the Umayyad palace of Qasr Amra in Jordan) and, of course, representations of animals—including fantastic ones.

This "deviance," so to speak, occurred mainly within the Shia tradition (considered by followers

سسه سک سمله بستسفی مسد عمیلکی و عمسمله عمسمل سه لقعد سوسم

بستستم وسسله لمم سسه سسفی عوسستح عنسقمی سستقصی بمو ین

سسه عح و سفسمو مسه سع یعتمل مسه ستقصی ٥

سعوه عستسه عفسی یو مسه لقعد سسمسفه سوسله مه مو سلصی یسه

سیم تحبی یسه سیم عسسفه نی بسلصه سع یعتمل ستقصی ٥

سسه بیقسه لعسه سیم ٥ نی یعسسمله تسعج مسه بم بسلصه

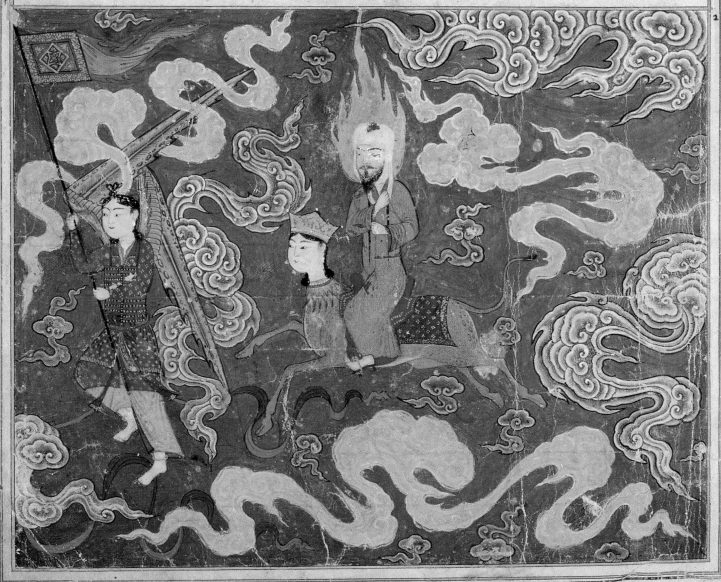

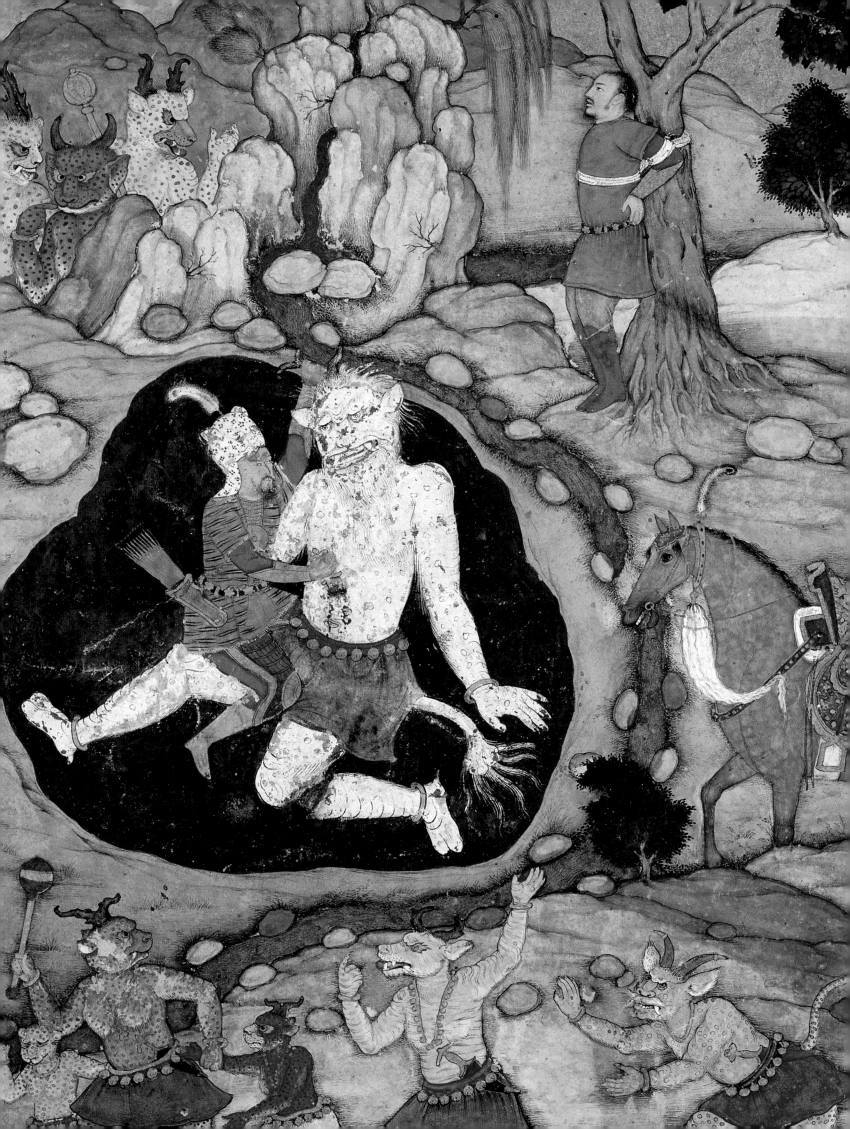

of the Sunni tradition of Islam as a deviant movement)—that is, in Egypt under the Fatimid occupation (969–1171), as well as in the Persian world, which, toward the end of the seventh century, tended to become Shiism's main stronghold. From Persia, it spread throughout Central Asia—most notably India, which, from the sixteenth century, fell under the domination of the Mughals, who were descended from the Timurid dynasty that had ruled Persia until then.

The art of the Indian miniature is thus an extension of the art of the Persian miniature, which explains the recurrence of the same iconographical elements, with stylistic variations according to regional schools. These elements include al-Buraq, the bay horse (with wings and a female head) that took the prophet from Mecca to the Rock of Jerusalem (housed today within the Dome of the Rock mosque) upon which Abraham nearly sacrificed Isaac and from which the prophet ascended to heaven (Koran, 17:1; plate 22); the *div*, a kind of jinni, or demon, that is occasionally good but mostly evil (Koran, 72:1; plates 23 and 24); the *simurgh*, which is comparable to the Greek phoenix; and, of course, griffins, which had been present in Persian art even before the Muslim conquest, and whose proliferation on everyday objects (seats, braziers, earthenware) reminds even the most tepid believer that there is indeed another world beyond this one.

Let us specify nevertheless that if the doctors of Islamic law have here and there accepted—during limited periods and for educational purposes only—the representation of fantastic animals in art (and almost exclusively in sophisticated court arts), it is because they, like the medieval clerics, wanted such images to make people think; the images were never intended as idols to be adored. This distinction is fundamental, for the main argument of those opposed to representations of the living was that such images risked becoming objects of idolatry by believers who perceived them as sacred. (The famous iconoclasts triggered a civil war over this issue in the Byzantine Empire during the

24

eighth and ninth centuries.) In other words, it is clearly because images of fantastic animals were not in the least regarded as sacred and did not threaten the monotheistic dogma that they were tolerated in Islam as well as in medieval Christianity.

The Christian situation changed radically during the transition from Roman Catholicism to what became, starting with the Great Schism of 1054, Eastern—Greek or Slavic—Orthodoxy. Here, the icon—whether it represented Christ, the Virgin, or a saint—was considered an authentic portrait; in other words, the realistic image of a sacred being. As a result, it ceased being just one image among many to become the object of religious veneration, elevating its status closer to that of the idol. This is why (contrary to what took place in the Roman Catholic world) icons remained practically unchanged in terms of style for centuries, as painters continued to reproduce the "true" image, without which there was no salvation.

23. Opposite: Rustam Fighting the White Div in Front of the Captive Awlaad. Mughal India, attributed to Mirak and Salih, c. 1610. Gouache heightened with gold on paper, 10¼ x 5⅞ in. (26 x 15 cm). Institut Néerlandais, Collection Frits Lugt, Paris

24. Above: Divs (demons). Tile illustrating a passage from al-Qazwini's Marvels of Things Created and Miraculous Aspects of Things Existing. Iran, 19th century. Siliceous ceramic, 10¼ x 10¼ in. (26 x 26 cm). Musée du Louvre, Paris

25. Below: Vajrabhairava, aspect of the deity Yamantaka. Tibet, 18th century. Gilded brass, heightened with red paint, 8⅝ x 6⅝ in. (22 x 17 cm). Musée National des Arts Asiatiques–Guimet, Paris

26. Opposite: Vajrabhairava, aspect of the deity Yamantaka. Tibet, 18th century. Distemper on canvas, 32¾ x 24¼ in. (84 x 62 cm). Musée National des Arts Asiatiques–Guimet, Paris

LET US NOW leave the religions of the Book to turn to Tibetan Buddhism—chosen here for its exceptional artistic richness as well as for the profusion of fantastic creatures that populate Himalayan art. These creatures are composed of heterogeneous elements that do not always have an animal origin. The Vajrabhairava (plates 25 and 26) is prominent in numerous *thangkas* (religious paintings on canvas that are displayed in monasteries to be the object of the monks' meditation as well as the believers' veneration). Representing just one of the many facets of the deity Yamantaka (the conqueror of death), at first sight it may appear to be a man with multiple arms and heads, in strict accord with the tradition of Hindu art from which Buddhist art is derived. However, a second glance reveals that these are the heads of angry bulls, transforming the imposing Vajrabhairava into a terrifying deity,

responsible for keeping evil away and scaring off evildoers. It is tempting to compare his role not to the dragon's but also to the Archangel Michael's or Saint George's crushing the dragon. This comparison only goes so far since, unlike the image of a Christian archangel or saint, any representation of Vajrabhairava is intrinsically sacred. It embodies a dangerous force, an energy whose origin is supernatural, a single spark of which could be enough to endanger human society. As such, it must be the object of ritualized devotion, a devotion intended to dispel its potentially misdirected strength. This is why *thangkas* in Himalayan monasteries are treated as incarnations of the divine: prayers and offerings are addressed to them, and impressive liturgies are periodically celebrated in their honor.

At the risk of oversimplifying, we can assert that the function of representing fantastic creatures in Tibetan Buddhism is neither essentially educational nor even decorative. It is first and foremost magical—inasmuch as the faithful expects tangible benefits in exchange for his devotion to these images.

MAGIC, RELIGION, AND THE SLEEP OF REASON

Of course there is no derogatory connotation in our use of the word *magical*. Even though Christian theology, especially in modern times, has tended to oppose linking magic and religion (a tendency also followed by certain anthropologists), they do not, from our point of view, refer to two fundamentally distinct activities. Rather, we see in the former a specific dimension of the latter. Within any religion, observances that aim, through means other than scientific rationality, at obtaining any visible or invisible results are magical practices. Whether or not this is what they are officially called and whether or not they have the approval of ecclesiastical authorities does not in any way modify this statement.

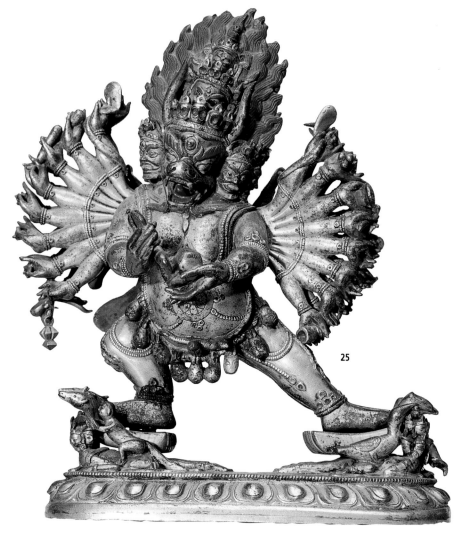

25

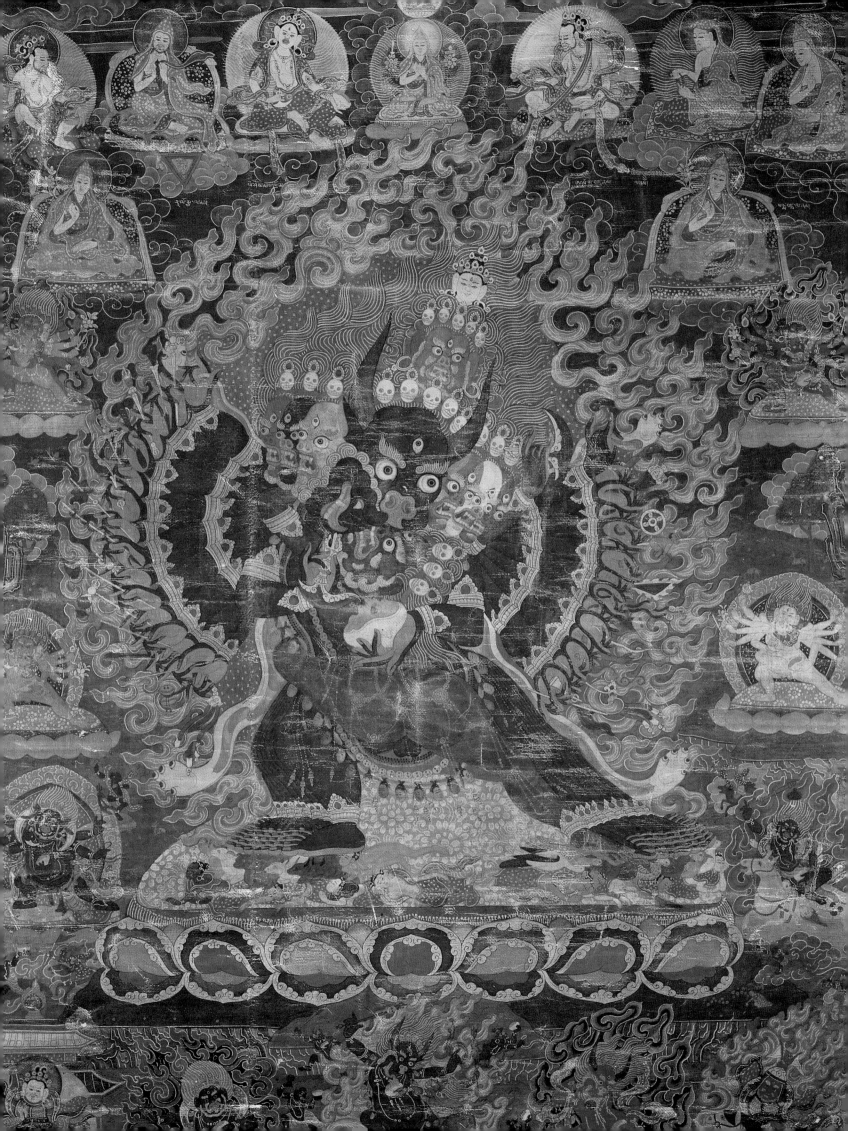

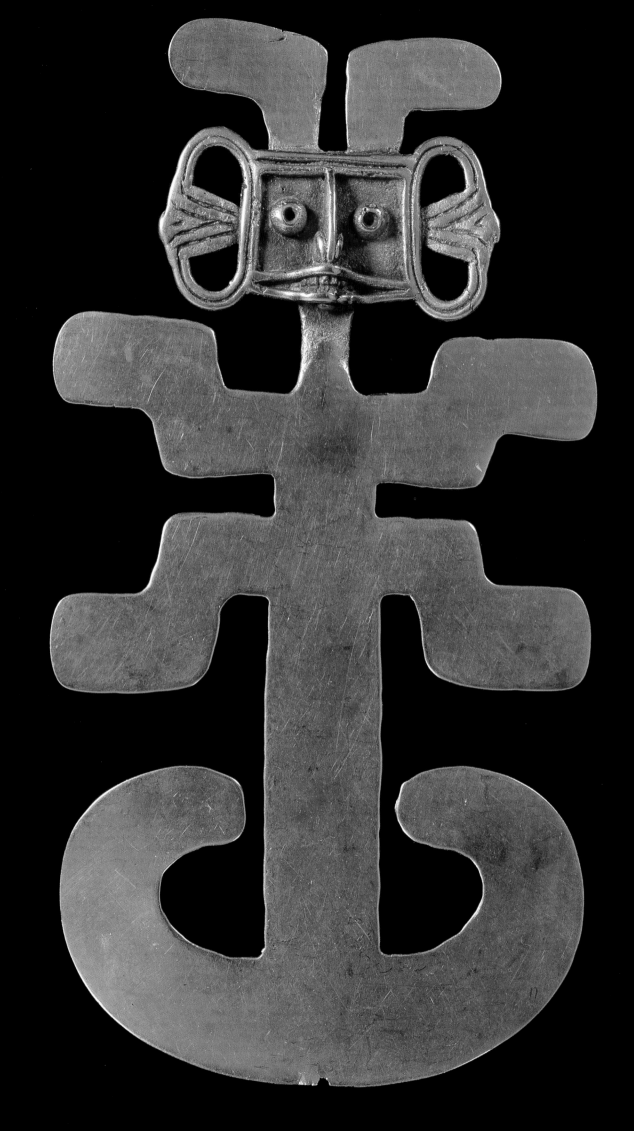

In this respect, Tibetan Buddhism is far from being the only religion to use magical practices linked to the representation, partly in animal form, of terrifying deities. On the contrary, such practices are universally established outside the religions of the Book (and survive even within the latter as "pagan" rites that are more or less tolerated, such as pre-Lenten carnival rites). Let us take the example of Pre-Columbian civilizations. Fantastic animals (plumed serpents and coyotes, dragons, fabulous fish or birds, felines with snake tails, man-jaguars, all types of composite creatures) proliferated within those civilizations, whether on the walls of religious edifices or as cult objects (plates 27 and 28). Unfortunately, in spite of the information left to us by the great precursor of modern anthropology, the Spanish monk Bernardino de Sahagun, in the aftermath of the destruction of the Aztec Empire, we know relatively little about the liturgies that structured worship among the Aztecs and even less about that of their predecessors. The little that we do know proves only that magical practices played an important part in those peoples' religious life.

Great Pre-Columbian temples were, for the most part, used as altars for carrying out human sacrifices intended to regenerate the sun's energy, which was viewed as the source of all life in the universe, by supplying it with blood. Representations of fantastic animals played a decisive role in this context. By serving as a support for the cosmic energy that sun worshiping was intended to channel, by concentrating that energy and by conveying it, these representations enabled priests to gain absolute power over the rest of society. This is what seems to have happened in the Aztec and Inca empires, the two Pre-Columbian kingdoms that came closest to forming what is commonly referred to in the West as "theocracies."

The case of preliterate societies from Amazonia, sub-Saharan Africa, and Oceania (which were once called "primitive" societies) is comparable but nonetheless different. Before colonization, these societies did not witness the rise of any great empires or theocracies. For the most part, they still lack a centralized structure even today. They are generally small, nomadic or semi-nomadic, self-sufficient, almost always geographically isolated or else striving to preserve their isolation through war. But we can find there, in very similar configurations, the same phenomena as in the great Indian empires of Pre-Columbian America: magical practices also play a predominant role, and representations of fantastic animals abound on objects associated with these practices.

It is religion, once again, that allows us to understand how these two phenomena are interwoven. Although we know little about most of the ritual activities that take place in secret societies to which only the initiated are admitted, we do know that the masks worn by officiants (and first of all

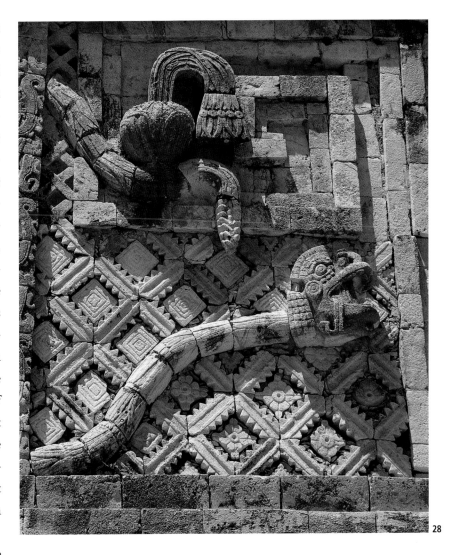

28

27. Opposite: Stylized man-jaguar. Chaparral, Tolima (Colombia), Ancient Tolima period (1st–5th century A.D.). Gold pectoral, 6¼ x 3⅛ in. (16 x 8 cm). Museo del Oro, Bogotá, Colombia

28. Above: Serpent decorating the western facade of the "nunnery quadrangle." Uxmal, Yucatán (Mexico), Maya civilization, Chenes period (A.D. 700–1000). This complex of four religious edifices received its nickname from the Spanish conquerors who believed it to be the residence of the Maya priestesses.

27

by dancers) during religious ceremonies are not simply images but instruments intended for conveying or storing supernatural energy. Therefore, animal representations decorating these masks (plates 31 and 32) have a magical function. Made to resemble the spirits they are supposed to summon, these representations enable the spirits to reside for a limited period within the community that has summoned them so that they might be offered due homage—whether in the form of an animal sacrifice or, more simply, in song and dance. In return, the spirits will take care of the community, protect it against evil, and strive to maintain peace between the living and the dead.

That is not all. In certain traditional societies of Oceania, as in numerous contemporary Native American societies (whose ancestral religions have resisted better than generally believed five centuries of Western acculturation), the magical role of the representations of fantastic animals seems to be reinforced by the pervasive cultural phenomenon of shamanism. This phenomenon has also been widespread from time immemorial in the regions of northern Asia (Tibet, Mongolia, Siberia)

where, some forty thousand years ago, the first migrations originated that led to the "Indian" settlements in the Americas. Exemplifying a practice that is inextricably both magical and religious, shamanism can be described, in psychological terms, as an experience of self-dispossession: falling into an artificially induced trance, a public figure with supposedly paranormal powers lends his body to a divine spirit, which often has the name of a real or fabulous animal. Imbued with this new personality, the shaman manages to heal sickness, induce rain—in short, to satisfy demands aimed at improving well-being on earth.

We don't need to dwell on the details of this paranormal experience in order to understand, once again, that the fantastic animal—precisely because it is fantastic—constitutes the simplest and the most immediate embodiment of the diabolical or the divine (two categories that overlap because of the basic ambivalence of the sacred). It is also obvious that the role played by fantastic animals in magical and religious observances is all the more important in a culture since, for members of that culture, the opposition between (official) religion

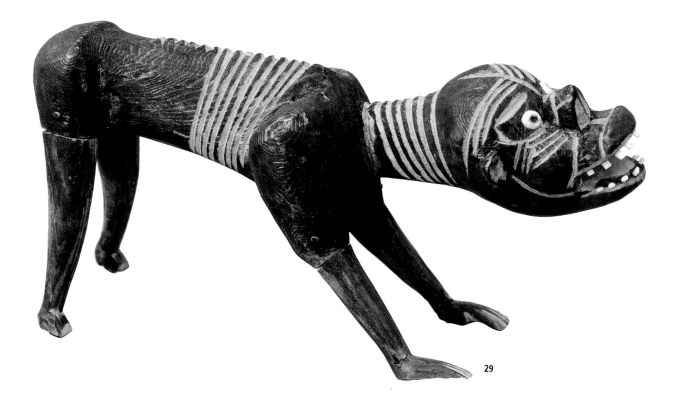

29

and (unofficial) magic is not institutionalized, as was the case in most societies that were spared Western aggression and, within Europe itself, in rural society prior to the Renaissance.

❧

TO CONCLUDE this quick survey of the religious function of fantastic animal imagery, let us emphasize that it is not at all our intention to use the distinction we have just made between the religious and magical practices in order to oppose the three main religions of the Book to all other religions. Such an opposition would be meaningless. First, these two functions, important as they are, are not the only ones fulfilled by fantastic imagery. Second, even if one seems more developed in certain cultures than in others, neither is completely disregarded in any culture. Let us quickly emphasize these two points.

When we describe the primary function of the representations of fantastic animals as magical or as intended for religious education, we adopt the point of view of whoever commissioned or produced the representations—i.e., the patron or the artist. But their ideas about such representations do not limit the meaning of them. Beyond conscious meanings lies the huge realm of unconscious meanings that, because they are unconscious, remain invisible not only to the patron or artist but also to any observer. As a result, there is no way to analyze exhaustively the full range of symbolic meanings attached to the representations of fantastic animals. The only thing we can sense is that the recourse to fabulous rather than to real animals (or any other living creatures) responds to complex psychological motivations, having something to do with the sexuality of the patron or artist; with his or her fantasies, urges, and familial surroundings; with how he or she imagines his or her position in this environment, the wishes and anxieties tied to this position; with childhood traumas (traces of which are manifested in dreams and nightmares), and so on.

Since the psychoanalytical relation, as defined by Sigmund Freud, cannot unfold without access to speech by a living patient, it is impossible for us to go further. Indeed, even if the representations that we are studying are sometimes very "talkative,"

29 and 30. Opposite and below: Tupilak. Amassalik (Greenland), date unknown. Wood. Musée de l'Homme, Paris. Believed to be capable of seizing the human soul and inflicting hardships on the living, the Tupilak are evil spirits that appear in dreams to the inhabitants of Greenland.

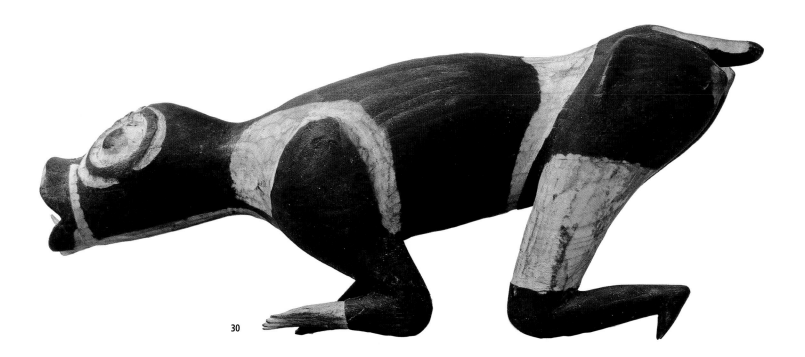

30

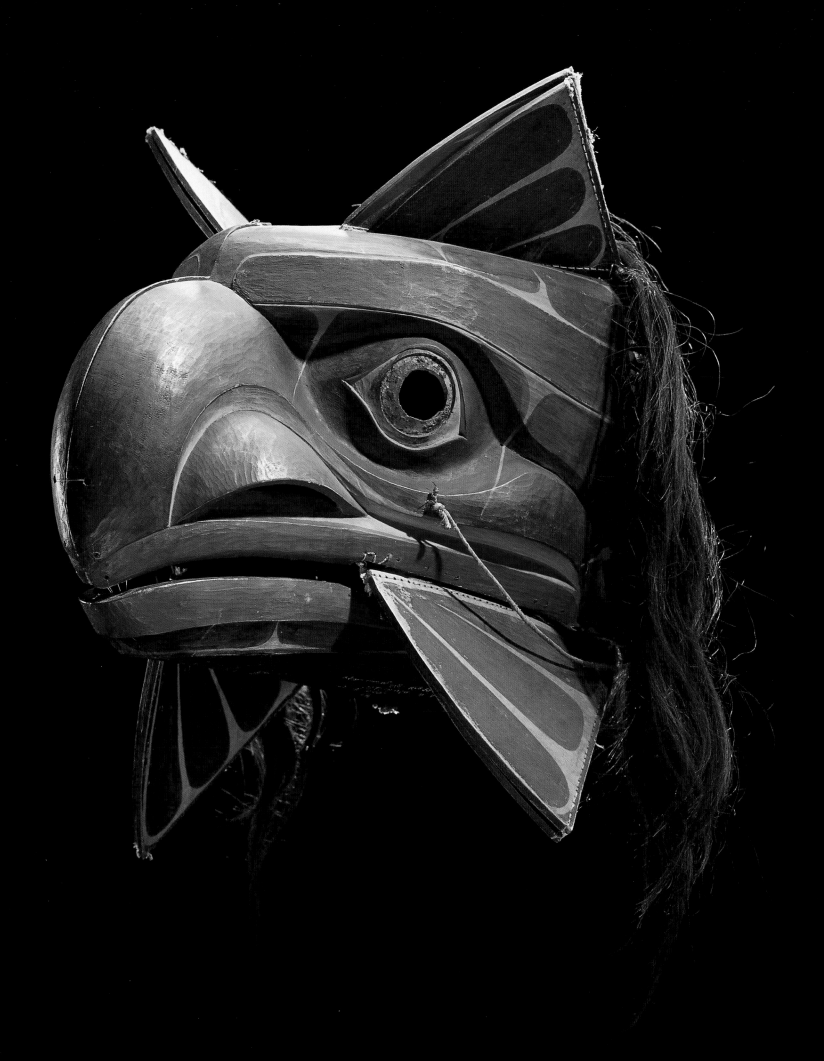

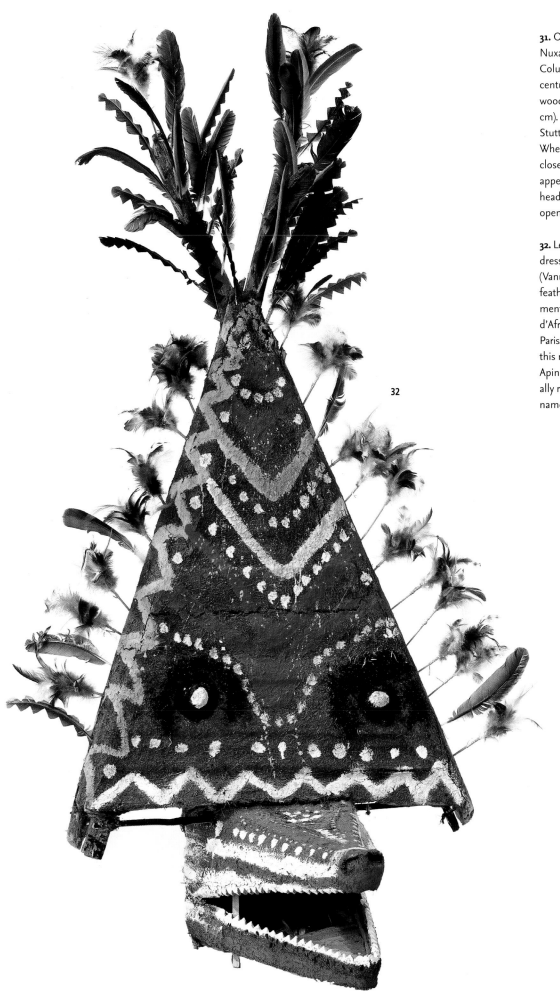

32

31. Opposite: Sun mask. Nuxalk People, British Columbia (Canada), 19th century. Polychrome wood, height 18⅞ in. (48 cm). Linden-Museum, Stuttgart, Germany. When this mask is closed, it takes on the appearance of a bird head, and when it is open, a man's head.

32. Left: Banlu mask head-dress. Malekula, Uripiv (Vanuatu). Plant fibers, feathers, rattan, and pigments. Musée des Arts d'Afrique et d'Océanie, Paris. The artist who made this mask was called Apinata. (It is exceptionally rare for the artist's name to be known.)

41

33. Opposite: "El Sueño de la razon produce monstruos" (The sleep of reason produces monsters). Etching from Los Caprichos (1799), pl. 43, by Francisco de Goya (1746–1828). Musée des Beaux-Arts, Lille, France

they are so only in a metaphorical sense, since those who commissioned or created them are long since dead. But the feeling of "disquieting strangeness" ("das Unheimliche," as Freud called it) that they inspire in us can be explained only by the fact that they are also, in a sense, familiar to us (otherwise their strangeness would not be so disquieting)—that is, we recognize them as products of an unconscious activity resembling our own. And this observation, in turn, prevents us from drawing too clear a distinction between fantastic animals that have a religious, educational purpose and fantastic animals that have a magical function. They all belong to the common pool—which is also the most obscure of all pools—that of the human psyche.

However, none of these purposes is specific to any one culture or to a set of given cultures. An African ceremony, with songs and dances, can have an educational function: this is particularly true of initiation rituals. Conversely, the most traditional Roman Catholic imagery can have a magical function: from one end of Christianity to the other, we can see statues of healer saints and effigies of the Virgin accomplishing "miracles." We must admit, once again, that all attempts made at classifying fantastic animals according to one criterion or another remain limited, however attractive such systems may be to a rationalist mind. At a more subterranean level, no matter the cultural context in which griffins, dragons, and tritons may appear and regardless of the religious ideology that accounts for them, they belong to the same family: they are all dreamlike fabrications of the human mind. As Francisco de Goya said, it is "the sleep of reason" that, in all parts of the world, "produces monsters" (plate 33).

Does this mean that our inquiry should end here? Not at all. Saying that fantastic animals have a dual root, that they derive at once from an unconscious psyche that is the same for all humanity and from cultural contexts that can have indefinite local variations, throws a general light on their genesis. But we still need to go from the general to the particular in order to improve our understanding of the genesis of certain fantastic animals and the way they are disseminated within certain cultures. This is what we will try to do by going back to the civilization we know best: that of Christian Europe (although it is clear that a similar effort could be undertaken by specialists in other bestiaries from different cultures).

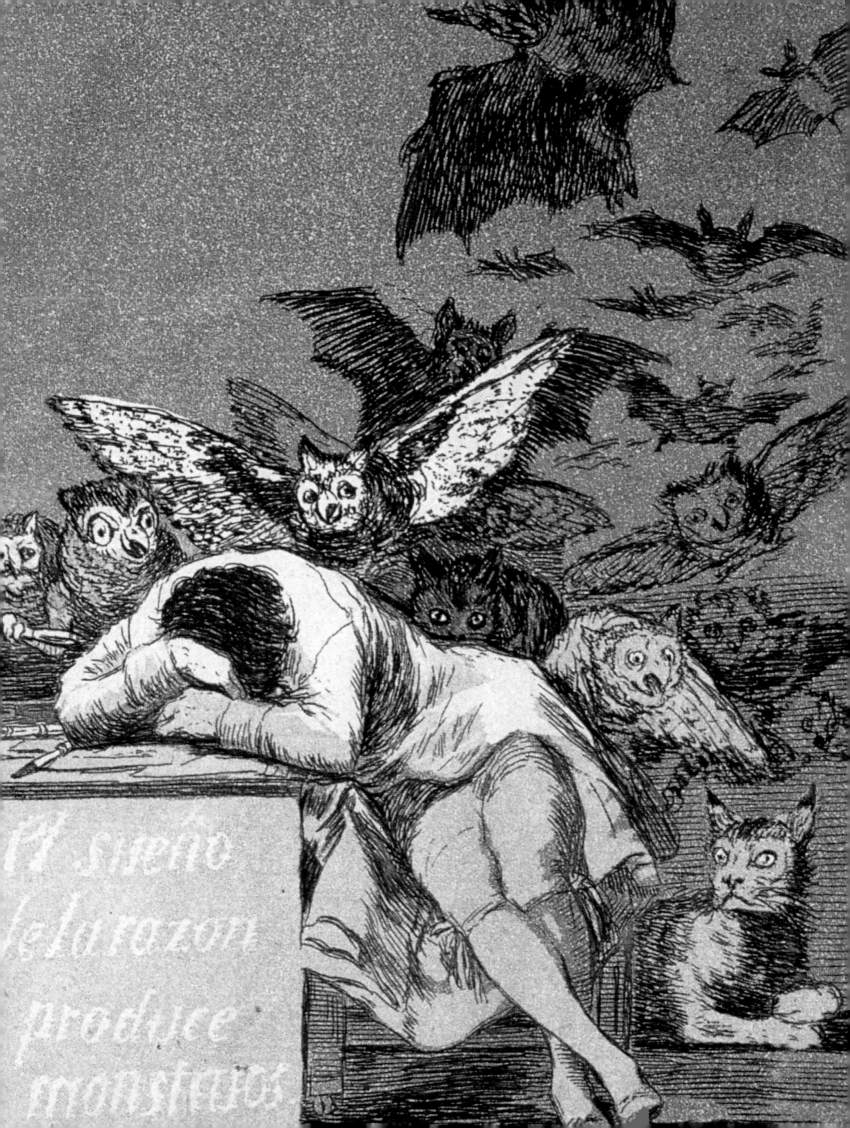

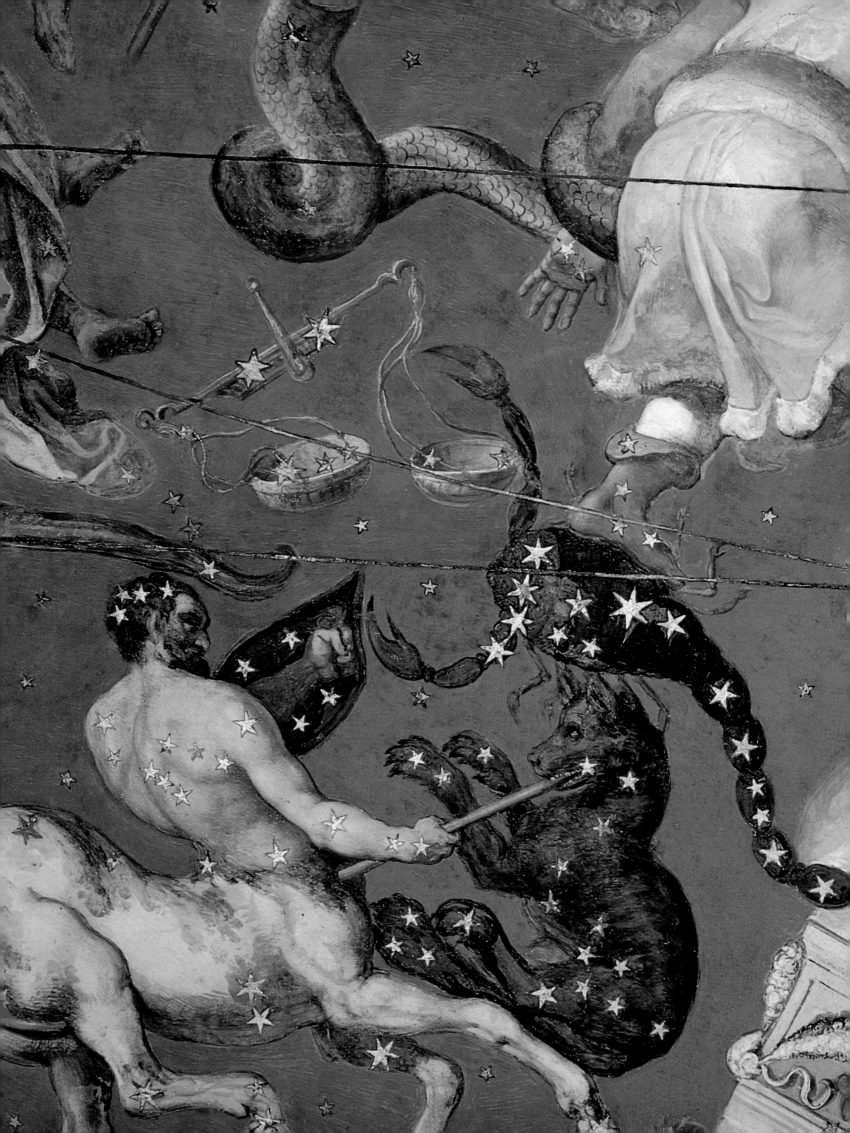

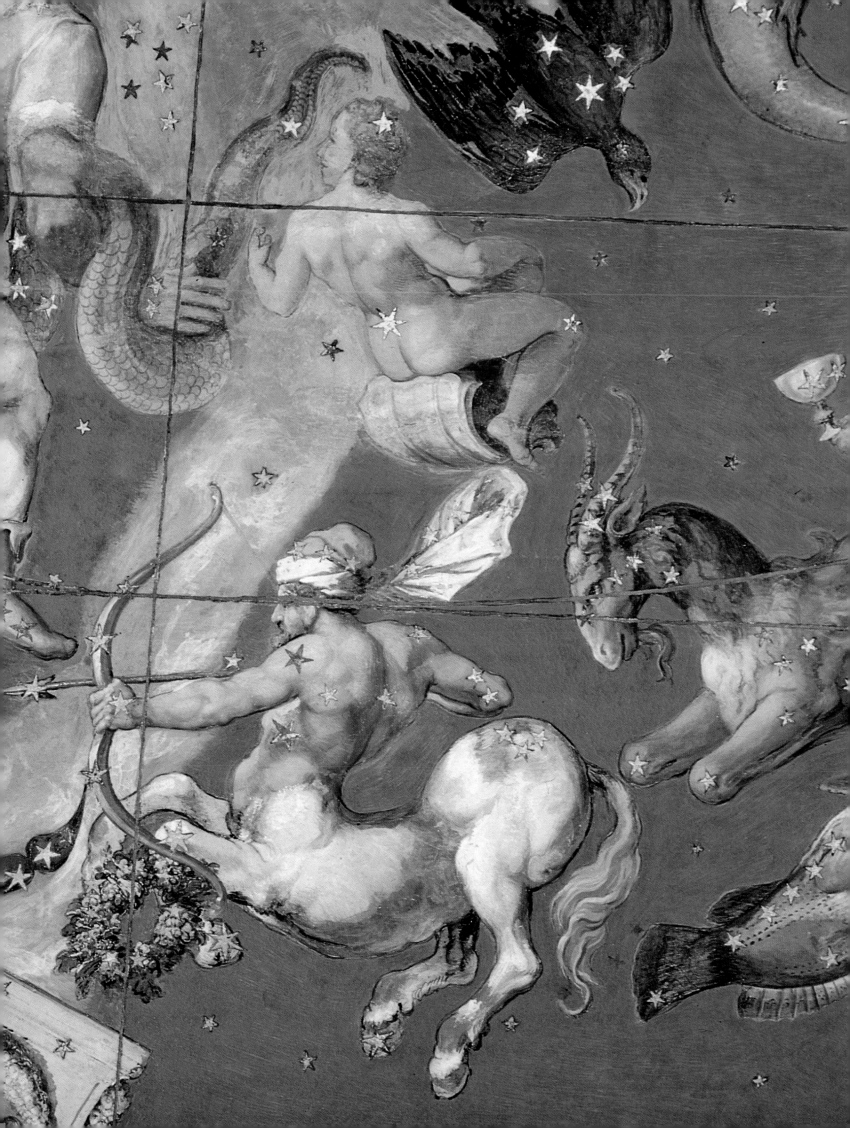

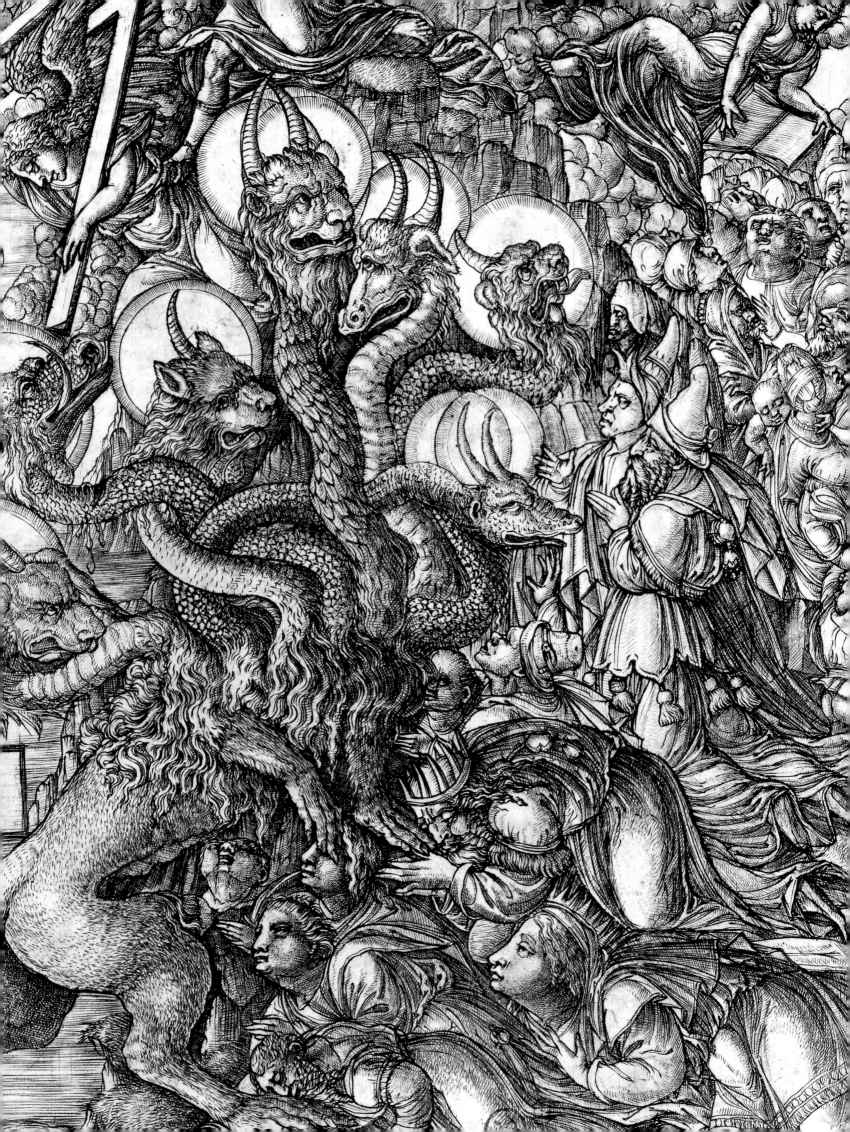

36

34. *Pages 42–43:* Celestial planisphere. Fresco (detail), c. 1574, from the ceiling of the Sala del Mappamondo in the Caprarola Palace, Caprarola (Italy). Giovanni del Vecchi (1536–1615) painted this fresco while collaborating with Taddeo Zuccheri on decorations for the Caprarola Palace, which belonged to Cardinal Alessandro Farnese.

35. *Opposite: The Beast with Seven Heads,* from the Book of Revelation, engraving by Jean Duvet (1485–1561). Bibliothèque Nationale de France, Paris. Jean Duvet, a Protestant and one of the best sixteenth-century French engravers, was formerly known as the "Master of the Unicorn" because of one of his works, a series of plates entitled "History of the Unicorn." His wild imagination, which sometimes recalls Albrecht Dürer's, seems to anticipate William Blake's visions; but the way Duvet filled space without leaving any blank is characteristic of his own style.

36. *Above:* Fantastic animal with the paws of a feline, a human head, and the wings of a dragon. France, 16th century. Fragment from a stained-glass window, 5½ x 5½ in. (14 x 14 cm). Musée de la Renaissance, Ecouen, France

CHAPTER TWO

Inventing a Bestiary

W
HERE DO fantastic animals come from? One might fancifully suggest that they come from staring at a cloud in the sky, a shadow on the ground, or a spot on the wall. If you look attentively at such a spot, as Leonardo da Vinci recommended to a young painter in 1492, "You will discover most admirable inventions, which the painter's genius can turn to good account in composing battles between animals or men, landscapes or monsters, demons or other fantastic things that will do you credit."

More seriously, one could attempt to demonstrate how certain ornamental schemes can be elaborated from a simple foliage line, by virtue of the laws of geometry. Developed symmetrically, such schemes can, in turn, suggest the silhouette of a two-headed animal or two animals facing each other. This

was, in any case, an original approach to the problem, proposed by the great art historian Jurgis Baltrušaitis (in *Art sumérien, art roman*) as early as 1934.

Taking a philosophical approach, Gilbert Lascault has also pondered (in *Le Monstre dans l'art occidental,* 1973) the nature of the mechanisms used by the imagination to breed "monsters"—a category that he conceived much more broadly than our own definition of fantastic animals in the introduction. Relying on the Aristotelian postulate that all works of art result from some type of imitation (since a purely creative imagination, owing nothing to nature, was as inconceivable to the Greeks as the very notion of creation), Lascault distinguishes four basic methods of imitation that could give rise to the monstrous form. The form could be based on the imitation of observable biological anomalies in living beings, due

37. Below: Monstrous animal. Illustration from *Universal Cosmography*, 1571, by André Thevet (1502–1592). Musée Barbier-Mueller, Geneva. Despite the fact that Thevet, a Cordelier monk, was the king's historiographer and cosmographer, he was well known for presenting as true even the most extravagant stories. He traveled to the Holy Land (1549–54) and, more briefly, to Brazil (1555), from which he brought the use of tobacco back to France.

38. Opposite: Two dragons. Engraving by the Master of Saint-Sebastian, an artist probably of Flemish origin, active in Marseilles and Aix-en-Provence between 1493 and 1508, who is considered one of the last representatives of the Avignon school. Bibliothèque Nationale de France, Paris

perhaps to genetic mutations or accidents occurring at birth. It could arise from the imitation of disguised or masked human beings, such as the participants at a ball, a tournament, or a carnival rite. It could derive from the imitation of an object that was incorrectly perceived. Or it could result from the fallacious (whether intentional or not) or inadequate description of a little-known living being.

Of these different "methods," the last two seem the most important to us, in that they open the door to the invention of the most diverse monstrosities (the first two, linked to very particular contexts, seem to be a priori less fertile). Consequently, we will examine closely the role played in the genesis of the medieval fantastic bestiary by erroneous perceptions as well as by misleading descriptions.

By "erroneous perceptions," we mean perceptions based on sensory data that are inaccurate (whether due to misperception or to flaws in the sense organs), as well as those resulting from cog-

nitive misinterpretation (the brain incorrectly interprets the material recorded by the senses). We will put aside one particular case: perceptions that have been artificially distorted by alcohol or drugs. The use of mind-altering drugs is an ancient practice, and cultures such as the Mexican Indians, for instance, have been putting hallucinogenic plants to ritual use for centuries. It is probable that artificially induced hallucinations have served as a matrix for a number of fantastic representations within these cultures. But, having said that, exploring artificial hallucinations is as difficult as probing the unconscious. And for good reason: in the final analysis, the two are the same field, insofar as any hallucination is the result of both perceived and unconscious images. However, we can have no insight into the latter, since the artists who conceived them have long disappeared.

On a different level, a more basic category of "abnormal" perceptions has been attested to

37

38

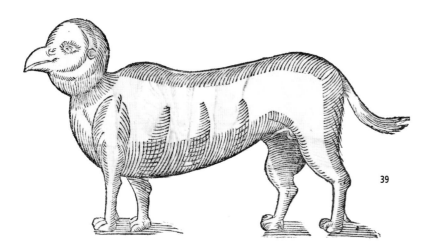

39. Above: Monstrous animals from *On Monsters and Marvels*, 1573/79, by Ambroise Paré (1509–1590). Bibliothèque Nationale de France, Paris

largely by medical literature: confused or erroneous perceptions of certain biological processes that people do not understand and therefore qualify as monstrous. What does "monstrous" mean in the biological world? Within this problematic notion are interwoven both moral and aesthetic judgments. For medieval thinkers who were faithful to Aristotle's definition, the monstrous was what happened "against nature"—in other words, that which occurred rarely, since the natural itself could be defined only by statistical frequency.

Although this theory had the merit of trying to be as objective as possible, the way Aristotle implemented it raises serious issues. First, if a definition of the monstrous is contingent upon a definition of the natural, insufficient knowledge of nature could lead us to classify as monstrous processes that are in fact not abnormal at all (in particular, prescientific minds were often induced to see things that did not exist or to exaggerate certain features that actually were seen).

Second, Aristotle, who often resorted to the opposition between "form" and "matter," tended to explain the origin of biologically abnormal phenomena in terms of matter resisting form. As a result, the monstrous phenomenon is not only abnormal in a statistical sense, it is also criticized because, for the philosopher, form (which is intellectual) must have control over matter (which is physical). This criticism is particularly visible when Aristotle, associating "form" with "masculinity" and "matter" with "femininity," defined the latter as the first sign of departure from the rule—that is, as the first sign of monstrosity. And while the imperfection of women when compared to men was obvious to Artistotle, the imperfections of barbaric peoples when compared to the Greeks were even more obvious. The barbarians were therefore biologically monstrous—a concept easily recognized as the thinly veiled beginnings of the future scourge of Western racism.

No matter how hard medieval theologians, most of them followers of Aristotle, tried to defend the divinity of creation—including monsters—by

explaining that the latter attested to the creator's infinite power, the damage was done. As imperfect and imperfectible beings, monsters remained stains on creation. Consequently, these stains had to be eliminated in order to save creation. A version of this idea has survived for centuries in certain modern Western states that have consequently used their economic and military power to implement dreadful "cleansing" programs.

The idea that nature's normalcy is frequently marred by aberrations is not only false, it is also dangerous. But it finds a home among minds ill prepared to question their own perceptions. This explains its prevalence in medieval and even Renaissance medical literature. *On Monsters and Marvels*, a treatise written by the surgeon Ambroise Paré that had a prolonged and substantial impact on the cultured elite, was instrumental in conveying, until the beginning of the Enlightenment, all kinds of beliefs concerning the possibility of the most implausible creatures.

Published for the first time in 1573 and considerably enlarged in its revised edition of 1579, this treatise is not the only one of this sort. On the contrary, it is part of a well-established tradition, including Werner Rolevinck's *Fasciculus temporum* (1474), Hartmann Schedel's *Nuremberg Chronicle* (1493), Sebastian Münster's *Cosmography* (1544), Conrad Gesner's *Historia animalium* (1551–87), Conrad Wolffhart's *Prodigiorum ac ostentorum chronicon* (1557) (Wolffhart was more famous under his Greek pseudonym Lycosthenes), and certain "scientific" engravings by Albrecht Dürer (such as *Monster Pig: Sow of Landser*, 1496). Paré's treatise also drew inspiration from Pierre Boaistuau's *Histoires prodigieuses* (1560), Jean Wier's *Cinq livres de l'imposture et tromperie des diables* (1563), Ludwig Lavater's *Of Ghosts and Spirites Walking by Night* (1572), and, for the 1579 edition, the two thick volumes of André Thevet's *Universal Cosmography* (1571).

Aimed at presenting as diversified a picture as possible of all the anomalies that a doctor could observe in his practice, Paré's book is so riddled with implausibilities that it might give the contemporary reader the impression that it was conceived by a credulous mind. But it would be incorrect to use modern reason to judge a work that attests to the vision of a world that no longer exists: the vision of an educated man in the second half of the sixteenth century who, never weary of marveling at the unpredictable richness of "Lady Nature," as he

40. Below: Monstrous pig from Paré's On Monsters and Marvels, 1573/79. Bibliothèque Nationale de France, Paris. However whimsical his illustrations, Paré was a great scholar and a personal physician to several French kings.

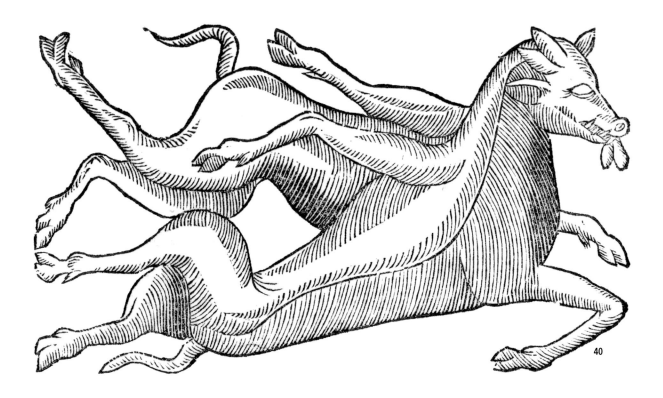

40

41. Right: Salamander on the Alwyn Court Building, 180–82 West 58th Street, New York. Architects: Harde & Short, 1908.

41

puts it, does not view as impossible the birth of a two-legged cow or a bird-headed dog.

One should be content simply with musing over the book's many engravings (plates 39 and 40), as generations of countless readers did before it fell into oblivion. The titles of the engravings alone reveal that the book is indeed a "fantastic bestiary": *Figure of Colt with a Human Head, Figure of a Monstrous Pig Born in Metz in Lorraine, Figure of a Child Who Is a Semi-Dog, Prodigious Portrait of a Monstrous Dog, with a Head Similar to a Hen, Portrait of a Triton and a Siren Seen on the Nile, Sea Monster with the Head of a Monk, Sea Monster Resembling a Bishop Wearing His Pontifical Gown, Sea Monster Having the Head of a Bear and the Arms of a Monkey,* and so on.

It is more difficult to be indulgent with the "teratological" treatises about the abnormality of organic growth or structure that, in the wake of works by Paré and his Bolognese colleague Ulisse Aldovrandi (*Monstrorum historia*, 1642), proliferated until the seventeenth century. Similarly, one must deplore the fact that weakness in scientific methodology led several European naturalists, right into the eighteenth century, to believe in cross-fertilizations between species (in other words, in the possibility of hybridizations) or to attribute magical properties to real animals such as the asp or the salamander. And lastly, one cannot but condemn current publications—books and tabloids illustrated with fake photographs—that still try to prove that anything is possible in the biological field. It is true that the idea of the miracle—understood here in the sense of "scientific miracle"—seems to enjoy renewed interest in an era that is fascinated by technological progress. Witness, for example, the extensive media coverage in August 2002 of Siamese twins who were joined at the head and separated after an operation that lasted more than twenty hours, as well as of more recent claims about human cloning.

❦

AFTER ERRONEOUS perceptions, our research takes a second track, that of misleading descriptions—whether voluntarily experienced or not. This time, it is not the doctors' views on biological monsters that concern us but the views expressed by geographers, anthropologists, and travelers (and, after them, by encyclopedists and compilers of travel stories) about the inhabitants of remote areas, "savage men and cultures," and the flora and the fauna of those exotic lands.

The psychological mechanisms involved in making such misleading descriptions closely resemble those we have just seen at work in the context of medical practice. In this case, as in the previous one, an observation that is poorly made or badly reported is at the core of the fabrication that the narrator believes (or feigns to believe) and that ends up being indefinitely repeated by others, until a more serious author manages to eliminate it. The main difference lies in an important detail: whereas the appearance of a biological monster in our culture can easily be verified or refuted, the description of exotic men or animals generally refers to distant realities that, far from scrutiny, can be liberally embellished without fear of contradiction.

Because the Europeans began traveling early on and because travel literature has always aroused a keen interest among them, it is not difficult to retrace the development in European culture of a number of beliefs concerning the existence of fantastic animals in distant lands. We will limit ourselves to indicating some of the main stages within this process of developing a fantastic bestiary in the Christian West.

THE PRECURSOR: CTESIAS

The life of the Greek physician Ctesias of Cnidus is known to us only through contradictory accounts. He was apparently captured by the Persians after the failure of the Expedition of the Ten Thousand (401 B.C.) and then spent several years as a "guest" at the court of King Artaxerxes II before fleeing back to Greece. He took advantage of his position as an involuntary observer to record not only what he saw but also the accounts of travelers from neighboring countries, notably India, and also of visitors to the court. His book on the Orient, written at the beginning of the fourth century B.C., probably constituted a vast historical and geographical epic in which fiction, lies, and gullibility mixed strangely with more truthful accounts. Unfortunately, nothing except a few pages from two chapters about Persia and India has survived.

The second of these chapters is particularly important. Along with some passages from Herodotus's *History*, it is the oldest European source of information about India—a country Ctesias never visited. According to the description he provides, it became, from the Western point of view, the archetype of the "fabulous Orient," the kingdom of all monsters and all marvels. His text contains, for example, a detailed account of the customs of the Sciapods—naked men each endowed with one huge foot that they used to protect themselves from the heat of the sun. Ctesias was also the first in Greek literature to give a description of three fantastic animals not fated to fall into oblivion:

æ The manticore (also known as the *martichoras*, the *martikhora*, the *mantichora*, the *manticora*, or the *mantiger*: there is some debate on the correct reading of ancient manuscripts) is "as

42. Below: Monstrous animal from Thevet's *Universal Cosmography*, 1571. Musée Barbier-Mueller, Geneva

42

43. *Below: Unicorn. Water-color from a French manuscript of Liber de proprietatibus animalium, 1566. Bibliothèque Sainte-Geneviève, Paris, MS. 3401. It is quite possible that Ctesias, who first described the unicorn, was influenced by horned lions he might have seen depicted on the walls of the Persepolis Palace (5th century B.C.).*

44. *Opposite: Manticore from a Greek manuscript of Liber de proprietatibus animalium, 16th century. Biblioteca Nazionale Marciana, Venice, MS. IX-18-1432*

big as a lion," "its face is like a man's," "it is in color red like cinnabar," and it has "the tail of a scorpion." The name of this frighteningly cruel animal is derived from two Persian words meaning "man-eater."

 The griffin or gryphon is a "four-footed bird, about as large as a wolf and having legs and claws like those of a lion." It lives in a region that is rich in gold and is difficult to capture.

 The unicorn is a white "wild ass" with a single horn that is about a foot and a half long—the horn itself having miraculous properties since whoever "drinks from this horn" becomes immune to all kinds of poisons (a legend that perhaps derives from a widespread belief in Asia concerning the magical powers of the rhinoceros horn).

THE ULTIMATE REFERENCE: ARISTOTLE

Given the scope of the research he devoted to living beings and considering the fact that what remains

of it (five books) represents approximately one-third of his entire body of work, Aristotle (384–322 B.C.) may be called the first naturalist with decidedly scientific ambitions. But since his science was still only embryonic, he sometimes strayed into myth, in spite of the distrust he expressed regarding Ctesias's accounts.

 Thus, in Aristotle's *History of Animals* ("history" understood here as "inquiry"), he mentions some twenty animals that are either fantastic or impossible to identify, and whose existence ends up acquiring some kind of objective validity based solely on his account. Among these are the manticore (2.1), whose description he borrows from Ctesias; the wild ass from India (2.1), with a single horn (in Greek, *monokeros*); and the salamander (5.19), a real animal to which Aristotle attributes a magical property that would endure—that it could "put out fire by crawling through it." Aristotle also recalls several times the *drakôn*, either in the general Greek sense of "huge serpent" or as a reference to a certain fish species. However, the word *drakôn*—which is etymologically related to a verb meaning "to stare" and

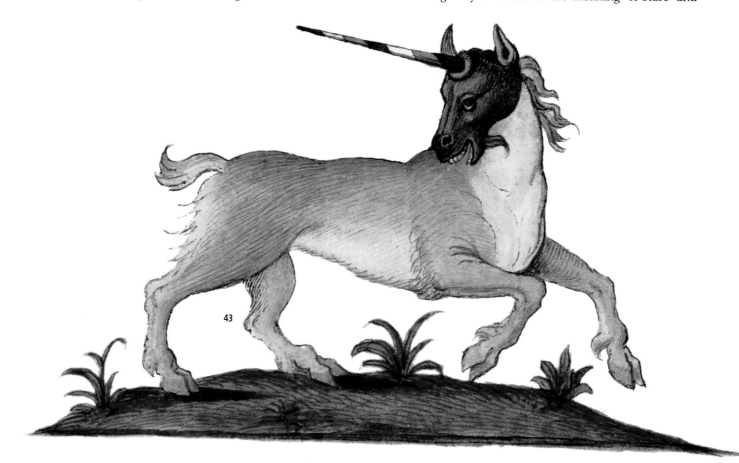

43

44

τῷ εὖ μέγαν ἄγρουγὶ, ἢ πριν ἠυνάδαν.
μόλις ὅνεκερς ὑπαυήσοϛ ἐ ὄμα : +

μαντιχώρας.

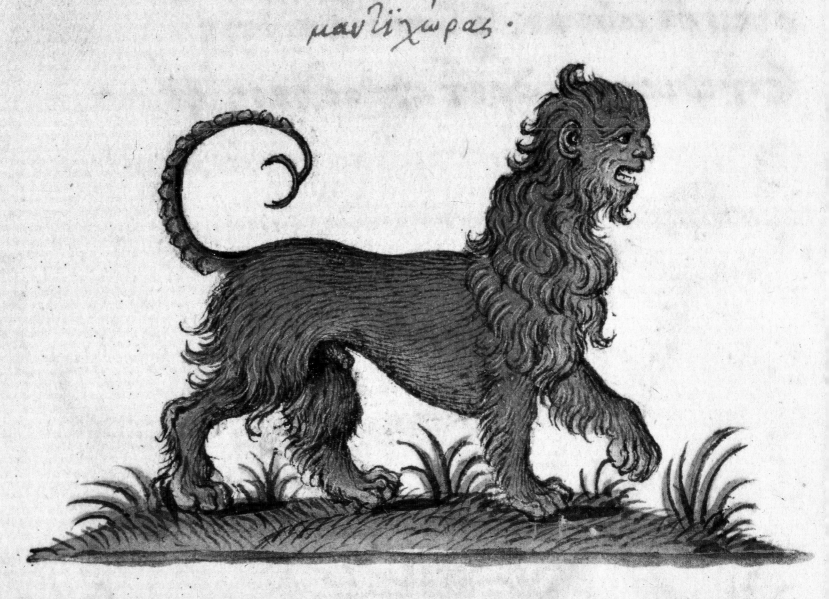

+ πρὶ μαντιχώρον :-

μαντιχώρας, θὴρ ἐν ἰνδοῖς εὑρέθη.
δασὺς, ἐρυθερς. εἶδος ἀνδεὸποῦφερ.
ὄμμαϊα πυρϛῖς ἐμφερῆ γλαυκογϛοοϛ.
ὀφρῦϛ ἱκανὰϛ ἐκφοβϛῦ ἢ μακϛϛῆ

which, since Homer, has also been used to refer to our own fabulous beast, the dragon—was loaded with ambiguities that have evolved over time. The *History of Animals*, translated into Latin in A.D. 1220, spread throughout Christian Europe by means of commentaries upon it: from Albert the Great's *De animalibus* to Bartholomew Anglicus's *De proprietatibus rerum* and to Saint Thomas Aquinas's *Summa theologica* (all written during the thirteenth century). This made Aristotle the ultimate authority until the Renaissance, at least for erudite Europe.

THE POPULARIZER: PLINY THE ELDER

Pliny (A.D. 23–79) got his inspiration not from real animals but from books—the first and foremost being Aristotle's *History of Animals*. Less discriminating than his predecessor, Pliny cheerfully peddled the most incredible legends, be they Ctesias's or other Greek authors' that are now even less known (Megasthenes, et al.). Book 8 of Pliny's *Natural History* is teeming with descriptions of fabulous animals, including:

- The *achlis* (book 8, section 39), a kind of horse that sleeps standing up and walks backward when grazing.
- The *leucrocuta* (8.72), "the swiftest of wild beasts, about the size of an ass, with a stag's haunches, a lion's neck, tail, and breast, badger's head, cloven hoof, mouth opening right back to the ears, and ridges of bone in place of rows of teeth." It is, moreover, capable of imitating the human voice.
- The manticore or *martikhora* (Pliny's spelling; 8.75 and 8.107) is this time located in Ethiopia (a region the ancients did not clearly distinguish from India).
- The *monoceros* or unicorn (8.76), "which in the rest of the body resembles a horse, but in the head a stag, in the feet an elephant, and in the tail a boar, has a deep bellow, and a single black horn three feet long projecting from the

middle of the forehead." To this Pliny adds, "They say that it is impossible to capture this animal alive"—an idea that gave birth to a legend that would delight his medieval readers.
- The *catoblepas* (meaning "that which looks downward"; 8.77), of which it was said that any man unfortunate enough to catch a glimpse of the beast's eyes would die on the spot.
- The werewolf (in Latin *versipellis*, from the Greek *lukanthrôpos*; 8.80–82), whose existence Pliny atypically denied, contrary to other authors such as Galien (19.719), Ovid (*Metamorphoses*, 1.209), Virgil (*Bucolica*, 8.97), and Petronius (*Satyricon*, 62).
- The amphisbaena (8.85), a serpent with two heads (the second one at the end of its tail), which is capable, as its name indicates, "of moving in either direction." Let us nevertheless specify that the amphisbaena, which engaged the medieval imagination for a long time, is perhaps not an imaginary animal but a harmless reptile from Europe (*Blanus cinereus*, from the family of amphisbaenians—a small burrowing snake with a short tail, similar to a head, which can effectively move forward or backward).

We are also indebted to Pliny for the first detailed account of the Egyptian legend of the phoenix (10.2), already mentioned by Hesiod and Herodotus. Every five hundred years, the mythical bird endowed with red, blue, and gold plumage would incinerate itself on the altar of the sun temple in Heliopolis (near Cairo) and, three days later, rise again from its own ashes. Pliny also provided a description of giant snails "of such size that the natives roof dwelling-houses with the expanse of a single shell" (9.10) and a description of the *cynocephalus*, a dog-headed man.

Finally, let us mention that the Roman historian and linguist Caius Julius Solinus, more famous under the name Solinus, wrote a vast compilation entitled *Polyhistor* (c. A.D. 230), which was heavily borrowed from Pliny but was nevertheless widely read during the Middle Ages.

45. Opposite: The scourge of the locusts from Beatus of Liébana's Commentary on the Apocalypse, lat. 2290, fol. 98. France, end of the 12th century. Bibliothèque Nationale de France, Paris

46. *Below: Monstrous snail from Thevet's Universal Cosmography, 1571. Musée Barbier-Mueller, Geneva*

THE LOVER OF CURIOSITIES: AELIANUS

Claudius Aelianus (c. A.D. 170–225) was a rhetorician who was born in Praeneste, near Rome. He was the only Latin sophist from the Imperial period who wrote in Greek. His treatise *On the Characteristics of Animals* is a colossal compilation that draws from several sources (principally Pliny and Aristotle). A second-rate and derivative work, it does not enjoy much prestige among historians of zoology.

Though Aelianus was not a serious zoologist, he was nonetheless the first Western scholar to be interested in facts that were likely to reveal the nature of various animals, shed light on their personalities, and help explain their behavior. In short, he was the remote precursor of a science that blossomed only eighteen centuries later: ethology. Aelianus's main flaw was his gullibility. Without questioning the objectivity of the authors from whom he took inspira-

tion, he gave credence to the existence of the most improbable animals, his sole preoccupation being to entertain his reader. We can find in his writings:

- The salamander (2.31), which can endure fire without harm.
- The unicorn horse and ass (3.41), from India, whose horn is an antidote to poison.
- The griffin or gryphon (4.27), another animal from India, described by Aelianus as a quadruped having the claws of a lion, the wings and beak of an eagle, and eyes like fire. Living in a desert where gold is abundant, the griffin uses it to build its nest and is able to foil any attempt aimed at capturing it (the theme of griffin hunt-

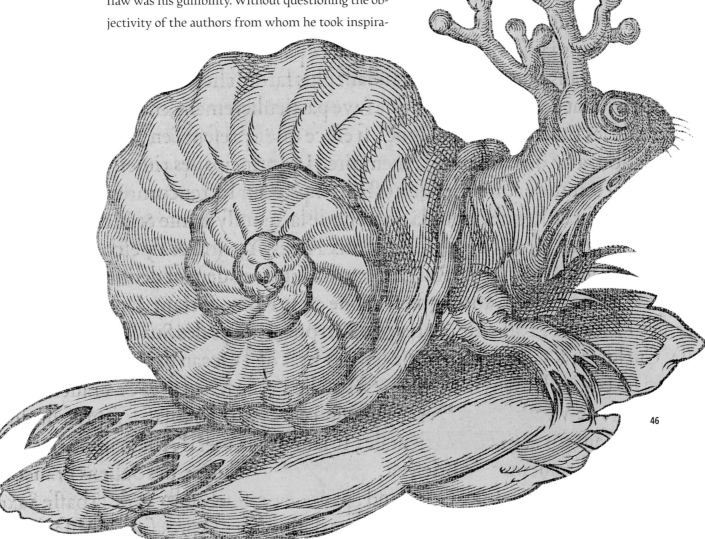

46

ing frequently recurs in Roman mosaics of the third and fourth centuries A.D., like those of the Villa del Casale in Piazza Armerina, in Sicily).

- The *asterias* (5.36), an Egyptian bird that understands human language and gets angry when insulted.
- The *katoblepon* (derived from Pliny's *catoblepas*; 7.5), an animal resembling a bull, which looks downward, not forward; its breath is so pungent that animals that approach it are "seized with fatal convulsions."
- The amphisbaena (7.8 and 9.23), which has skin that repels animals that have a poisonous bite.
- The dragon (8.11), a keen-sighted animal that must have a good disposition, given that a certain Hegemon, in his poem *Dardanica* (now lost, unfortunately), described a huge dragon that fell in love with a golden-haired Greek shepherd, Alenas the Thessalian: "It crept to him, kissed his hair, and with its tongue licked and washed the face of its loved one and brought him the spoils of its hunting as presents." Aelianus does not specify whether this affectionate dragon was rewarded for its ardor; but the anecdote is interesting as one of the oldest sources of the great Western myth of Beauty and the Beast.
- And several sea monsters (9.49–50), which Aelianus called monsters but which also included more or less faithful descriptions of real animals (sawfish, walrus, whale, and so on).

Finally, the credulous Aelianus did exercise a bit of critical acumen when he stated (9.23) that he did not believe in the existence of the Hydra of Lerna or the three-headed Chimera.

THE FIRST THEOLOGIANS (SECOND–SEVENTH CENTURY)

In the second century A.D. the first of a long series of Christian treatises and homilies started appearing, which were called *hexaemeron*. As this Greek word indicates, these are edifying reflections on

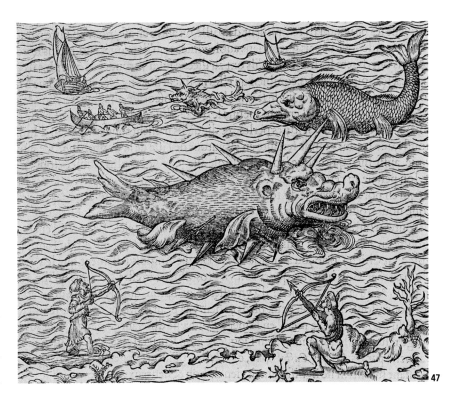

47. Above: Sea monsters from Thevet's *Universal Cosmography*, 1571. Musée Barbier-Mueller, Geneva

the six days of the creation as narrated in Genesis; in other words, they are reflections on God's marvels. These books ended up constituting a veritable literary genre, part encyclopedia and part apologia. The most famous among them are by Origen (185–252) and Basil of Caesarea (331–379) for the Greek Church, and by Saint Ambrose (340–397) for the Roman Catholic Church.

Ambrose's books contain a great deal of information about all types of real and fabulous animals, yet this information was developed according to a moral and edifying perspective. The church fathers who commented on the Holy Books were concerned mainly about understanding their symbolic meaning. They were less interested in animals per se than in the ways animals could be used to embody moral qualities, to illustrate vices or virtues, and thus to provide examples and metaphors that would be easily accessible to the public.

Turning now to the huge body of work by Saint Augustine (354–430), we would like to mention in particular chapter 8 of book 16 of *City of God*. Entitled "Whether Certain Monstrous Races Sprang from the Seed of Adam or the Sons of Noah," this short text has nothing to do, at first sight, with the interest devoted to animals by the authors of

hexaemeron. In fact, its aim is different. After examining, in the earlier chapters of his book, the dissemination of Adam's descendants over the earth, Augustine then ponders "certain monstrous races of men, described in pagan history," some of which he had seen "pictured in mosaic on the esplanade at Carthage." Based on the premise that God knows what he is doing, "selecting in his wisdom the various elements from whose likeness and diversities he contrives the beautiful fabric of the universe," Augustine's reasoning reaches a theologically reassuring conclusion: "Either the written accounts of certain races are completely unfounded or, if such races do exist, they are not human; or, if they are human, they are descended from Adam."

By reasserting the profound unity of humankind, Augustine thus offers one of the best possible arguments against racial prejudice. But unfortunately, that would not be the most immediate result of this text. Readers of Augustine in the Middle Ages instead found in it the confirmation of other beliefs: since this great theologian recognized the possibility of the existence of

"monstrous peoples," that must mean that they did indeed exist. And if they existed, why couldn't the most fantastic animals exist as well? For the next ten centuries, the scientific approach to the zoological world initiated by Aristotle was overshadowed by a kind of religious propaganda, compatible with the most fanciful interpretations of reality.

Let us finally mention one last theologian. Saint Isidore (560–636), the archbishop of Seville and the "last father of the Western Church," who wrote a vast encyclopedia, *The Book of Etymologies*, in which he gathered everything he could borrow from the books of the naturalists who had preceded him. This compilation also served as a reference for several centuries, until the Renaissance.

THE POPULARITY OF BESTIARIES (ELEVENTH–TWELFTH CENTURY)

Both the *hexaemeron* and Isidore of Seville's work constituted inexhaustible sources for medieval authors, in particular for those compiling bestiaries. The word *bestiary*, as applied to a literary genre that seems to have derived from the *hexaemeron*, appeared at the beginning of the twelfth century to refer to works (in prose or verse, in Latin or the vernacular Romance languages) using real or legendary animals as symbols for moral or religious instruction.

48. Opposite: Sea horses. Facade of the House of Jonah, Pardubice (Czech Republic), late 16th century. On the upper portion of the facade appears the whale that, according to the Bible, swallowed the Prophet Jonah for three days and three nights (Jonah 2:1).

49. Below: Imaginary siren. Wood, dried fish skin and tail, moray or eel teeth, claws of an unidentified animal. Objects like this, presented as siren "corpses" and generally originating in the Far East, were exhibited in European salons and popular fairs in the seventeenth and eighteenth centuries. Few specimens survive; this one belongs to Charles-Edouard Duffon, Témoin Gallery, Geneva.

49

48

50 and 51. Opposite: Various fabulous animals from a bestiary from England or northwest France, c. 1285. Bibliothèque Nationale de France, Paris, lat. 3630

The direct source for medieval bestiaries was, once again, Hellenistic: the *Physiologus*, an Alexandrian compilation from the second century A.D., whose title refers to an anonymous author, "the Naturalist." This book, which had remarkable success in the medieval world, is a catalogue of animals, plants, and stones usable as symbols for moral precepts, though devoid of any logical order or scientific principles. It was first translated into various Eastern languages and then benefited from several Latin translations between the fifth and the eleventh centuries.

In time, these translations, moving further and further away from the original, were enriched with notations borrowed from the various authors mentioned so far, from Pliny the Elder to Isidore of Seville. The theological perspective, aimed at framing moral preaching, continued to assert itself. In the end, animals, whether real or fabulous, were divided into one of two camps, God's or the devil's (the latter's image, which varied considerably throughout the first millennium A.D., started to become more and more uniformly animal-like from the eleventh century on).

The teachings of Latin bestiaries ended up serving as a basis for Christian moralization while also providing believers with a lexicon that could help them find meaning in the slightest details of daily life. Their texts, which often appeared in lavishly illuminated manuscripts, constitute today an essential tool for interpreting the sculpted bestiaries whose considerable popularity in Romanesque art (eleventh–twelfth century) persisted through the end of the Gothic era (thirteenth–fourteenth century).

From the twelfth century on, bestiaries started to appear in Romance languages. Philippe de Thaon, a cleric who lived in England at the beginning of the twelfth century, was the first to produce a rhyming version of the *Physiologus* in Latin, with more than three thousand verses. The next century witnessed a proliferation of more and more sophisticated versions of the same text. Let us mention in particular Pierre de Beauvais's prose version (prior to 1217) and

an adaptation in verse produced around 1210 by Guillaume le Clerc of Normandy (who also seems to have been settled in England at the time he wrote it). These two texts, especially the latter, were enriched with moral commentary and destined for both clerical and lay audiences. Although not identical, they greatly resemble each other, since they draw on the same sources.

Except for a few details, they contain the same fantastic animals, the only difference being the order in which they appear: the *serra*, a bird with huge wings that pursues sailing ships before diving back into the sea when it realizes that it cannot catch them; the *caladrius*, a snow-white bird with the power to heal sickness; the phoenix; the salamander; the dragon; the siren, a bird with a female face (for Pierre de Beauvais) or a woman partly shaped like a fish or a bird (for Guillaume le Clerc); the unicorn; the hydra, a many-headed serpent; and the *lacovie* (Pierre) or *cetus* (Guillaume), a sea monster that was perhaps a whale but that can also be seen as a reminder of the leviathan mentioned in the Book of Job (40:25). Guillaume said about this beast (lines 2260–80):

> Just like unto sand is the crest on top of its
> back. When it rises to the surface in the sea,
> they who are wont to sail that way quite believe
> it is an island, but hope deceives them. Because
> of his great size there they come for safety from
> the storm that drives them. They think to be in
> a safe place, they throw out their anchors and
> gangway, cook their food, light their fire, and to
> make their ship fast drive great stakes into the
> sand, which is like land in their opinion. Then
> they light their fire, I do assure you. When the
> monster feels the heat of the fire that burns on
> top of him, then he makes a sudden plunge
> down into the great deep and drags the ship
> along with him, and all the crew perish.

Finally, Guillaume mentions the asp, a real snake. In order to make it symbolize the virtue of

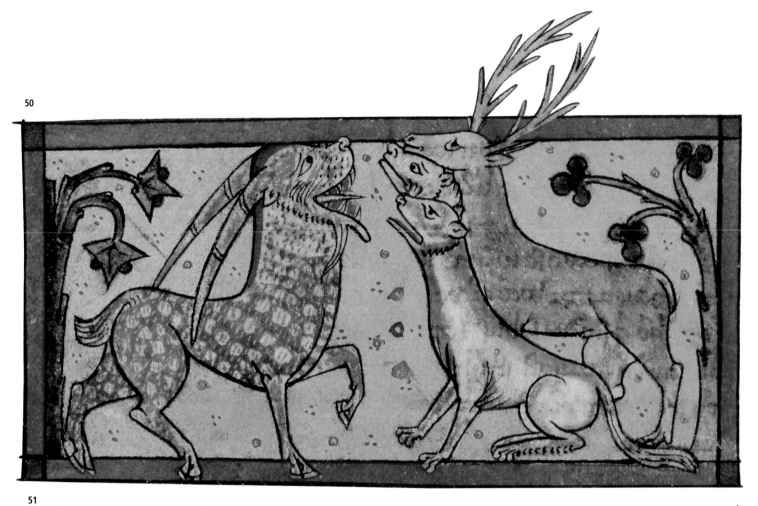

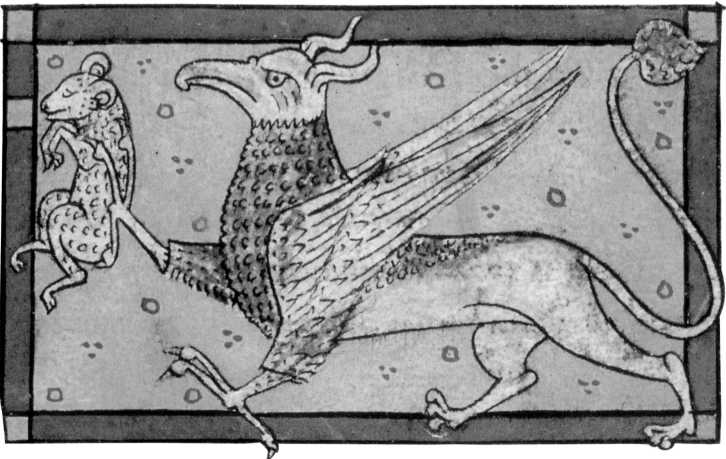

52. *Above:* Alexander fighting a herd of unicorns. Illustration from a French manuscript of the *Life of Alexander,* fol. 260r, 15th century. Musée du Petit Palais, Paris. The ancient unicorn, perceived as a dangerous beast, co-existed with the Christian unicorn, symbol of the Christ (and sometimes of the Virgin Mary), until the end of the Middle Ages.

prudence, a singular property was attributed to the asp: "When it is afraid of being enchanted by the enchanter whom it fears, one of its ears it presses on the ground quite firmly and with its tail deftly stops the other ear so that with it the enchanter cannot be heard in no wise."

Toward the middle of the thirteenth century, animal symbolism started to evolve. Next to the deliberately edifying Christian use of this symbolism, there appeared a new way of using it as part of an amorous rhetoric that is oddly indifferent to any

moral perspective and obviously influenced by the rise of courtly love literature. The main representative of this new aesthetic was himself a canon, Richard de Fournival, who lived in Rouen and Amiens and seems to have died around 1260. A highly refined poet, endowed with a vast culture that made him a precursor of the humanists, Richard de Fournival wrote the prose *Bestiary of Love* (1250) and began its versification, which was completed by an anonymous poet. Both versions met with great success.

In these texts (which, not surprisingly, mention such real and imaginary beasts as the *caladrius*, the siren, the asp, the salamander, the unicorn, the hydra, the *serra*, the dragon, and the whale), symbolism inherited from the *Physiologus* but diverted from its original meaning helps illustrate the various stages of an amorous quest that, from the start, is destined to fail. As a rejected lover, the poet tries, unsuccessfully, to touch the heart of his lady, who turns a deaf ear. While attempting to seduce her, he reveals himself to her under the guise of different kinds of animals, some of which are unreal, while others do not have a clear meaning. The hermetic symbols and esoteric allusions that he resorts to characterize what we might call the aesthetic of the "bestiaries of love," and these features can also be found in the series of tapestries known as *Lady with Unicorn*, which is obviously a visual transposition of the same aesthetic.

Toward the middle of the thirteenth century, at the same time that Richard was composing his lyrical bestiary, the bestiary tradition also started to merge with another tradition, that of popularized

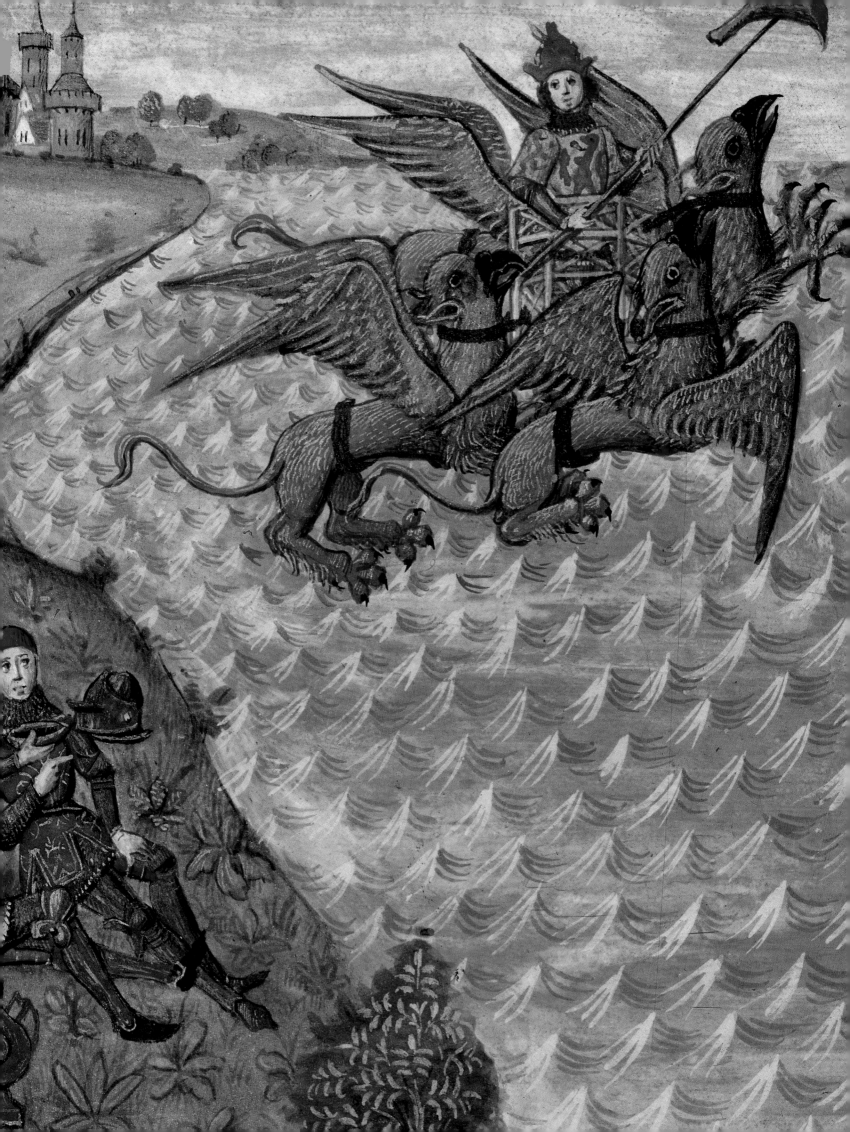

repositories of knowledge, which were offered to a large audience eager to understand the world. The apex of the Middle Ages, the thirteenth century was an age of dictionaries and encyclopedias, books devoted in large part to natural history—a discipline that received renewed life thanks to the rediscovery of Aristotle (through his Jewish and Arab commentators) and increased contact with Asia through trade, pilgrimage, and the Crusades.

We have already mentioned Albert the Great's *De animalibus* and the Franciscan Bartholomew Anglicus's *De proprietatibus rerum*, of which numerous handwritten copies, followed by several editions that appeared after the invention of the printing press, attest to the huge success they enjoyed among laymen as well as clerics. This list must be supplemented by mentioning four other important titles:

- *De Naturis rerum* by Thomas de Cantimpré, written between 1228 and 1244, an encyclopedic compilation addressing humans, both fantastic and real animals, plants, metals, and astronomy.
- *L'Image du monde*, a book written in French by Gautier de Metz (c. 1245), based on a twelfth-century Latin poem bearing an identical title by Honorius of Autun.
- *Speculum naturale*, part of the encyclopedic compilation known as the *Speculum majus* (completed c. 1258), by the Dominican Vincent of Beauvais. As the title suggests, this work was meant as a mirror of creation, containing vast amounts of information about science, history, and nature.
- *Le Livre du trésor* (c. 1270), by the Florentine Brunetto Latini. Temporarily exiled in France for political reasons, this philosopher (who included Dante among his disciples) wrote this book in French. The part devoted to animals, although based on Aristotle, Pliny, Isidore, and many others, includes much information derived from Latini's personal observations and extensive readings. We find among them, as usual, the *serra*, the siren, the asp, the amphisbaena, the basilisk, the dragon, the salamander,

the halcyon (a seabird with the power to ward off tempests), the *caladrius*, the phoenix, the *leucrocuta* (derived from Pliny's *leucrocuta*, mentioned earlier), the manticore, and the unicorn.

One last word about bestiaries: this brief survey of some of the books that struck the medieval imagination has undoubtedly left out other important titles, but it does give an idea of the considerable role that medieval culture was ready to give to the zoological vocabulary. However, this role, which seemed perfectly justified to some theologians, such as Hugh of Saint-Victor, was far from being unanimously welcomed.

From the twelfth century onward, it elicited the reprobation of austere personalities such as the Cistercian monk Bernard of Clairvaux. Far from recognizing any educational value in animal sculptures, the future Saint Bernard criticized them (in his famous *Apology to William of St. Thierry*, 1122) for distracting the soul from its spiritual duties:

> But in cloisters, where the brothers are reading, what is the point of this ridiculous monstrosity, this shapely misshapenness, this misshapen shapeliness ["*difforma formositas ac formosa difformitas*"]? What is the point of those unclean apes, fierce lions, monstrous centaurs, half-men, striped tigers, fighting soldiers and hunters blowing their horns? In one place you see many bodies under a single head, in another several heads on a single body. Here on a quadruped we see the tail of a serpent. Over there on a fish we see the head of a quadruped. There we find a beast that is horse up front and goat behind, here another that is horned animal in front and horse behind. In short, so many and so marvelous are the various shapes surrounding us that it is more pleasant to read the marble than the books, and to spend the whole day marveling over these things rather than meditating on the law of God.

Given the opulence—even extravagance—in the decoration of certain cloisters, such as the abbey

53. Opposite: Alexander on his chariot, pulled by four griffins. Illustration from a French manuscript of the *Life of Alexander*, fol. 257v, 15th century. Musée du Petit Palais, Paris

54. Below: Fabulous animal. From the mural decoration (c. 1564–70) of the salon of Torrechiara Castle, near Parma (Italy), attributed to Cesar Antonio Paganino (16th century).

54

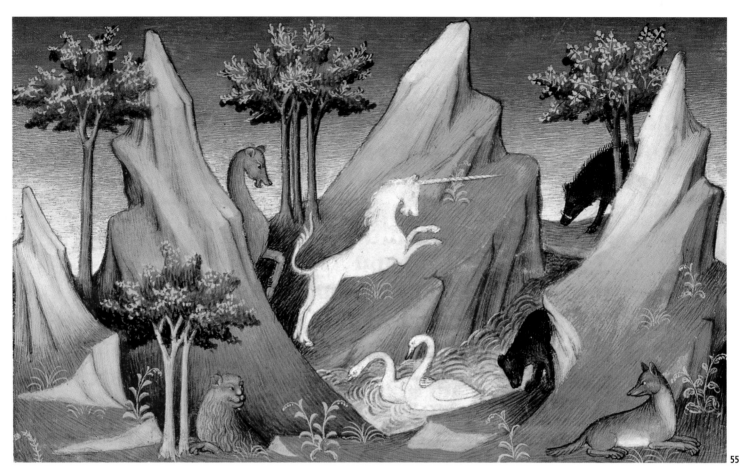

55

church of Saint-Pierre in Moissac (completed around 1100), one can understand Saint Bernard's indignation. But fortunately for us, the iconoclasm that he proposed did not find any support outside the Cistercian order, at least until the Protestant Reformation. In the Middle Ages, people enjoyed dreaming far too much to give up fantasy, especially at the moment when, thanks to the accounts of the explorers of Asia, the horizon of their dreams started suddenly to widen.

REAL OR IMAGINARY TRAVELOGUES

With its slow pace, frequent stops, unforeseen events, and unexpected encounters, travel in the age of the caravans lent itself to the telling of stories, which then became intertwined because travelers love telling their adventures to one another. Conversely, ever since the *Odyssey* haven't some of the most popular stories in world literature been travelogues? The structures of the journey and the narrative are so tightly interwoven that the traveler can

hardly resist the temptation of embellishing, or even inventing imaginary travels, to entertain his audience. Similarly, it becomes difficult for the audience to distinguish between accurate description and pure invention. This distinction is not only difficult, it is often futile, since what ultimately matters is the entertainment value rather than the truth.

At the source of medieval literature, two great travel stories served as references and models for centuries. Both were, for the most part, imaginary. The first was the *Navigatio Sancti Brendani*, an anonymous poem whose earliest Latin version dates to the first half of the tenth century and which was subsequently translated into numerous medieval vernaculars. This poem relates the odyssey of Saint Brendan, an Irish monk from the sixth century who goes in search of the promised land, Adam's paradise. Saint Brendan reaches his destination after a long journey marked by encounters with a dragon, griffins, a fire-breathing sea serpent, and so on. Most of the themes in this epic, which is full of "marvelous" developments (that is to say, worthy of causing wonder, in the etymological

56

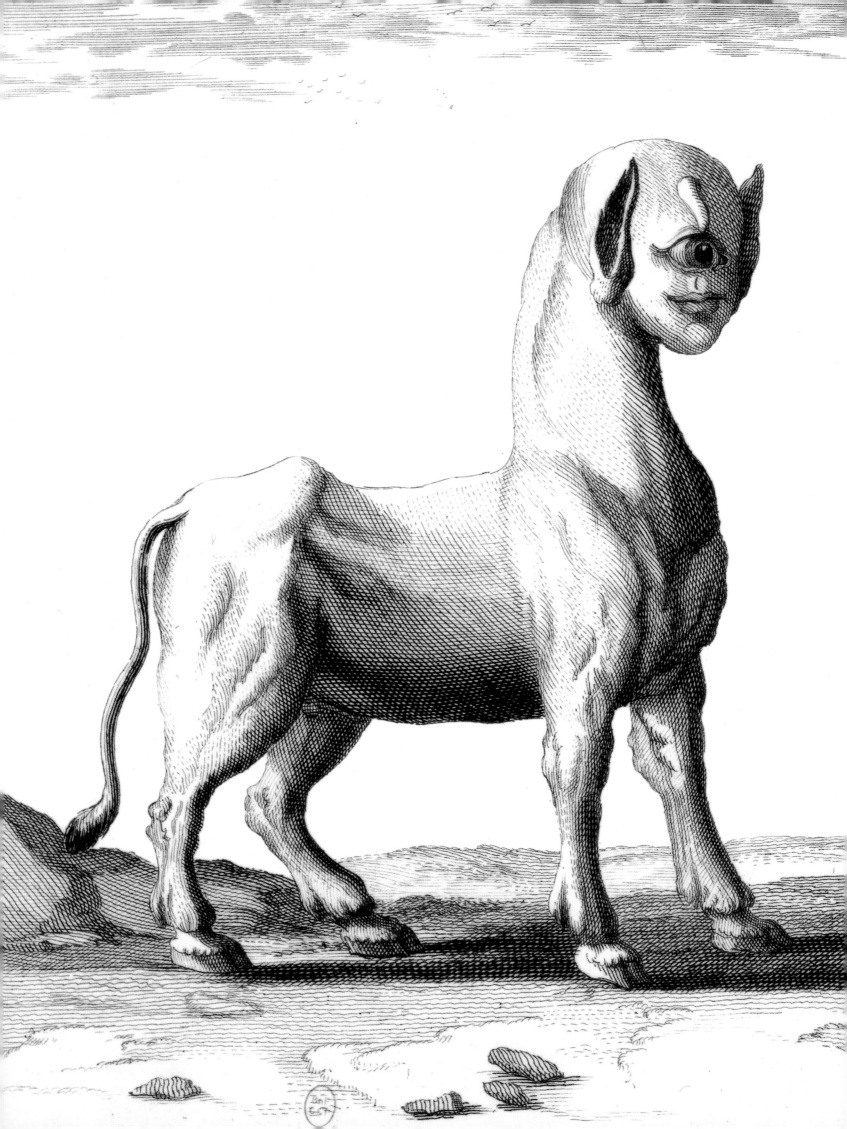

sense of the word *marvelous*, which is related to the Latin word *mirabile*), are Celtic in origin. Others, such as the scene of griffins fighting among themselves, are similar to themes found in the Arabic legend of Sindbad the Sailor, suggesting the possibility of early exchanges with the Muslim world.

The second foundational text is the *Romance of Alexander the Great*—so called because it is a part historical, part fictional collection of accounts that have traditionally been gathered under that title but in fact come from different eras and have diverse natures. Nevertheless, they all have a common origin: *The Life of Alexander,* which was written in Greek, in Alexandria, in the third century A.D. For a long time this text, known as the Pseudo-Callisthenes, was wrongly attributed to Aristotle's nephew, Callisthenes of Olynth, who was believed to have been one of Alexander's official biographers. Armenian, Syriac, Ethiopian, Byzantine, Turkish, and Persian translations of this text followed. In the West, the first Latin version, attributed to Julius Valerius Alexander Polemius, appeared in the fourth century. This text was in turn variously shortened and interpolated over the succeeding centuries. The first adaptation into a Romance vernacular, that of southeastern France, is a poem in octosyllabic verse dating to the first third of the twelfth century. This text was subsequently modified and expanded by northern French writers. Around 1170 Lambert le Tort added a lengthy section, in twelve-syllable verse, devoted to Alexander's adventures in the Orient, with many references to fantastic beasts. Sometime after 1180, Alexandre de Paris took these various strands and fused them into a magnum opus known as the *Roman d'Alexandre*. This text enjoyed great popularity until the end of the Middle Ages and was translated into many other languages. The medieval fascination with Alexander the Great is also evident in the success of the Latin *Alexandreis* written by Gautier de Châtillon c. 1176, which survives in more than two hundred manuscripts.

A model king and warrior, Alexander was also an adventurer and explorer whose exotic encounters guaranteed his popularity. His legend, set in the mysterious Orient, features a menagerie of fabulous animals: dragons, flesh-eating hippopotamuses, giant bats, white lions, winged serpents, and snakes with female faces, not to forget Bucephalus, the conqueror's fiery horse that, as his name indicates, has a mark on his thigh in the form of a bull's head. Depicted as well are strange and exotic human specimens (savage men, human beings slit to the navel, aquatic women) that are directly inherited from scholarly literature (Pliny) but also from popular legends whose origins (Greek, Egyptian, Celtic, Germanic) are lost in the deep, dark past.

Such intertwining of the real and the imaginary, of fantastic animals and equally fabulous men—exemplified, as early as the twelfth century, by the tympanum of La Madeleine in Vézelay (France)—did not happen by chance. On the contrary, it was part of the code governing travel stories as a literary genre— at least as conceived by the European audience until the end of the Middle Ages. And this code, of course, also applied to stories that were based on reality,

57. Opposite: The Monster of Buenos Aires. Engraving from Journal des observations physiques, mathématiques et botaniques, faites par l'ordre du roy sur les côtes orientales de l'Amérique méridionale et dans les Indes occidentales depuis l'année 1707 jusques en 1712 (Paris, 1714), by Louis Feuillée (1660–1732). Bibliothèque Nationale de France, Paris. A French traveler and scholar, Father Louis Feuillée explored South America between 1707 and 1711. Less prone than Thevet to making total fabrications, he nevertheless peddled the most incredible legends, right in the Enlightenment.

58. Below: Fantastic animal. France, 16th century. Fragment from a stained-glass window. Musée de la Renaissance, Ecouen, France

58

57

59. Right: Dog-headed man worshiping a cow. Wood engraving from *The Travels of Sir John Mandeville*, in the edition printed on Anton Sorg's presses in Augsburg, 1482. Bibliothèque Nationale de France, Paris

60. Opposite: Cellarius's *Celestial Atlas*, 17th century. Bibliothèque Nationale de France, Paris

59

such as accounts written by the first pilgrims, missionaries, and explorers in Asia, starting in the thirteenth century. Here are some examples:

- William of Rubruck's report on his travels. A Flemish Franciscan monk, William was sent by French King Louis IX on a mission to see the Great Khan of Mongolia, whom he did indeed meet in 1254.
- *The Book of Ser Marco Polo, the Venetian: Concerning the Kingdoms and Marvels of the East*, said to have been dictated in French (*Le Livre des merveilles du monde*) in 1298 by the Venetian merchant Marco Polo upon his return from a long journey to the Far East.
- *Descriptio orientalium partium* (1330) by the Franciscan monk Odoric of Pordenone, the first missionary who tried to spread the Gospel in Central and Southeast Asia, as well as in China.
- *Liber de quibusdam ultramarinis partibus* (1336), the story of the pilgrimage undertaken to the Holy Land by William of Boldensele.
- *The Travels of Sir John Mandeville* (1356).

The last-named, in particular, deserves special mention. Nothing is known about its author and, even though he describes the world at the outermost borders of the Far East (by taking inspiration from Odoric of Pordenone), it is not certain that he went any farther than Jerusalem. But that didn't seem to matter. Written in the middle of the fourteenth century, his text was translated into practically all the European languages (more than 250 manuscripts of it exist) during the following century, before being among the first books to be printed on Anton Sorg's presses in Augsburg (1482). The printed version includes some hundred wood engravings, illustrating the "marvels" and "monsters" that Mandeville encountered on his way. From the fourteenth to the sixteenth century, more than one hundred editions were produced, and their illustrations, in turn, inspired the fantasies of cartographers (Martin Behaim's map of the world, 1492) and other makers of portulans, or early navigation manuals, as well as André Thevet, whose famous *Singularités de la France antarctique* (1558), a wildly imaginative report of a nevertheless real journey to Brazil, later elicited Montaigne's sarcasm (*Essays*, 1.31).

It is no exaggeration to say that we are greatly indebted to Mandeville for the continued existence, until the dawn of the Enlightenment, of legends about pygmies, giants, cynocephali, and men with goat legs, as well as the Egyptian phoenix, the dragons of Silha Island (Ceylon), the griffins of Bacharie (Bactria), the unicorns inhabiting the land of Prester John (the mythical Christian ruler whose existence, in the heart of Asia, became an object of faith around the middle of the twelfth century), two-headed geese, white lions, and the famous snails of such grandeur that several people could live under each shell—Pliny's lovely invention that, thirteen centuries later, continued to amaze Mandeville's readers.

It would be wrong to snicker: these fantastic stories fueled the imagination of audacious explorers like Christopher Columbus, Amerigo Vespucci, and Hernán Cortés, keeping alive the fiction of paradises to the east (Columbus, convinced that the earth was round, became the first to search for it by sailing west), pushing on the adventurous path that would eventually lead to the discovery and exploration of a new world. Through them, fantasy entered into history and the imaginary changed reality. Is there any more beautiful proof of the power of utopia?

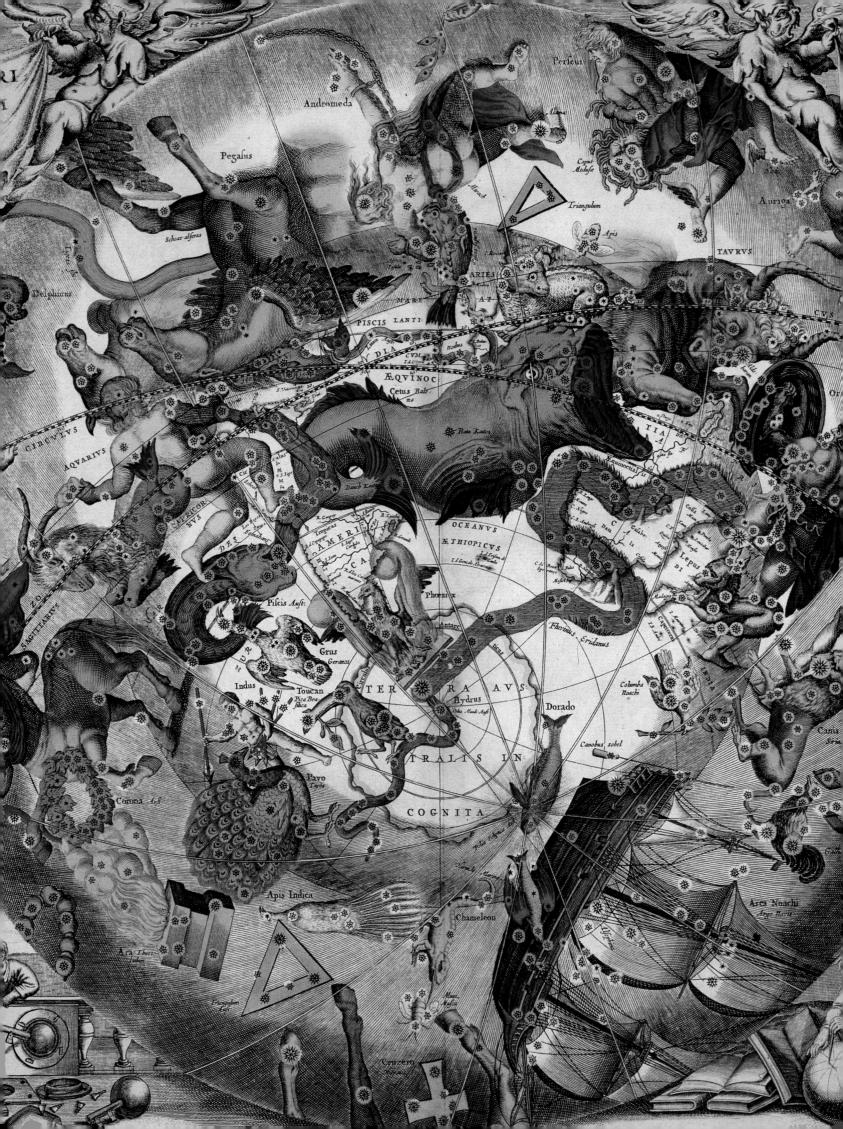

63

61. *Pages 72–73: Gherardo del Fora (c. 1432–1497). The Triumph of Chastity (detail). Galleria Sabauda, Turin, Italy.* In this procession, reminiscent of the triumphs of the Roman emperors, the chariot of chastity is pulled by unicorns because this animal symbolizes virginity.

62. *Opposite: Unicorn from The Loves of the Gods, a fresco designed and executed by Annibale Carracci (1560–1609), with help from his brother, Agostino Carracci (1557–1602). Carracci Gallery (1597–1604), Palazzo Farnese, Rome.*

63. *Left: Griffin, by a collaborator of Perino del Vaga (c. 1501–1547). Apollo Hall (detail from the ceiling), Castel Sant'Angelo, Rome.*

CHAPTER THREE

Unicorns and Human Hybrids

IN THE PREVIOUS CHAPTER, we traced the genealogy of one fantastic bestiary that, from the year 1000 on, started proliferating on the facades and capitals of churches throughout western Europe, in their stained-glass windows, and on the pages of illuminated manuscripts. We saw, too, the decisive role that the works of ancient authors and those of medieval theologians, compilers, encyclopedists, poets, and travelers played in the diffusion of these animals.

However, other, undocumented sources have likely also played an important role: collective sources such as folklore (that is, popular culture, the orally transmitted tales, legends, proverbs, and so on that are peculiar to each culture), as well as totally subjective sources, such as the idiosyncrasies, obsessions, fantasies, and nightmares of individual artists. We will probably never know for sure how these various elements came together in the minds of medieval artists, who will forever remain anonymous, to produce the wonderfully diverse fantastic animals of the Middle Ages.

Yet what is certain is that some types of fantastic animals seem to have a history, in that illustrations of them can be found in places that are often geographically or temporally very far apart. Everything indicates that certain "structures," in particular those of hybridization, have benefited

from exceptional longevity and cross-cultural diffusion. We will demonstrate this more specifically by providing, in this chapter and the next, a description of five of these structures: the unicorn (a mixture of a horse and a horned animal), the animal-headed human, the human-headed animal, the flying quadruped, and the dragon (a composite animal derived from the snake).

Why only five? Because covering everything is impossible. And because these structures, even if they are not the only examples, are nonetheless the ones encountered most often when glancing at the vast field of world art since prehistoric times. We will limit ourselves to mentioning here their most general features, for their infinite individual variations would require a much more detailed study than we could possibly undertake within the framework of this book.

THE UNICORN

Except for a small ivory sculpture of a lion-headed man that dates back to the Aurignacian period (c. 30,000 B.C.) and was found in a cave in Hohlenstein-

Stadel, Germany (plate 71), the oldest fantastic animal yet recorded is, according to prehistorians, the so-called Unicorn of Lascaux (plate 64). The vast network of caves of Lascaux, located near the village of Montignac, France, seems to have been painted at the beginning of the Magdalenian age (c. 15,000 B.C.). The animal in question is among the first to be seen by a visitor climbing down the stairs that lead to the Great Hall of Bulls. However, one look is enough to cast doubt on the name that has been given to it. This quadruped looks more like a bovine than a horse. It has a voluminous rump, a short tail, and a head with a square muzzle, which is too small in comparison with the rest of its body. From the head sprout *two* slender horns— one too many for a unicorn, an animal that, by definition, has the body and the head of a horse and a *single* horn protruding from the middle of its forehead (the French word *licorne* comes from the Italian *alicorno*, which is derived from the Latin *unicornis*).

Moreover, according to some prehistorians, these are not horns but, more prosaically, the end of another bovine's tail, clumsily juxtaposed with the head of our quadruped. We tend, however, to

64. Below: "Unicorn" (with two horns). Entrance to the Great Hall of Bulls, caves of Lascaux, Montignac (France). This vast ensemble (which was discovered in 1940, by accident) is centered on the confrontation between two big bulls, separated by an incomplete horse. A big horse follows the bull on the left; a series of little black horses, followed on the far left by the famous "unicorn," runs along the lower part of the frieze.

64

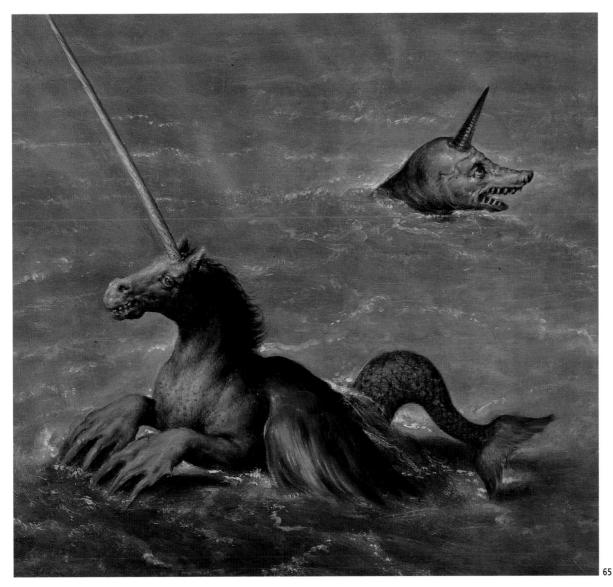

65. Left: Sea unicorn. Gouache on parchment from Rudolph II's *Bestiary*, c. 1610. Österreichische Nationalbibliothek, Vienna. As a Germanic emperor, king of Hungary and Bohemia, Rudolph II of Habsburg (1552–1612) lived in Prague, surrounded by scholars and artists. The legend pertaining to the sea unicorn can be linked to an existing sea mammal—the narwhal, which is rarely observed but does have a long spiraled tusk.

agree with the French prehistorian André Leroi-Gourhan, who rejects this interpretation because it fails to acknowledge the skill of the Lascaux artists: the horned animal depicted here may not be a unicorn but it certainly is a fabulous horned beast.

This "unicorn" is the only one of its kind at Lascaux, but it is not the only fantastic animal in Paleolithic art. There are indeed other figures of fabulous animals—for instance, on the walls of the French caves of Gabillou (in Sourzac), Pech-Merle (in Cabrerets), and Pergouset (in Saint-Géry). The fact that these various animals bear vague similarities to one another (even if the animal at Lascaux is the only one with long horns) is interesting. It proves, on one hand, that Paleolithic artists already

66. Right: *The Martyrdom of Saint Stephen:* the body of the martyr displayed in front of the beasts. Piece V from the Tapestry of Saint Stephen, c. 1500. Brussels, circle of Colijn de Coter (1455–1538). Wool and silk, 65¾ x 69¼ in. (167 x 176 cm). Musée National du Moyen Âge–Cluny, Paris

67. Opposite: *Lady with Unicorn,* detail of the panel À mon seul désir (To my only desire). Tapestry, Paris (cartoons) and Brussels (weaving), 1484–1500. Musée National du Moyen Âge–Cluny, Paris

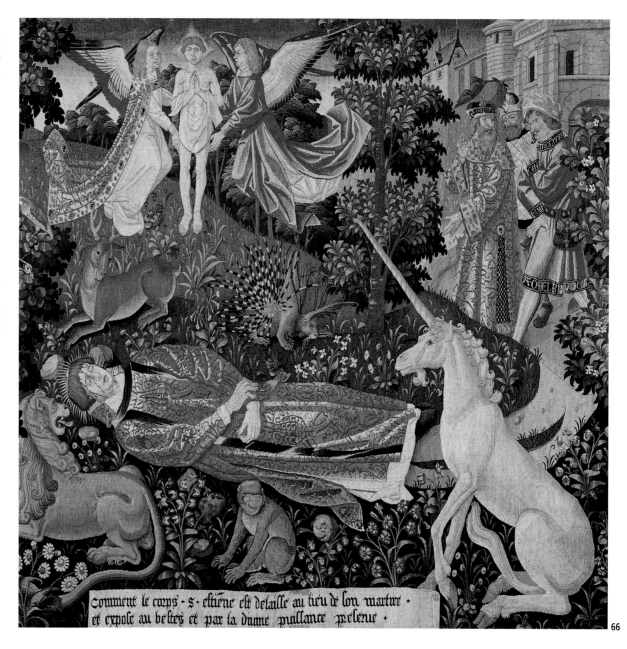

66

possessed a sense of play, dreaming, and invention. And it supports, on the other, the hypothesis first formulated by Georges Bataille in *Lascaux; or, the Birth of Art* (1955): If the function of these prehistoric paintings was, in all likelihood, magical and religious, it was nevertheless not directly linked to rituals geared toward ensuring fertile supplies of edible game, as Henri Breuil (1877–1961) had believed. This is confirmed by the fact that the animals most frequently depicted at Lascaux were the horse and the stag, whereas those that were consumed most abundantly, based on evidence found in the cave, seem to have been the reindeer and the roe deer.

In any case, the horned horse of Lascaux—if indeed it is a horned horse—remained without descendants for a long time. It was not until the apex of the Indus Valley civilization that unicorns started appearing on a great number of steatite cylinders that were found in the region of Chanhu Daro (2600–1900 B.C.), in what is now Pakistan, not far from the Oman Sea. Could these unicorns explain the much later tradition that attributed an Indian origin to this animal?

It is, in any event, thanks to Ctesias that the unicorn made its debut in Western literature in the fourth century B.C. The Greek doctor's description remains, for the most part, the standard one. Cited

67

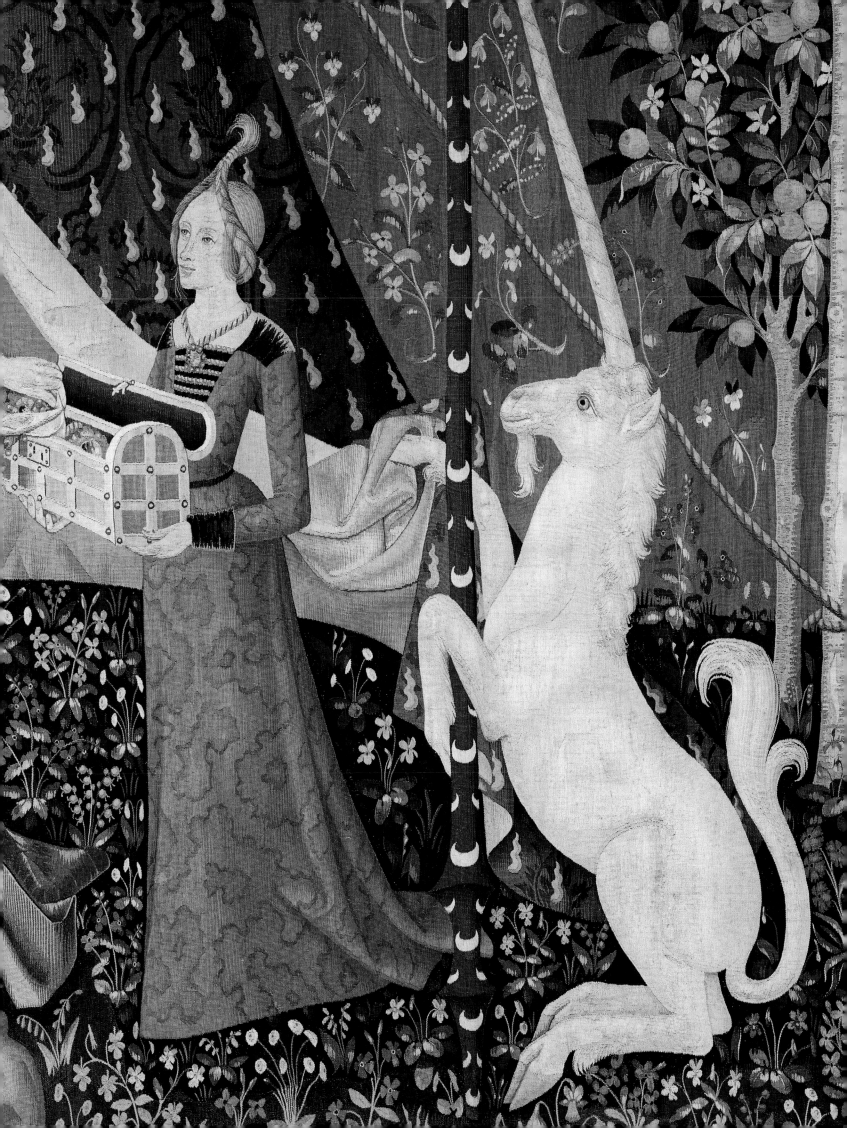

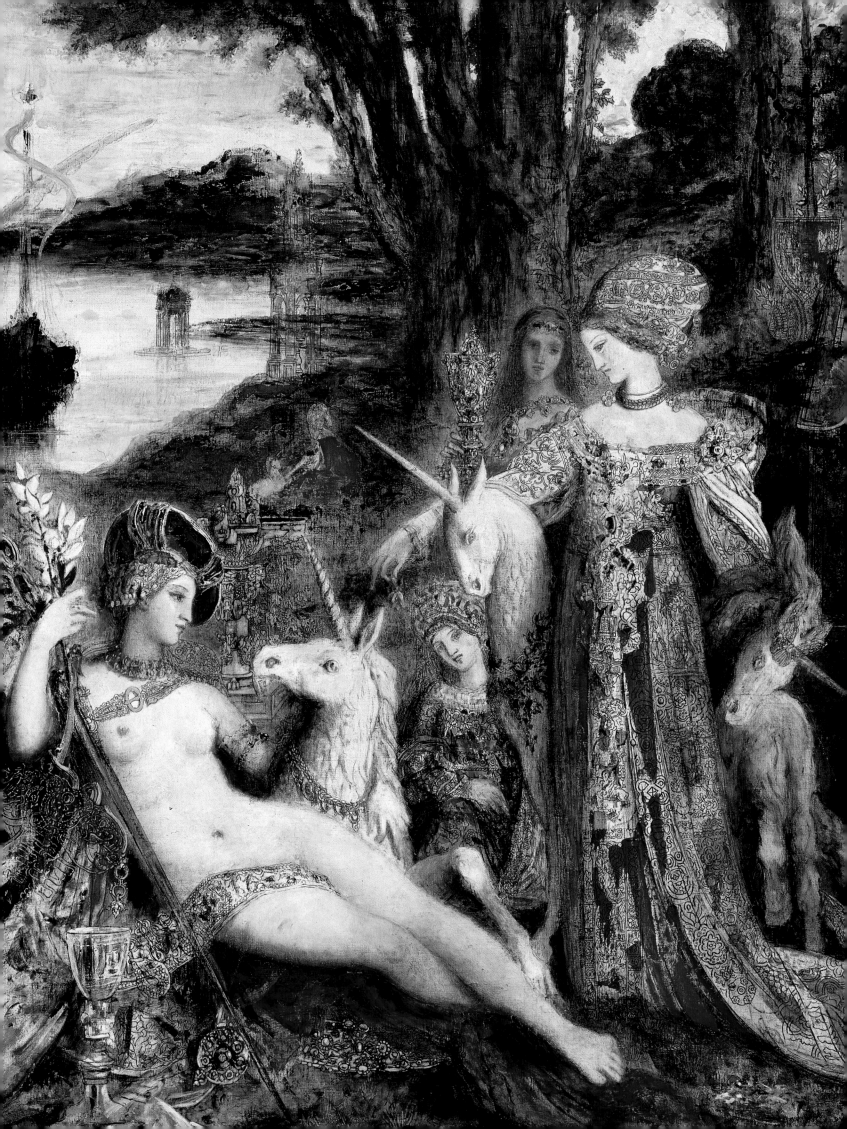

by Aristotle, Pliny, Aelianus, and most of the authors of medieval bestiaries, it gave rise to the most diverse legends, which, in turn, inspired the most various representations. And those representations have lived for centuries, as painters such as the Carracci (plate 62) and Gustave Moreau (plate 68) have continued to paint unicorns.

The Greeks and the Romans considered the unicorn a ferocious animal (its hoof was said to be as sharp as its horn), but among Christians of the second or third century, it acquired a diametrically opposed symbolic value. Initially thought to be a biblical animal because of an erroneous Greek translation of the Hebrew word *re'em*, which is found in Job (39:9–10) and in fact refers to an ordinary wild ox, the unicorn eventually became a metaphor for Christ. Its whiteness, synonymous with purity, facilitated this association. Likewise, an ancient legend held that the only way to capture a unicorn was to offer it the peaceful sanctuary of a virgin's lap; there, no longer concerned for its safety, the unicorn would fall asleep. This association with a virgin was easily linked to the relationship between Jesus and his mother, the Virgin Mary.

This Christian interpretation prevailed as late as 1500, as we can see in the tapestry of the legend of Saint Stephen (plate 66). The blossoming of courtly love and the success of Richard de Fournival's *Bestiary of Love* generated a more sophisticated, even sexual interpretation, although expressed in purposely veiled, esoteric language. With its futilely erect horn, the unicorn can indeed serve as an emblem for the lover whose passionate desire is not (and never will be) satisfied. Composed toward the mid-thirteenth century, song 34 by the *trouvère* Thibaud de Champagne reflects this new mutation:

> Aussi comme unicorne sui
> Qui s'esbahit en regardant,
> Quant la pucelle va mirant.
> Tant est liée de son ennui,

> Pasmée chiet en son giron;
> Lors l'ocit-on en traïson.

("I am like the unicorn, which is struck with amazement while contemplating the maiden. It derives so much joy from its torments that it falls swooning onto her lap; then it is treacherously killed.")

It is in the light of this last text that the famous series of six tapestries known as *Lady with Unicorn* (plate 67) should be reinterpreted. Completed in Brussels between 1484 and 1500, this series is undoubtedly an allegory of the six senses—a theme that became popular as early as the end of the fourteenth century, through several widely dispersed religious works. Five of the six tapestries are indeed dedicated to sight, hearing, touch, smell, and taste. As for the sixth sense, we might designate it as the "heart," understood here as the spiritual guide to the other five (physical) senses along the path to Christian renunciation of worldly pleasures. This provides a key to understanding the sixth tapestry, bearing the subtitle *À mon seul désir"* ("To my only desire"), which depicts a young woman depositing her necklace in a small box held by a servant. This gesture seems in fact to express her desire to dedicate herself to her soul's salvation rather than to earthly matters.

But this edifying interpretation, which is so general that it could theoretically apply to any young Christian woman, is probably not the only one possible, especially within a social class (the person who commissioned this tapestry, though unidentified, is known to have belonged to a rich bourgeois family in Lyons) and at a time that favored works of art that could be read in a multitude of ways. Another more specific explanation seems to be justified by the atmosphere of melancholy that pervades this set of tapestries, and in particular the sixth one. Quite obviously, this exceptionally magnificent commission was not destined to celebrate a wedding or any other happy event. It could, however, have been destined to

68. Opposite: Gustave Moreau (1826–1898), The Unicorns, 1885. Oil on canvas, 45¼ x 35⅜ in. (115 x 90 cm). Musée Gustave Moreau, Paris. Moreau, a great colorist and teacher who deeply influenced the young Henri Matisse, remains one of the spiritual fathers of twentieth-century modern painting, despite his predilection for mythological themes.

69. *Below:* Bottom of a ceramic dish with a qilin. Persia, 17th century. Musée du Louvre, Paris

70. *Opposite:* Boarding the Ark. Detail from a triptych (c. 1550) representing three biblical episodes: Building Noah's Ark, Boarding the Ark, and the Flood, by Abaquesne Masséot (known in 1526, died before 1564). Decorative *grand feu* (fired at a high temperature) earthenware tile, 54¼ x 37¼ in. (138 x 95 cm). Musée de la Renaissance, Ecouen, Paris

commemorate the *impossibility* of a wedding—due, for instance, to the premature death of the fiancé. The young woman (accompanied by her dog, a symbol of fidelity) who takes off her necklace would then be announcing publicly that she intends to espouse chastity (symbolized by the unicorn) and to devote the rest of her life "to [her] only desire"— that is, to the memory of her lost love. (If the motto written on the sixth tapestry is treated like an anagram, it can also be read, as Ezio Ornato astutely perceived, as "sens amor deuil," *deuil* being the French word for mourning.) In this case, the amorous interpretation and the Christian one could coexist without any contradiction.

The Eastern unicorns are undoubtedly as rich and as polysemous as their Western counterparts; but the secret of their symbolic connotations seems even more elusive. The Islamic world, which tends to mix up the unicorn and the rhinoceros,

seems to favor its confrontation with the elephant. In India, the religious epic the Mahabharata, evokes a unicorn with the body of a bovine. As for the art of the Far East (China, Japan, Korea), we find, beginning with the tombs of the emperors of the Qi dynasty (fifth–sixth century A.D.), an animal called a *qilin* (*kirin* in Japanese), which is a sort of spotted feline. Several variants exist, most being endowed with a single horn, though others, more rare, have twin horns. From the moment that the Timur-led Turkic Mongols (the heirs of classical Chinese civilization) extended their empire into Persia (by the end of the fourteenth century), this animal began to appear in Persian art (plate 69), as well as in specifically Turkish art.

Presented in different shapes (sometimes evoking a horse, sometimes a stag or a feline), and often represented as fighting a lion adorned with flying sparks, an antelope, or a dragon, the *qilin* depicted by Asian artists is for us just a decorative element whose meaning is poorly understood. But the fact that it has been reproduced thousands of times on ceramics and rugs, right into the twentieth century, proves that it remains highly popular up to this day—probably because it is unanimously considered, in East Asia, as an animal of good omen, renowned for its kindness, its sense of justice, and its respect for life.

69

THE ANIMAL-HEADED HUMAN

One indefinable being has the general form of a standing man but is endowed with the horns of a deer, the ears of a reindeer, the eyes of an owl, a long beard, and a penis angled back like a feline's (all attributes intended to underline its virility): this is the strange figure that prehistorians, following their French colleague Henri Breuil, have dubbed the "sorcerer." It hovers imposingly some twelve feet above the ground in a room (known as the Sanctuary) of the cave of Les Trois-Frères, in

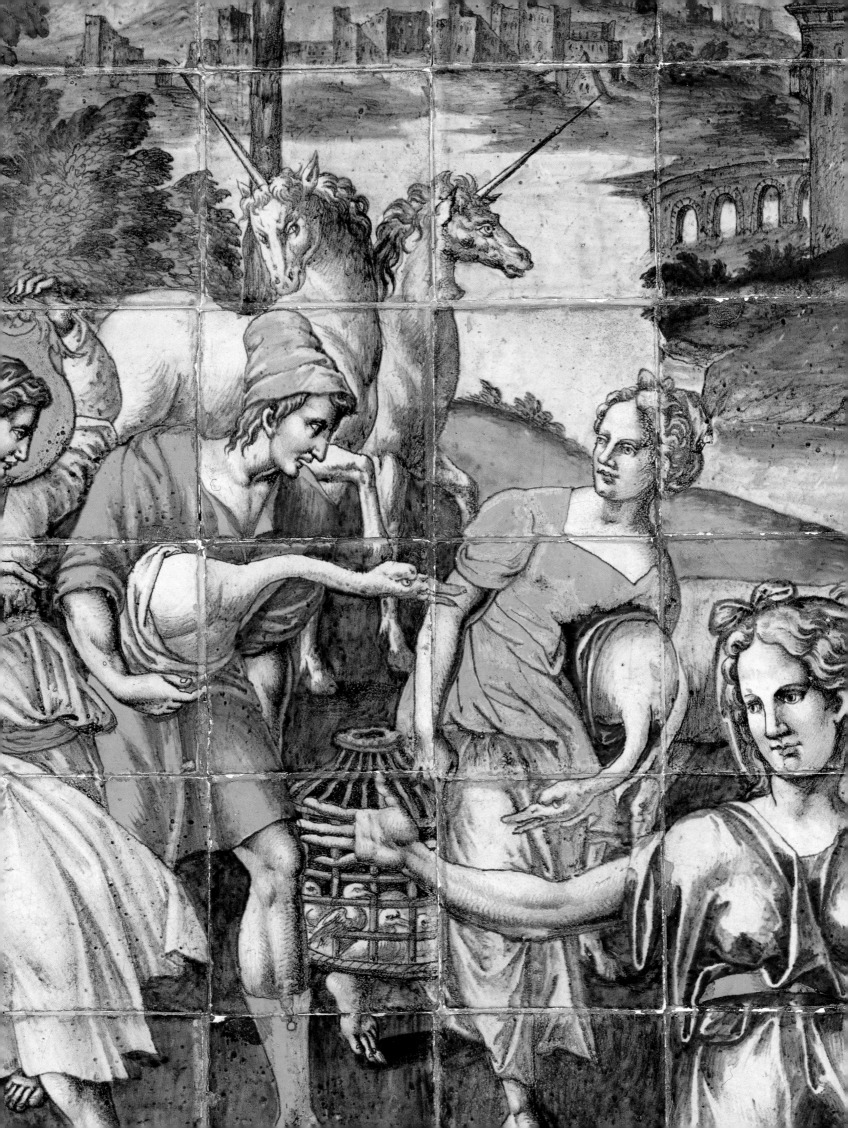

Montesquieu-Avantès, France. This image was probably scratched into the cave's wall and painted during the Middle Magdalenian age (c. 11,000 B.C.). But is it really, as Breuil believed, a sorcerer? That is to say, is it really a man disguised as a fantastic animal for a shamanistic ritual meant to guarantee abundant game? Or is it a fantastic animal that the artist had seen, perhaps in a trance? Or is it perhaps the representation of a divinity codified by oral tradition?

Unfortunately, it is impossible to give a definite answer to these questions, whether in terms of this "sorcerer," the much older lion-headed man found in the cave of Hohlenstein-Stadel (plate 71), or other animal-headed human figures (from a later period) that have been spotted in other prehistoric caves, such as the ox-headed man in the cave of Gabillou, the men-fawns in the Abri Mège in Teyjat, France, or, stranger still, the man in the cave of Pergouset whose head seems to have been replaced by the tail of a bison (unless it is an erect penis). One cannot help noticing, in these various representations, a deliberate refusal on the part of the Paleolithic artists to depict the human face openly. Whereas their works of art are, as has often been said, a testimony to the humanity emerging from bestiality, the depicted faces are always hidden behind animal masks. Returning once again to Bataille's book on Lascaux, we should note the very strong connection that prehistoric hunting societies maintained with the wildlife around them. This link went beyond merely physical, alimentary needs. For them, it was spiritual, almost mystical in nature. "The animals of the hunt are like humans, except holier"—a statement that Bataille attributes to the Navajo Indians (themselves once a population of hunters)—applies here as well.

One finds horned men and antelopes in prehistoric art until the end of the Neolithic period. For example, the Jordan Archeological Museum in Amman has, among other things, a curious mural painting that was discovered in 1977 on the site of Telelat-Ghassul (the Jordanian side of the Dead Sea). It dates back to approximately 4000 B.C. and shows a group of three people standing in front of some kind of reliquary. In spite of the painting's poor state of preservation, one can see that these three figures have horns and overly large eyes; but it is difficult, once again, to determine whether they are masked priests or mythical creatures that are half-human and half-animal.

Turning our attention now to pharaonic Egypt, we see that from the third millennium B.C. onward, it started representing most of its gods and goddesses in the form of animal-headed men or women. Everybody remembers hawk-headed Horus, cow-headed Hathor, crocodile-headed Sobek, jackal-headed Anubis, ibis-headed Thot (plate 74), ram-headed Khnum, and so on. And yet, in several of these representations it is the human aspect that prevails, as it does with most Hindu deities (the elephant-headed Ganesh, the eagle-headed Garuda, and certain incarnations of Vishnu as a bear- or lion-headed man). Nevertheless, some of these Egyptian representations seem to be more animal than others. Such is the case, for instance,

71. Opposite: Lion-headed man. Cave of Hohlenstein-Stadel, Bade-Wurtemberg (Germany); Aurignacian period (c. 30,000 B.C.). Ivory, height 11½ in. (29.6 cm). Ulmer Museum, Ulm, Germany

72. Below: Two elephants mounted by divs, page from the Shir Djang album. Mughal India, early 17th century. Ink, colors, and gold on paper. Bibliothèque Nationale de France, Paris, MS. or., Smith-Lesoüef 247, fol. 33v. We can see here the same technique of assembling multiple animals into a composition that was encountered in plate 3.

72

73. Right, top: The hippopotamus-headed Thueris. Green shale, height 37⅜ in. (96 cm). Karnak, Twenty-fifth Dynasty (751–666 B.C.). Egyptian Museum, Cairo

74. Right, bottom: Thot, the ibis-headed god of writing, holds in his hands the "Udjat" eye. Egypt, Late period (c. 525–c. 332 B.C.). Bronze, height 5½ in. (14 cm). Musée du Louvre, Paris. Often placed on the Egyptian pharaoh's forehead, the "Udjat" eye, symbolized by a cobra, was intended to annihilate his enemies.

75. Opposite: Vâjimukha (horse-headed man). Tower no. 7, Sambor Prei Kuk, Kompong Thom Province, Prasat Sambor District (Cambodia), Angkor period, Prè Rup style (third quarter of the 10th century). Sandstone. Musée National des Arts Asiatiques–Guimet, Paris

73

74

of the goddess Thueris (also known as Taueret or Thoeris), represented as a woman with the head of a hippopotamus, the claws of a lion, the tail of a crocodile, and a big belly that identifies her as the deity protecting pregnant women (plate 73). It is also true of the statuette of a hawk-headed crocodile—a strange synthesis of Horus and Sobek, of the sky and the underworld (Twenty-fifth to Thirtieth Dynasty, eighth to fourth century B.C.; Walters Art Museum, Baltimore). Within the Egyptian sphere should also be mentioned the existence of tomb-protecting demons, which were frequently represented during the New Kingdom as antelope- or turtle-headed human beings.

Animal-headed genies and demons are also pervasive in Sumerian art (bull-headed men at the end of the third millennium B.C.), Anatolian art (lion-headed men toward 1800 B.C.), ancient Cypriot art, and Assyrian art. Greek mythology is the source of several figures of the same type, starting with the Minotaur, a Cretan monster that was the offspring of the illicit union between Pasiphaë and a bull, and Actaeon, a hunter who was transformed into a stag after he surprised the goddess Artemis bathing. These two figures, in turn, were abundantly treated by European artists: we need only mention, to limit ourselves to the twentieth century, Jacques Prévert's amusing collage of Actaeon (plate 157) and Picasso's numerous variations on the theme of the Minotaur made during the 1930s (plate 133), which have an impressive erotic power. Along the same line, we could also mention *The Faithful Bride*, by the Surrealist painter Alberto Savinio, in which the artist ironically depicts a goose-headed woman (1929; Galleria dello Scuodo, Verona, Italy).

The animal-headed man is also a common type in most non-European civilizations. We can see horse-headed men in Cambodian art (plate 75) and bird- or fish-headed men in Oceanic art—in particular, in Hawaii (Bernice P. Bishop Museum, Honolulu) and in Easter Island. Behanzin

7

(1844–1906), the last ruler of the kingdom of Abomey at the time France conquered Dahomey (modern-day Benin), has been immortalized as a shark-headed man in one of the most striking sculptures that precolonial African art has bequeathed to us—and one of the rare instances in which the name of the sculptor is known: Sosa Adede (plate 76). Behanzin's predecessor, Glele, had himself represented as a lion-headed man (plate 77).

Gold pendants, fashioned in the form of a human body with the head of either a crocodile, a bat, or a jaguar, were widespread in Central America during the centuries preceding the conquest. To this day, a bull-headed man appears among the kachinas, those singular "dolls" that are intended to serve as receptacles for the spirits and that are made by the Zuni and Hopi Indians of New Mexico in order to familiarize their children with the afterlife. These dolls (of which some two hundred types exist) have tended to become trivialized in response to the booming tourism industry, but the oldest specimens of kachinas—such as those found in the Heard Museum in Phoenix, Arizona, or in the Millicent Rogers Museum in Taos, New Mexico—are remarkable in quality. André Breton, who developed a passion for Native American art while living in the United States during World War II, was among the first to celebrate their baroque inventiveness.

Finally, let us note the existence in several cultures of a very popular myth: that of the werewolf. In Greek mythology, King Lycaon of Arcadia, who was guilty of sacrificing a newborn during a banquet given in his honor, was turned into a wolf (*lukos*) by Zeus. The predatory nature of this animal, rightly feared by ancient shepherds, has occasionally led to its association with the idea of plunder and, consequently, with the image of a bird of prey. This is why the wolf-headed man depicted on the medallion of an Etruscan plate dating back to 520 B.C. also possesses the claws of a raptor at the end of his forelimbs (Museo Nazionale di Villa Giulia, Rome).

THE HUMAN-HEADED ANIMAL

The converse of the beings we just examined, the human-headed animal appeared in Sumerian art as early as the third millennium B.C. And like its counterpart, it too became quite widespread. A steatite cylinder seal that was found in Agade (Akkad) and that dates back to approximately 2250 B.C. (Musée du Louvre, Paris) depicts a bull deity offered as a sacrifice by the sun and fire gods to ensure natural order. Adorned with a horned crown attesting to its divine essence, this composite being has the legs of a bull and the torso, arms, and head of a human.

Such beings are pervasive in Assyrian as well as in Persian art, until the Muslim conquest. They can also be found in the art of the civilizations that are geographically close to them. For instance, human-headed bulls have been found at the Neo-Hittite site of Aïn Dara (tenth–ninth century B.C.), in the northern part of present-day Syria, and in other regions of the fertile crescent that once united Mesopotamia to the Nile Valley. But for some of the most famous fantastic animals, we must look to pharaonic Egypt and, first of all, to the creature that has most resoundingly struck the human imagination: the sphinx, with its body of a lion and head of a human.

No sphinx is known in Egyptian art prior to the rule of the third pharaoh of the Fourth Dynasty (Old Kingdom), Radjedef (2528–2520 B.C.). It was during the rule of his successor Khafre (also known as Chephren;

76. Opposite: Behanzin, king of Dahomey, depicted as shark-headed, by Sosa Adede. Fon People, Dahomey (now Benin), last quarter of the 19th century. Wood, height 62⅜ in. (160 cm). Musée de l'Homme, Paris. Behanzin, who was Dahomey's last king (1889–93), was deported to Algeria after France conquered his kingdom; he died in Algiers in 1906.

77. Below: Glele, king of Dahomey (Behanzin's father and predecessor), depicted as lion-headed. Fon People, Dahomey (now Benin), last quarter of the 19th century. Wood, height 66¼ in. (170 cm). Musée de l'Homme, Paris

77

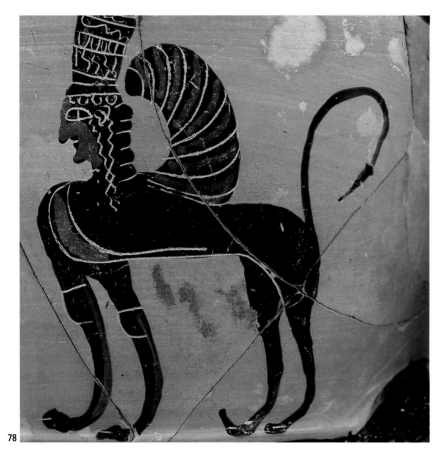

78

78. Above: Sphinx from a kantharos with black figures on red background, with two high-arching handles. Greece, c. 560 B.C. Terra-cotta, height 9⅞ in. (25 cm). Musée du Louvre, Paris

79. Opposite: Sphinx. Bone sculpture, with an amber face. Würtembergisches Landesmuseum, Stuttgart, Germany. Discovered during excavations of a princely tomb near Asperg, Bade-Wurtemberg (Germany), this Celtic sculpture dating back to the end of the fifth century A.D. is an original reinterpretation of a Greco-Roman model.

2520–2494 B.C.) that the most colossal sphinx statue was produced—187 feet long, 65 feet tall. To this day, on the western bank of the Nile (the realm of the dead, according to the Egyptians), it seems to be watching over the Great Pyramid, which formerly housed Khafre's mummy. The naturalness with which the human face—adorned with the *nemes* (a cloth wrapping the head) and the *uraeus* (the divine serpent) on the forehead—is linked to the lion's body makes the Sphinx of Giza one of the great masterpieces of world art and one of the most photographed monuments in the world. (Modern-day Egyptians call it, in Arabic, "Abu el-Hol," "the father of the terror.") And yet, whatever idea originally inspired such a creation remains for us, four thousand years later, utterly impenetrable.

The small temple that was erected in front of the forelimbs of the Sphinx bears some resemblance to the solar temples that were later built by the pharaohs of the Fifth Dynasty on the sites of Ab'u Gorab and Ab'usir, which are located close to

Giza. However, we have virtually no information as to the exact religious meaning during the Old Kingdom of the animal in question. At most, we can observe that the sphinx was constructed on the edge of the Nile and that the lion was, in the Egyptian imagination, associated with the river's floods. The link was made because the flooding of the Nile, upon which the region's agriculture and consequently its very life depended, used to occur at the beginning of the summer, just as the sun entered the constellation of Leo (as a reminder of this, in most Mediterranean countries, a lion spitting water is still a traditional ornament of public fountains).

It was not until the Eighteenth Dynasty (New Kingdom) that the Sphinx of Giza started to be viewed as an image of the god Harmakhis, which means "Horus in the horizon" (not to be confused with the other Horus, son of Isis). Harmakhis was supposed to guard the gates of the beyond, the gates through which the day star appears each morning and disappears each evening. And it was a pharaoh of this dynasty, Thutmose II (1520–1505 B.C.), who, in a dream, was ordered by Harmakhis himself to free the statue of the sphinx from the sand that was threatening to swallow it. This story was commemorated by a stele that was placed, by order of Thutmose, in front of the paws of the Sphinx of Giza. And this is considered today to be the oldest known account of a dream.

After Khafre's rule, sphinxes linked to solar worship and probably possessing the power to chase away bad spirits started proliferating in Egyptian art, whether as human-headed lions or rams (the ram being the Theban god Amon's sacred animal, which explains the ram-headed sphinxes bordering the alley linking the temple of Luxor to the temples of Karnak). Today, we can find sphinxes from many different periods in all parts of the Nile Valley. They are also present, of course, in the Eastern or Mediterranean civilizations that can be considered heirs of the pharaonic civilization: in Syria, in Palestine, in Mesopotamia as early

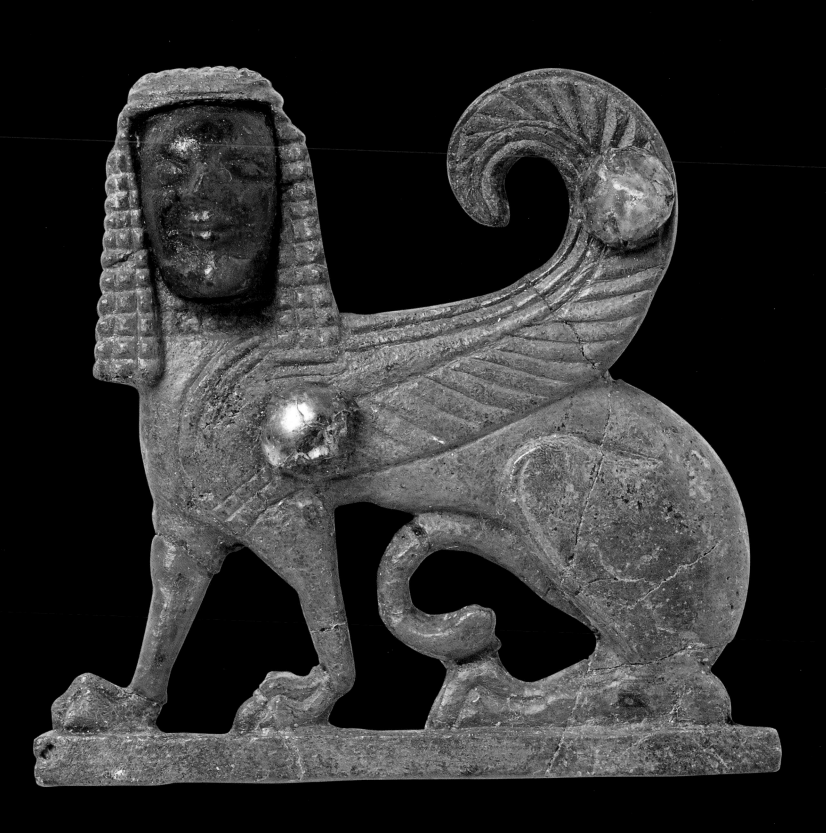

80

that Oedipus put to rout when he solved her riddle ("What walks on four legs in the morning, two legs at noon, and three legs in the evening?"—the answer being, "Man"), thus liberating the Greek city of Thebes (not the Egyptian one!) from the ravages of this cruel monster.

As a result, the winged sphinxes encountered in Greek art, whose main function seems to be guarding tombs, have a woman's rather than a man's head. That is also true of numerous painted or sculpted sphinxes in European art, in particular those made after Bonaparte's expedition to Egypt (1798), when Western Egyptomania reached its peak. In Paris, London, and most Western capitals, the sphinx became a highly prized architectural ornament. It is hardly surprising that the Greek legend—popularized by the works of Aeschylus, Sophocles, and their successors (Euripides, Seneca, Corneille, Voltaire, and so on, as well as the Roman poet Statius's *Thebaid* and the anonymous *Story of Thebes* written in the twelfth century)—has managed to supplant the ancient Egyptian myths. Is it not obvious that the famous riddle, which continues to be associated with the Greek sphinx and is related to the story of Oedipus's incestuous relationship to Jocasta, expresses man's permanent anxiety about his lineage?

But the sphinx is not only an ancient Mediterranean animal. It can also be found in Celtic art of the fifth century A.D. (plate 79); in the art of the Christian Middle Ages, whether Latin or Eastern; in Islamic art, where it seems to have been linked to royal iconography; in the Buddhist art of Siam; and even in Japanese art, where we find the great Hokusai depicting himself, near the end of his life, as a human-headed lion in an album of drawings entitled *Manga Sohitsu Gafu* (1820). Let us mention, finally, a strange capital, originally from the abbey of Montmajour, France, and currently kept in the cloister of the Saint-Trophîme abbey in Arles, France. In all likelihood reflecting an Eastern influence, this twelfth-century capital depicts two quadrupeds leaning against one another.

80. Above: *The Sphinx* (1879), by Félicien Rops (1833–1898). Frontispiece for *Les Diaboliques* by Barbey d'Aurevilly. Pen, black chalk, Conté crayon, and gray wash, heightened with white, on white prepared paper, 10⅝ x 7¾ in. (27 x 20 cm). Musée du Louvre, Paris

81. Opposite: Louis-Welden Hawkins (1849–1910), *The Sphinx and the Chimera* (1906). Oil on canvas, 31½ x 28¾ in. (80 x 73 cm). Musée d'Orsay, Paris

as the thirteenth century B.C., in Greece as early as the seventh–sixth century B.C. (plate 78), among the Etruscans and the Persians from the sixth century B.C., in Cyprus during the same era, and later in Roman art.

It was during the Greek stage of its history that the sphinx—for reasons that are, once again, unknown to us—suddenly changed sexes and came to be adorned with a pair of wings. The Greek word *sphigx*, which derives from a verb meaning "to clutch" or "to squeeze," is indeed feminine. Thus, Herodotus was forced to coin the neologism *androsphinx* ("male sphinx") to refer to its Egyptian source. Consequently, it was a female sphinx

81

82. Right: The *ba* of the dead fluttering over his body, from the *Tchenena Book of the Dead*. Egypt, New Kingdom, Eighteenth Dynasty (c. 1550–1292 B.C.). Musée du Louvre, Paris

83. Opposite: *Kinnara*. China, Tang dynasty (618–907). Terra-cotta, height 5⅞ in. (15 cm). Musée National des Arts Asiatiques–Guimet, Paris

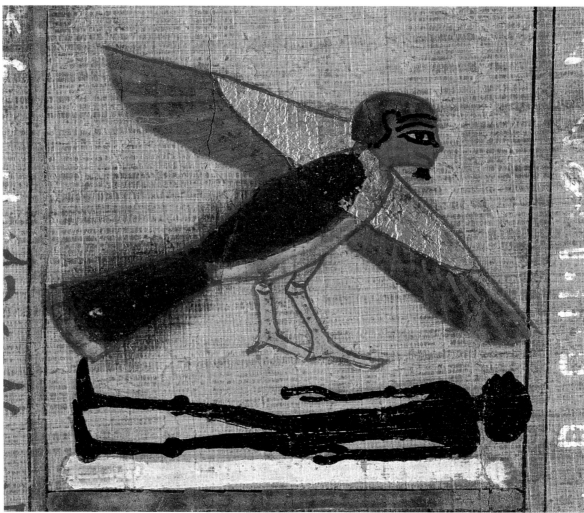

82

Although the figures seem to have the body of a horse rather than that of a lion, medievalists have generally viewed them as sphinxes. One of them, with a long square beard, is a male sphinx, and the other, a female sphinx.

Another enduring invention of the pharaonic civilization is the human-headed bird. According to the ancient Egyptians, this remarkable animal, sculpted in various materials, is the receptacle of the *ba*, one of the six parts forming every personality (plate 82). The *ba*, a concept difficult to translate, seems to be closest to what we call "soul," in a psychological sense. The other parts of the personality are the body, the shadow, the name, the *ka* (a vital energy that is necessary for the afterlife), and the *akh* (an immortal spirit that was a privilege reserved to the pharaoh and his court during the Old Kingdom and that began to be shared by any-

body who could afford a tomb during the Middle Kingdom). The Nubian Museum in Aswan has magnificent *ba* statues dating back to the Twenty-fifth through the Thirtieth Dynasty. In Nubia, too, a local god known as Mandulis was represented as a human-headed bird. Its image appears on the vestibule walls of the temple in Kalabsha that was dedicated to it during the Roman occupation. When Lower Nubia was flooded by the rising waters of Lake Nasser, this temple was dismantled and reassembled next to the Aswan High Dam.

The human-headed bird reappeared in the sixth century B.C. in other regions of the Mediterranean, in particular in Cyprus but also in Etruscan, Coptic, Islamic, and later Hindu art (where its features are used to depict Garuda, the mount of the deity Vishnu). It is also present in medieval European art. We previously mentioned birds with

8

bearded faces, sculpted by Gofridus in the Collegiate Church of Saint-Pierre in Chauvigny, to which we could add—to underscore the longevity of the image—those decorating the first page of Sargis Khizantzi's Armenian Gospel, which was painted in Jerusalem in 1572. These beards remind us of the (false) beard that adorns the representation of the *ba* in the Papyrus of Ani, or Book of the Dead (Nineteenth Dynasty; British Museum, London).

The woman-headed bird has a specific story that needs to be studied separately. The belief in the existence of this animal—which is frequently associated with anxiety about violent death or with the fear of the dead returning to take hold of the living—makes an appearance in diverse civilizations. In the Greco-Roman world, harpies (that is to say, "abductors," a notion closely linked to the Greek word *harpè*, meaning hawk) are initially (in Hesiod) storm goddesses, then eventually become (in Virgil) infernal, dirty, and appalling creatures. They also appear in Islamic art, mainly in Egypt and in Syria from the Abbasid period until the end of the Fatimid period (eighth–twelfth century); in Chinese and Javanese art, where oil lamps, from the beginning of the tenth century, take the shape of the *kinnara* (a bird with the tail of a peacock and the head and breasts of a woman; plate 83); and even in Mayan art. By the time Francisco de Goya used the image in *Los Caprichos* to depict women of loose morals, into whose talons men are doomed to fall, the woman-headed bird had long been a familiar figure in world art (plate 84).

In the West, nevertheless, the negative connotations of the woman-headed bird seem to have transferred progressively, starting in the Hellenistic period, to a different creature—a woman with the tail of a fish. One remembers the sirens (Homer used the word *seirèn*) who, in the *Odyssey* (canto 12), try to bewitch Ulysses with their song. In the iconography of the Greek vases of the Classical period, these sirens are still woman-birds, supposedly living on the coasts of Sicily. The bird-to-

85

fish transformation occurred later—perhaps in the course of an assimilation with the Nereids (Nereus's daughters, who are water nymphs dwelling in the depths of the sea and thus are endowed with the tail of a fish). Or perhaps the transition occurred when the astronomer Eratosthenes (276–195 B.C.) linked the constellation of Pisces to the Syrian goddess of fertility, a woman-fish called Derketô, who was renamed Atargatis in Greek and who was ultimately fused with Aphrodite, the sea-born goddess of beauty and seduction.

In any case, the spread of Christianity hastened this development. Starting in the early Middle Ages, the word *siren* applied in most cases to an aquatic creature that was dangerously enticing but impossible to capture. Simultaneously, the woman-fish was perceived by medieval theologians as the symbol of the sin of lust, which led to hell.

84. Opposite: "Todos caeran" (All will fall). Etching from Los Caprichos (1799), pl. 19, by Francisco de Goya (1746–1828). Biblioteca Nacional de España, Madrid

85. Above: Story of Bânâsura, Bali's Son, King of the Demons. Nepal, 1795. Gouache on canvas, 29½ x 14⅛ in. (75 x 36 cm). Musée National des Arts Asiatiques–Guimet, Paris. The story of Bânâsura comes from an ancient Indian religious text, the Vaishnava Purana.

86.

86. Top: Fountain of the Girondins, Bordeaux, by Gustave Debrie and Félix Charpentier, executed between 1864 and 1902.

87 and 88. Bottom, left and right: Tritons Fountain, place de la Concorde, Paris, by Jacques Ignace Hittorff (1792–1867). Hittorff, who had a passion for archaeology, was a great connoisseur of ancient sculpture, which he imitated in this fountain executed between 1836 and 1846.

89. Opposite: Drawing of the Ambassadors' Staircase at Versailles (central niche: fountain surmounted by the ancient group *Silenus Taken Away by a Triton*), by Jean-Michel Chevolet (1698–1772). India ink wash, heightened with white, on paper, 17⅜ x 12½ in. (44 x 32 cm). Castles of Versailles and Trianon

87

88

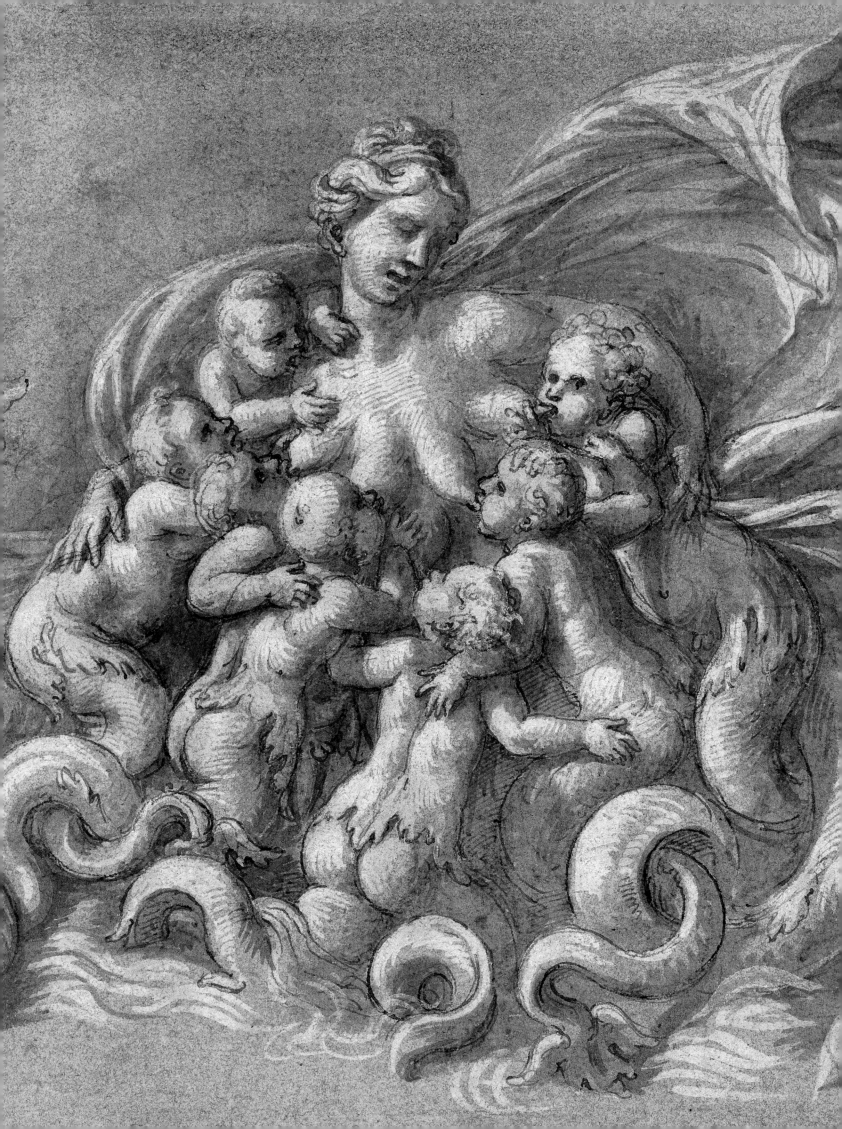

A ubiquitous figure in the folklore of sailors and fishermen (those male seafarers deprived of women on their long journeys), the siren-fish also appears in Coptic art, in medieval art (plate 91), in the art of the Renaissance (plate 90), and in the illustrations of alchemical manuscripts. Closer to our own times, it reappears in Symbolist art, which often exploits the association between the feminine element, the aquatic one, and the specter of death that is suggested by the legend of the elusive woman-fish. Fortunately there also exists a less somber, more attractive variant, starting with the fairy Mélusine and extending to the Little Mermaid of Copenhagen and to the more grown-up mermaids that decorate fishing boats and seamen's lounges in many parts of the world.

We cannot leave the universe of human-headed animals (to which the manticore, deriving from Ctesias, is of course linked) without also mentioning fauns, satyrs, centaurs, sagittarii, and tritons, as well as certain species that are even more rarely depicted. In Greek mythology the faun

and the satyr are rural deities with hairy bodies, the legs of a goat, and a bearded human face, topped off with horns and long pointed ears. They are Pan's companions, in the same way that the potbellied Silenus is affiliated with Dionysos. A deity originating in Arcadia (like the werewolf), Pan is the god of the earth and, by extension, of irrational forces that stir beneath the surface of the world, starting with sexuality (his unpredictable behavior can lead to "panic" attacks). This explains both the bad reputation of satyrs and their huge popularity in European art from the moment ancient culture was rediscovered during the Renaissance.

An animal familiar to Greco-Roman, Byzantine (plate 92), and Islamic art (plate 94), the centaur, a horse with the head and torso of a man, also recurs in Celtic and in particular Gallic art. We find the human-headed horse on Gallic coins that were admired by André Breton and André Malraux. Recognizing the virtuosity of the artists who had engraved them, Breton (in a 1954 text entitled

90. Opposite: Giulio Romano (1499–1546). *Siren Breast-feeding Her Children*, n.d. Black chalk, pen, and brown ink, brown wash, heightened with white on paper, 9½ x 9⅞ in. (24.4 x 25.3 cm). Musée du Louvre, Paris

91. Below: Twin capital, with sirens facing each other. From the abbey church of Saint-Denis (Ile-de-France), Romanesque period, c. 1160. Stone, 10¼ x 16⅛ x 11¾ in. (26 x 41 x 30 cm). Musée National du Moyen Âge–Cluny, Paris. These sirens are still depicted as women-headed birds, according to the ancient Greek tradition.

91

92

92. Above: Satyr-centaur pulling the chariot of the sun. Elephant ivory binding, representing (here) Helios (the Sun) and on the other side Selene (the Moon). Byzantine. Bibliothèque Municipale, Sens, France, MS. 46

93. Opposite: Sandro Botticelli (1447–1510), *Pallas and the Centaur,* c. 1485.

Tempera on canvas, 80¾ x 57¾ in. (205 x 147 cm). Galleria degli Uffizi, Florence. Suffused with neo-Platonic spirituality, this enigmatic painting is far from having revealed all its secrets. It could be an allegory of the triumph of the soul (represented by Pallas-Athena) over matter (represented by the centaur) or of good over evil.

The Triumph of Gaulish Art) even went so far as to attribute to the Gaulish spirit, as opposed to the Latin spirit, the true ancestry of both Surrealism and abstraction. Did Breton, when he wrote that text, remember the self-portrait of the famous Surrealist Frida Kahlo, depicting herself as a human-headed doe (1946; private collection)?

It is undoubtedly because of the attractive nature of its physical appearance, at once athletic and harmonious, that the Greco-Roman centaur enjoyed a new career in European painting and sculpture, from Sandro Botticelli (plate 93) to César (plate 172). The battle between the Centaurs and the Lapiths constituted a very popular subject, not only in the decoration of ancient temples but also in the art of the Renaissance and beyond. Let us note incidentally that the drunken Centaurs who abducted their hosts' spouses behave like true barbarians, whereas Homer depicts the centaur Chiron, who was Achilles' tutor, as a model of wisdom—one more example of the ambivalence that characterizes fantastic animals.

An essential character in any representation of the zodiac, the *sagittarius* (from the Latin *sagitta,* or arrow), who originates from Mesopotamia, is a centaur aiming a bow. It is particularly prevalent in the art of Islamic Persia (plate 95) but is also known in Christian art, as proven by the Gospel of Lothaire (849–51; Bibliothèque Nationale de France, Paris).

As for Triton, a sea god with the head and torso of a man and the tail of a fish, he spends his time in Greek mythology in the company of the Nereids. This role suited the triton to become a popular ornamental figure. From the sixteenth century and in particular during the Baroque age, it appeared on many public fountains, as well as in works of art depicting the turbulent procession of Amphitrite and Poseidon (plates 86–88). As a cousin of the triton, the capricorn, originating in Mesopotamia, shares with it the tail of a fish but has the head of a ram, not a human. We will link to

93

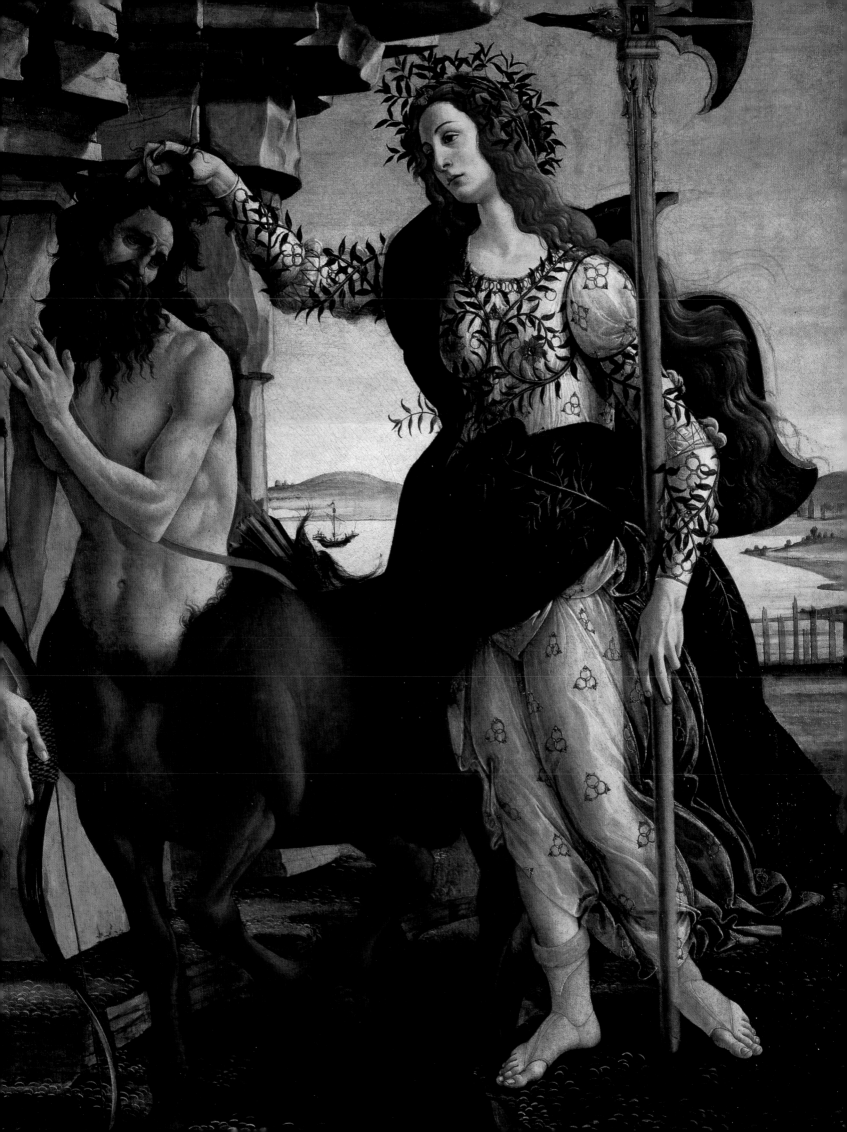

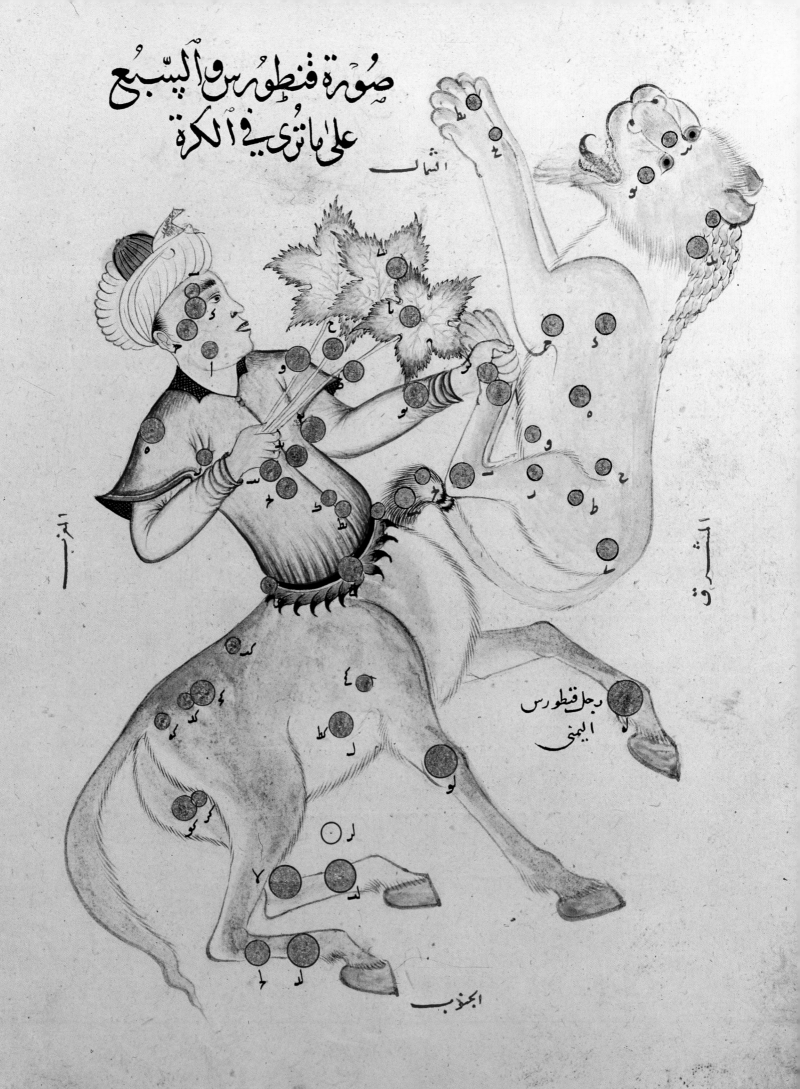

94. Opposite: The centaur and the lion. Illustration from a manuscript of the *Book of the Fixed Stars*, by Abd al-Rahman al-Sufî, copied for Ulûgh Beg. Samarkand, c. 1430–40. Gouache, ink, and gold on paper, 92½ x 64⅞ in. (235 x 165 cm). Bibliothèque Nationale de France, Paris

95. Below: The Sagittarius (1st Decan). Illustration from the *Book of Nativities*, c. 1300, MS. ar. 2583, fol. 25v, attributed to Abu Mâ Shar. Bibliothèque Nationale de France, Paris. The image of the centaur aiming his bow at the dragon at the end of his own tail is frequently interpreted as a symbol of human efforts to dominate bad instincts.

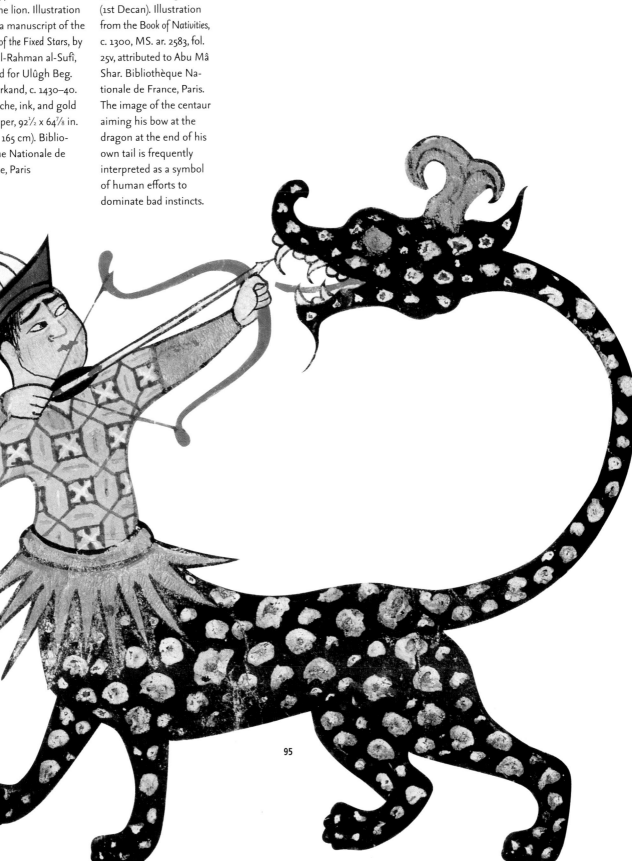

95

96. Right: The Hydra of Lerna, from the Labors of Hercules mosaic in the Villa Romana del Casale, Piazza Armerina, Sicily, late 3rd–early 4th century A.D. This depiction of the Hydra is unusual: it is generally depicted with several heads (between three and twelve).

97. *Below: Tumbler with a frieze depicting three "men-scorpions." Bactria, c. 2500 B.C. Chlorite, height 2¾ in. (7 cm). Musée Barbier-Mueller, Geneva*

98. *Opposite: Female centaur carrying a little draped girl on her back. Illustration from the Album of the Herculaneum Frescoes. Italian school, 18th century. Gouache on paper, 14⅞ x 19¼ in. (38 x 49 cm). Musée du Louvre, Paris*

this latter structure the panther with the tail of a fish that is depicted in a mosaic at the Villa of the Peacock (end of the first century A.D.; Musée de Vaison-la-Romaine, France).

The human-headed snake that appears first in Egyptian art (as a representation of the goddess Merseger), then in the fourth-century mosaics decorating the floor of the Villa Romana del Casale in Piazza Armerina, Sicily (plate 96), is another rare occurrence of a partly human animal. The snake in question (which sometimes has two heads, one at each extremity) subsequently became the Christian symbol of the demon: at least that was the function it fulfilled both in Renaissance paintings (by Hugo van der Goes, Lucas Cranach the Elder, and others) and in magical scrolls that were painted, until the twentieth century, by Ethiopian Christians.

Stranger, still more disquieting animals haunt Egyptian art (human-headed beetles) and the art of Central Asia (human-headed scorpions; plate 97), as well as African and Oceanic art. Small sculptures from Easter Island depict the bodies of reptiles or birds that have vaguely human heads (Musées Royaux d'Art et d'Histoire, Brussels). The Eskimos, for their part, carve minuscule human-headed seals in ivory (Baltimore Museum of Art). All of these objects, destined to house spirits, probably share the common function of fending off bad spells.

Finally, let us mention the nineteenth-century caricaturist Grandville. Known for his whimsy and sudden changes of mood, this artist depicted himself as a human-headed porcupine, while in the same drawing (Musée Historique Lorrain, Nancy, France) he mischievously depicted his wife, Henriette, as a harpy . . .

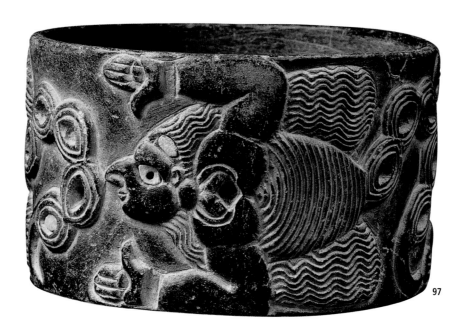

97

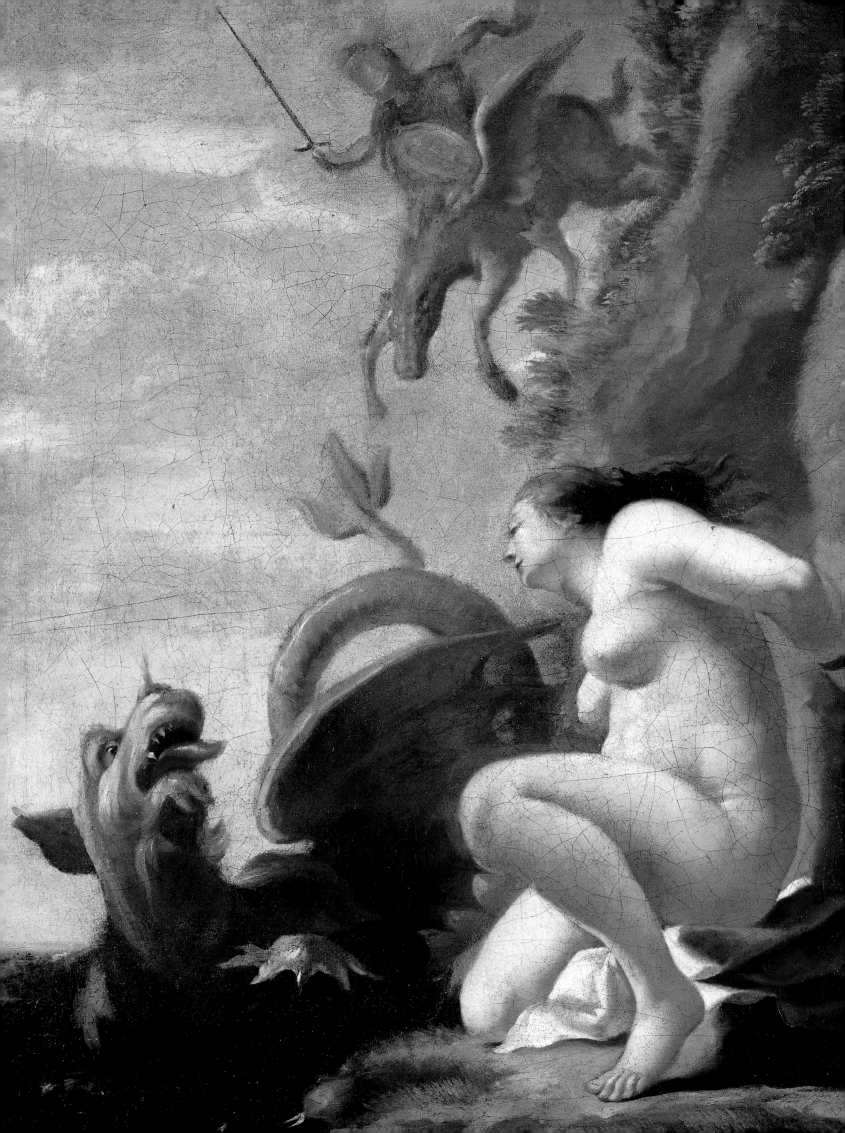

99. Pages 110–11: Jean-Auguste-Dominique Ingres (1780–1867), *Roger Freeing Angelica*, 1819. Oil on canvas, 58¼ x 74¾ in. (147 x 190 cm). Musée du Louvre, Paris. Here, Roger is riding on a hippogriff.

100. Opposite: Attributed to Jacques Blanchard (1600–1638), *Perseus Freeing Andromeda*, 1630–38. Oil on canvas, 20¾ x 18⅞ in. (53 x 48 cm). Musée Magnin, Dijon, France

101. Left: Winged horse. Dodon, Epire (Greece), third quarter of the 6th century B.C. Bronze, 5⅛ x 5⅛ in. (13 x 13 cm). Musée du Louvre, Paris

CHAPTER FOUR

Flying Quadrupeds and Dragons

UNLIKE THE UNICORN, which from the Middle Ages on was considered an incarnation of Christ, and unlike the animals we have just seen, those in this chapter have nothing human about them. As a result, their physical appearance varies considerably, according to the whims of the artists depicting them. However, in spite of the wide diversity of those variations, certain features remain fixed and unchanging.

THE FLYING QUADRUPED

What explains the universal and enduring popularity of the flying quadruped? Is it because its four legs call to mind the earthly strength of a bull, horse, or lion, while its wings give it an ethereal quality associated with an eagle or hawk? The fact remains that it is, with the sphinx, one of the dominant fantastic animals, whose popularity has not waned for five millennia. Whether it comes in the shape of a winged horse or a griffin, the flying quadruped appears in almost every major civilization.

One of the most successful visual inventions in Greek art was Pegasus, the winged horse. It sprang from the blood of Medusa, the gorgon beheaded by Perseus. It was tamed by Bellerophon, whose companion it became and whom it helped kill the Chimera (see the Roman mosaic from Autun; Musée

102. *Below: Antoine-Louis Barye (1795–1875), Angelica and Roger Mounting the Hippogriff, c. 1840. Bronze, with green patina, 20 x 27 1/4 x 11 3/8 in. (51 x 69 x 29 cm). Musée du Louvre, Paris. The hippogriff is born of the union between a mare and a griffin. According to Ariosto (Orlando furioso, 4.18), Roger rode one in order to save Angelica, just as Perseus rode Pegasus, according to some versions of the myth, in order to set Andromeda free.*

103. *Opposite: Winged ibex. Persia, Achaemenid period (6th–4th century B.C.). Silver handle (with gold inlays) from a ceremonial vase. Musée du Louvre, Paris*

des Antiquités Nationales, Saint-Germain-en-Laye, France), before being promoted to the rank of Zeus's own mount. Over time, Pegasus would also become known as the steed of the Muses and, beginning in the Renaissance, that of poets. Winged horses with fish tails were frequently depicted in Poseidon's procession, whether in Greco-Roman art or in Italian Mannerist and Baroque sculpture (as in bronzes attributed to Alessandro Algardi and Bartolommeo Ammanati at the Walters Art Museum, Baltimore). Another winged horse, called al-Buraq, is said to have transported the prophet Muhammad in his dreams and is well known among Muslims. We could also group with these various figures the Sleipnir of Northern European mythologies. The steed of the Scandinavian god Odin (or Wotan, according to the Germanic tradition), the Sleipnir does not actually have wings but does have eight legs that allow it to gallop quickly through the skies.

A lion with wings and the beak of an eagle, the griffin (called by the ancient Greeks *grups*, a word that resembles *gups*, meaning vulture) was first described in Hellenic literature by Ctesias. Previously, Aeschylus (*Prometheus Bound*, 804) and Herodotus (*History*, 3.116) had briefly mentioned it. To discover the origin of the griffin, however, one must travel back to the third millennium B.C. and to the fertile crescent of Egypt, Mesopotamia, and Iran. Here, we find, for example, a winged lion with the limbs (but not the head) of an eagle depicted on Sumerian cylinder seals.

These two basic models, though important, are far from being the only examples of flying quadrupeds. Crossing a mare with a griffin produced the grotesque hippogriff, evoked by Ariosto in his *Orlando furioso* (4.18; 1516–32) but depicted only on the rarest of occasions, as in a painting by Ingres (plate 99) or in a rather kitsch bronze by Antoine-Louis

102

103

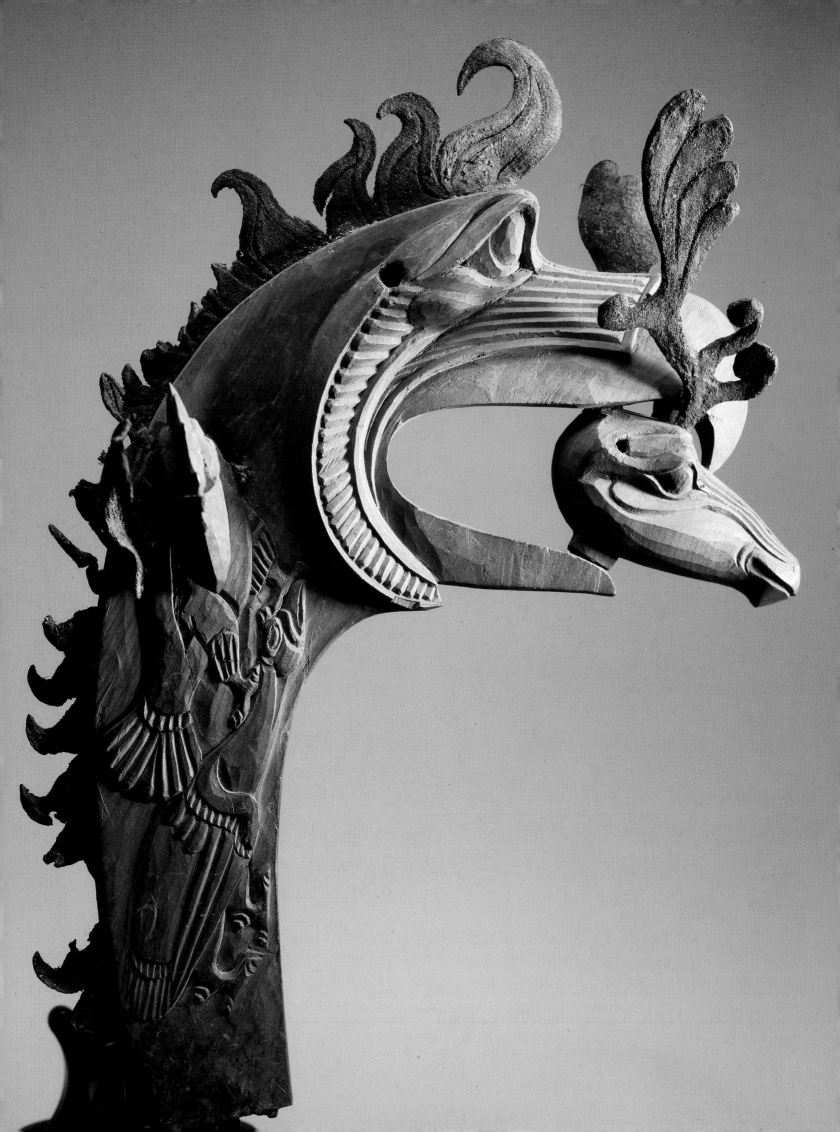

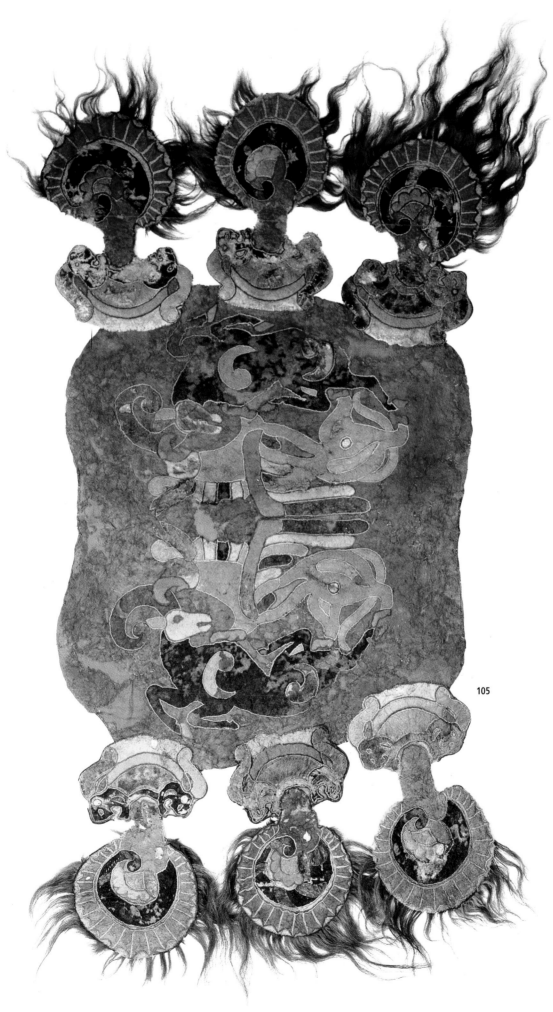

104

104. Opposite: Griffin holding a stag head in its beak. Kurgan no. 2 from Pazyryk, Russian Altai, 4th century B.C. Detail from a Scythian wood-and-leather harness piece, height 9 in. (23 cm). State Hermitage Museum, Saint Petersburg. This masterpiece gives us an idea not only of the inventiveness but also of the technical mastery that Scythian artists achieved in their representation of animal forms.

105. Left: Griffin slaying an ibex. Kurgan no. 1 from Pazyryk, Russian Altai, 4th century B.C. Scythian saddle blanket, with mountain-sheep-head decorations. Felt, leather, fur, hair, and gold, 46¾ x 23⅝ in. (119 x 60 cm). State Hermitage Museum, Saint Petersburg

105

106. Right: Attributed to Henri-Joseph Van Blarenberghe (1741–1826), *Muse and Pegasus*, 18th–19th century. Enamel, 14¾ x 28⅞ in. (38 x 74 cm). Musée du Louvre, Paris

107. Opposite: *Perseus Riding Pegasus to Free Andromeda.* Italian school, c. 1610–20. Oil on alabaster, 17¼ x 14⅛ in. (44 x 36 cm). Musée Bonnat, Bayonne, France

106

Barye (plate 102). As a matter of fact, the flying quadruped family is as vast as it is ancient.

One of the oldest specimens, which is all the more curious since it seems to be unique in its genre, is a small winged giraffe. Made of ivory and inserted in the wood of a funerary bed, it was found in the ruins of a cemetery in Kerma, the bygone capital of the Nubian kingdom of Kush, in the northern part of modern Sudan (c. 1750–1570 B.C.; Museum of Fine Arts, Boston). Unfortunately, we know nothing about its meaning.

We could also mention, in approximately chronological order: the horned griffins of the Phoenicians from Ugarit (fourteenth century B.C.); a Hittite winged lion with twinned heads of a man and a lion (tenth–ninth century B.C.; Museum of Ankara); the Assyrians' griffins and winged bulls (eighth century B.C.); winged bulls, winged ibexes (plate 103), and winged lions carved by nomadic bronzesmiths from Luristan (tenth–seventh century B.C.) and then by their heirs, the Persian artists from the Achaemenid dynasty (seventh–fifth century B.C.); Scythian griffins (sixth–fourth century B.C.; plates 104, 105, and 134); Greek griffins entrusted with protecting ritual cauldrons dedicated to Zeus or Hera (sixth century B.C.; plate 101); Etruscan griffins; griffins from Central Asia (fourth–third century B.C.); Punic griffins (third century B.C.), which are reminiscent of their Phoenician ancestors; the human-headed winged horse and the winged horned lion, each adorning the mouthpiece of one of the two Parthian rhytons (horn-shaped cups) that were discovered in 1948 near Ashkhabad (Turkmenistan, second century B.C.; on loan to The Metropolitan Museum of Art, New York); the winged horses of Chinese folklore (first century A.D.); the winged tigers (sometimes horned and bearded) that were "tomb guardians" in China, particularly during the Han (206 B.C.–A.D. 220) and the Tang dynasties (A.D. 618–907); Persian griffins during the Sassanid Empire; griffins painted on Egyptian ceramics from the Abbasid period (eighth–ninth century); and winged lions from the Fatimid period (tenth–twelfth century).

Focusing now on Christian civilization, the first thing to be said is that it borrowed shamelessly from all those preceding it. At the very least we should draw attention to griffins that are found in sculpture, on medallions, and on medieval and Byzantine reliquaries; the "locusts" (human-headed winged horses) illustrating the Book of Revelation (plates 16 and 18); the winged lion and ox that, from the early Middle Ages on, became symbols for the evangelists Mark and Luke (plate 17); a German drinking horn in the shape of a griffin's claw (Musée National du Moyen Âge–Cluny, Paris); and the winged horses and lions that seventeenth- and eighteenth-century painters and sculptors in Europe particularly liked to depict (plates 106–9). Closer to us, there is a disquieting quadruped that

107

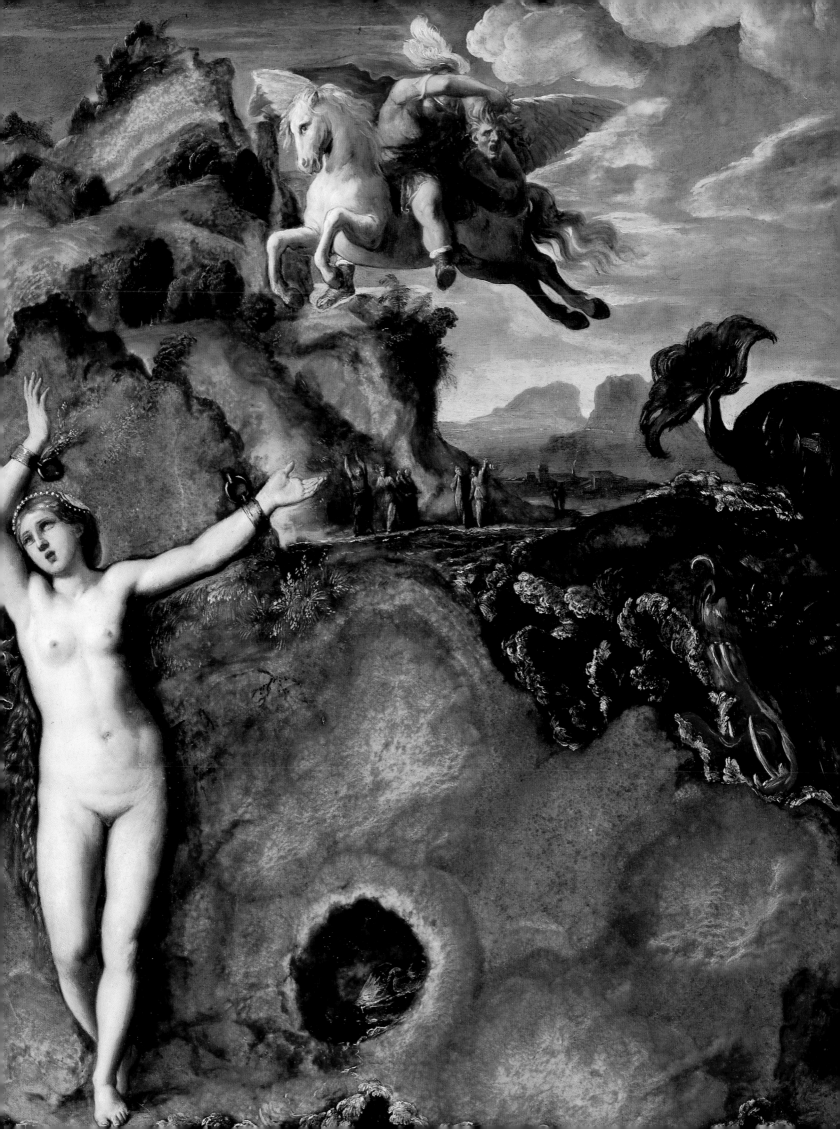

108. Below: Winged horse, by Cassien-Bernard and Alexandre Cousin, 1898–1900. Pont Alexander III, Paris

109. Opposite: Peter-Paul Rubens (1577–1640), Bellerophon (Riding Pegasus) Slays the Chimera, c. 1635. Oil on wood, 13⅜ x 10⅝ in. (34 x 27 cm). Musée Bonnat, Bayonne, France

was ironically nicknamed the *Angel of the Hearth* by Max Ernst (1937; Staatsgalerie Moderner Kunst, Munich). We should also mention the popular ceramics that are still being manufactured in the region of Teruel, Spain, and whose favorite motif is a griffin, originally borrowed by the master Domingo Punter from Arab potters in the Middle Ages (plate 170).

Even though this list does not pretend to be exhaustive, it does allow us to formulate two hypotheses: one about the geographical distribution of flying quadrupeds and the other about their symbolic function.

Geographically, the flying quadruped appeared, as we have noted, within the fertile crescent that, at the dawn of the third millennium B.C., witnessed the simultaneous birth of three great and inseparable inventions: writing, the city, and the centralized state. From there, it spread progressively toward the East (into Persia and China) and the West (into Asia Minor; Greece, where the griffin became Apollo's favorite animal; and Italy).

In both cases, its dissemination must have followed the main commercial routes—whether the

108

caravan trails such as the Silk Road, which connected the Sassanid and Chinese empires by the beginning of the Christian era, or the Mediterranean sailing routes that were successively used by Phoenician, Greek, Roman, Arab, and Turkish navigators. It is therefore not surprising to discover griffins on the tombs of Petra (in modern-day Jordan), the capital of the Nabatean kingdom, which was a prosperous trading hub for Asians and Romans during the first century A.D.; or winged lions in the ruins of the palace of Shabwat in Yemen, which lay at the heart of a South Arabian kingdom of the third century A.D. that also owed its fortune to trade.

In terms of function, it is not by chance that the birth of the flying quadruped coincides with the appearance of the centralized state embodied by the figure of the all-powerful leader, exercising strong spiritual as well as temporal power. By the end of the fourth millennium and the beginning of the third millennium B.C., such leaders appeared almost at the same moment at the head of the first Sumerian city-states (Uruk, Ur, Lagash, and so on) and at the head of the first kingdom unifying the lower and upper Nile Valley (First Dynasty) in Egypt. An absolutely new political and religious context was thus created, justifying the invention of appropriate new symbolism. Didn't the flying quadruped, since it had at once the bulk and strength of the lion (king of terrestrial animals) and the speed and elusiveness of the eagle (king of celestial animals), provide the best symbol of an omnipotence that could be exerted "on earth" as well as "in heaven?"

If the latter hypothesis is indeed true, it helps explain the proliferation of flying quadrupeds (in particular the griffin) in Assyrian, Persian, and Chinese civilizations—three worlds where a strong centralized political power always strived to present the most impressive image of itself. We could similarly interpret the first Muslim caliphs' fondness for griffins and winged horses (for example, a winged horse dominates the reception hall of the bathhouse in the Umayyad palace of Khirbat al-Mafjar, built in the eighth century in Jericho for

1

110. *Below: Dante and Virgil Watch the Serpent Seizing Agnello. Illustration from a manuscript of Dante's Divine Comedy, accompanied by commentary by Fra Guidone of Pisa; Inferno, canto XXV, fol. 169v. Sienna, c. 1328–30. Illuminated manuscript on parchment, 12⅞ x 9⅜ in. (33 x 24 cm). Musée Condé, Chantilly, France.* The Florentine Agnello dei Brunelleschi was an infamous robber who was condemned, in Dante's poem, to eternal punishment.

111. *Opposite: Andrea Mantegna (1431–1506), Parnassus (detail), 1497. Tempera on canvas, 23⅝ x 75⅝ in. (60 x 192 cm). Musée du Louvre, Paris.* Mount Parnassus, in central Greece, was dedicated first to Dionysos and then to Apollo; in late antiquity it became the mythical home of the Muses, who inspired poets and artists.

the caliph Hisham). The fact that we rarely find flying quadrupeds of any kind (and never a griffin) in the preliterate societies of Amazonia, black Africa, or Oceania also seems to support our hypothesis, since these societies long sought, by any means necessary (including war), to prevent the establishment of a centralized state likely to threaten individual liberty.

As to the Christian West, from the moment it appropriated the oriental griffin, it conferred a religious meaning on it. For Saints Basil and Ambrose, this animal became the emblem of Christ. As Isidore of Seville explains in his work *The Book of Etymologies* (seventh century), Christ is indeed "a lion because He rules and has power; an eagle, because after resurrection, He ascends to Heaven." In canto 29, verses 112–14 of *Purgatory*, Dante recalls a triumphal chariot pulled by a griffin, the eagle part being golden and the lion part being white mixed with blood (the color of flesh)—which led commentators to see it as a symbol of the dual nature of Christ, both divine and human.

Between the twelfth and the fifteenth centuries, however, there occurred a development we have already mentioned: in an effort to control society more effectively by "moralizing" it, theologians began emphasizing the distinctions between

man and animal. Bestiality was linked in Christian doctrine to the sins of lust and henceforth associated with the devil, whose image, without being completely dehumanized, became black in color and progressively bestial from the twelfth century onward, with features such as horns, a tail, cloven-hoofed feet, and abundant hair. As a result, no animal—with the exception, imposed by the official interpretation of biblical scriptures, of both the unicorn and the lamb—was authorized from then on to represent Christ.

The griffin eventually lost all religious meaning and was transformed into a simple ornamental motif in the art and architecture of Western courts. A stereotypical symbol of temporal (but no longer spiritual) power, it became a mere decorative element on thousands of pieces of furniture, earthenware, fabrics, tapestries, rugs, and of course coats of arms of European rulers, who were always eager to give an aura of majesty as well as a legendary justification to their often questionable authority. This is just one example of how the great myths of the past end up embodied in decorative forms, long after men stop believing in them.

110

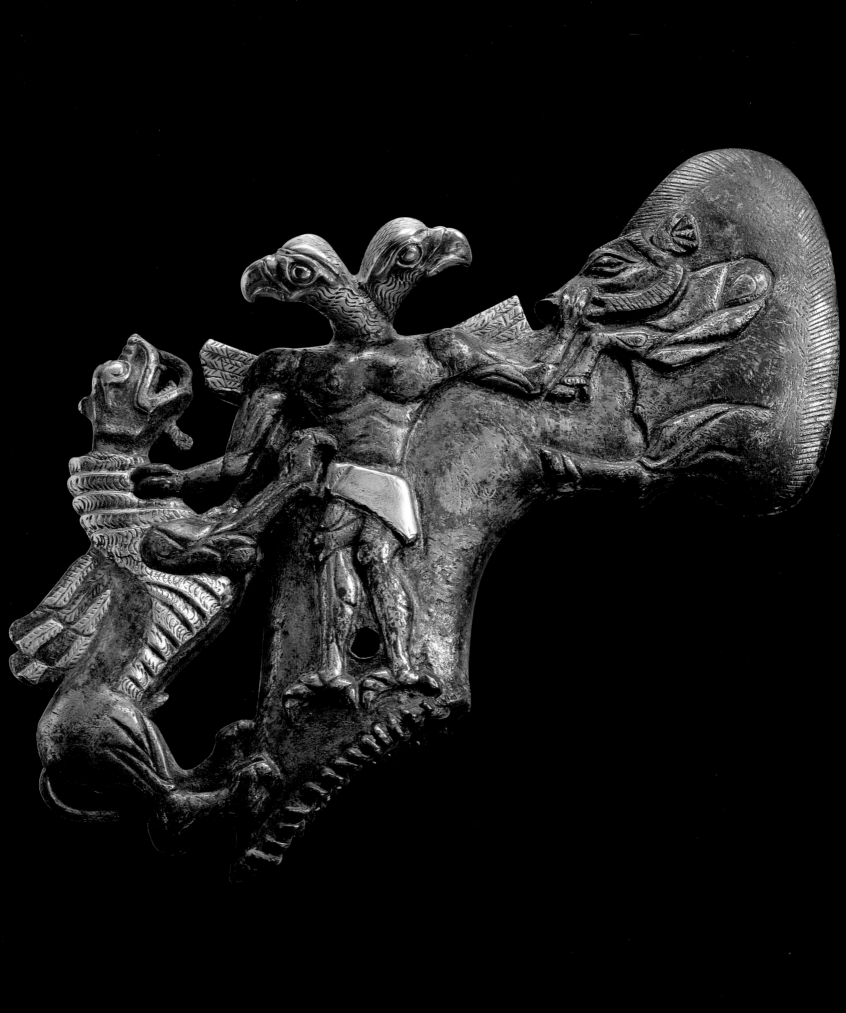

112. Opposite: Shaft-hole ax head with bird-headed demon, boar, and dragon. Bactria, late 3rd–early 2nd millennium B.C. Silver with gold foil, height 5⅞ in. (15 cm). The Metropolitan Museum of Art, New York. Purchase, Harris Brisbane Dick Fund, and James N. Spear and Schimmel Foundation Inc. Gifts, 1982 (1982.5)

113. Left: King Gudea libation vase, dedicated to the god Ningishzidda. Tello (Mesopotamia), Neo-Sumerian period (c. 2150 B.C.). Steatite, height 9 in. (23 cm). Musée du Louvre, Paris. Standing on the right is a snake-headed divinity wearing a tiara with horns and holding a kind of scepter: this might be the oldest known representation of a dragon.

THE DRAGON

Like many other fantastic animals, the dragon seems to have been invented in Sumer. The Louvre has in its collection a libation vase originating from Telloh (ancient Girsu, in the Sumerian state of Lagash) and dating back to c. 2150 B.C.; on this vase is depicted a human-headed winged snake, wearing the horned tiara peculiar to the Mesopotamian gods (plate 113). This could be the oldest-known depiction of a dragon. Since the vase in question belonged to a prince, this dragon could also be, like the griffin, a symbol of royal omnipotence.

Because temporal and spiritual power were inextricably interwoven in the ancient Near East, it is not surprising to find a dragon on a magnificent sacrificial ax (plate 112) from late third millennium to early second millennium B.C. Bactria (north of modern-day Afghanistan). In this instance, though, the symbolic value of the dragon has been reversed. This silver ax shows a winged bird-headed demon taming a boar with his left arm

while he immobilizes a winged dragon with his right. This scene could be interpreted as a deity imposing its law on material forces agitating the cosmos, and it might be one of the first images illustrating the triumph of good over evil.

The dragon subsequently became a ubiquitous figure in world art and folklore. And yet this ugly snake endowed with horns, legs, and claws—which might have one head or several, one tail or several, which might have wings and breathe fire, and might even be able to turn into a sea monster—never managed to acquire a fixed or determined shape, even within a stable cultural context.

Let us consider, for instance, Greek mythology between the eighth century (the period when Hesiod wrote his *Theogony*) and the fourth or third century B.C. Within this limited space and within this restricted time frame, we encounter multiple varieties of dragons, which cannot possibly be schematically reduced to a single type. Without even mentioning the sea dragon slain by Perseus, a dragon that Piero di Cosimo strangely depicted with the tusks of a walrus (plate 115), Hesiod's pantheon presents at least two great sets of monsters that bear no resemblance to each other, although they do share certain family ties and formal characteristics associated with the dragon (a word that, in Greek, designates a snake with impressive proportions, as opposed to the "normal"-size snake, *ophis*).

The first set comprises the offspring of the incestuous union between Phorkys and his sister Keto (who are themselves the products of an incestuous relationship between Gaea and her son Pontos). We find in this set the snake that, at the other end of the world, guards the garden of the Hesperides; a certain Echidna, having the torso of a woman and the lower body of a snake; and the three Gorgons, who are subsequently described (by Aeschylus, Apollodorus, and others) as winged women with serpent-entwined hair, sharp teeth, and claws. Among the three sisters, Medusa was by far the most fearsome and notorious, turning the

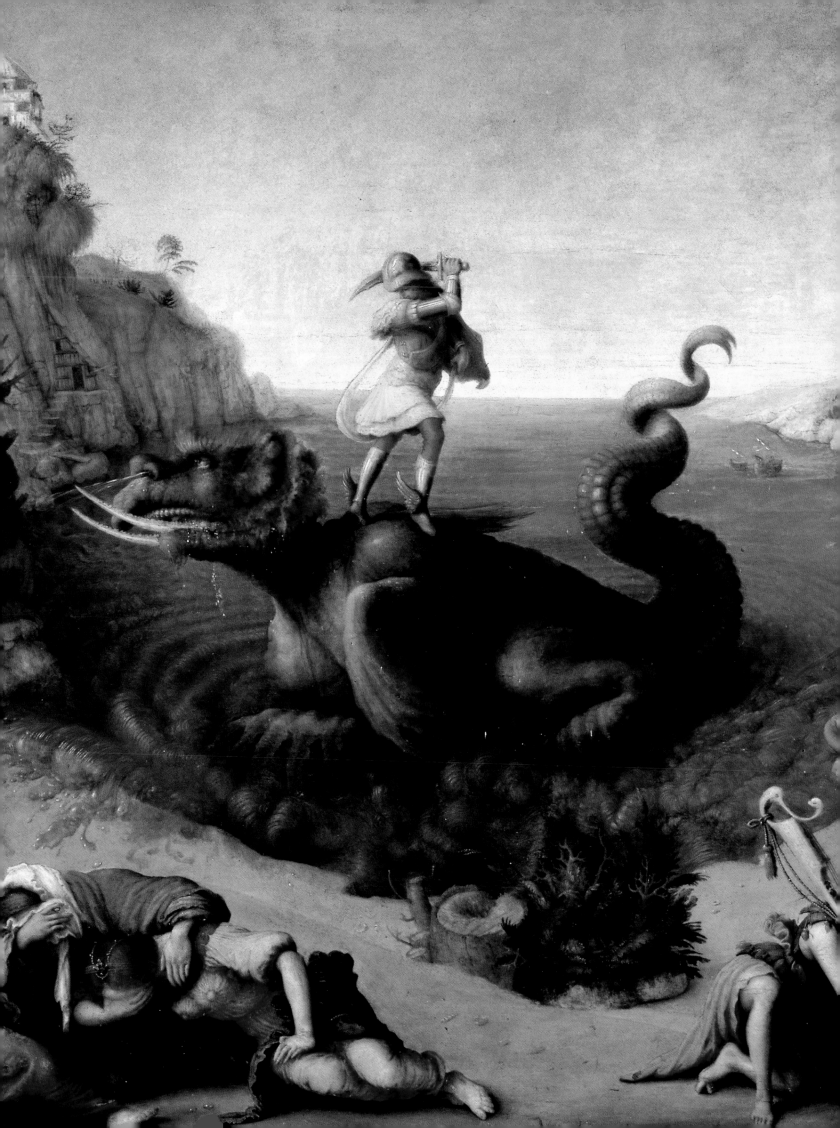

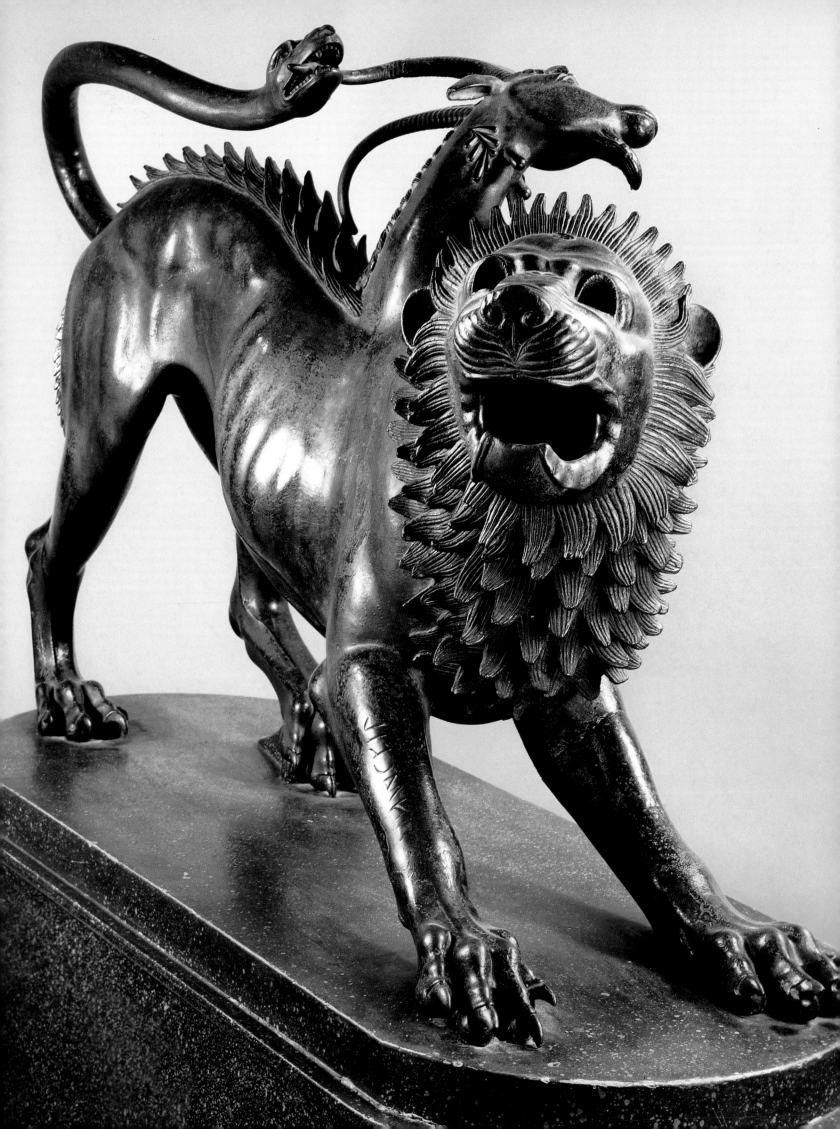

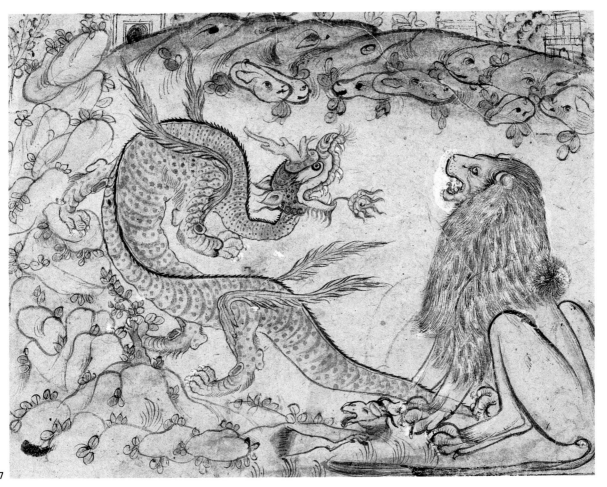

117

116. Opposite: Chimera. Arezzo, Tuscany (Italy), 5th–4th century B.C. Museo Archeologico, Florence. Inspired by a Greek model, this bronze statue was probably a votive offering to an Etruscan deity, as suggested by the inscription carved on the right foreleg. The discovery of the Chimera of Arezzo in 1553 constituted an important event that helped stimulate interest in Etruscan art and, consequently, Tuscan nationalism.

117. Left: Hamid Umrani (1663–1721), Lion and Dragon in a Rocky Landscape, c. 1700. Bikaner, Mughal India. Brush and dark gray ink, heightened with white gouache and some dashes of color, 5½ x 6⅝ in. (14 x 17 cm). Institut Néerlandais, Collection Frits Lugt, Paris

onlooker into stone (one should recall that *drakôn* is related to a verb meaning to stare). A terrifying figure and a metaphor of castration, the head of Medusa, cut off by Perseus the dragon-slayer, became the emblem of Athena's shield; this is why we often find it on Athenian coins. The theme enjoyed renewed interest from the Renaissance on (see, for example, Benvenuto Cellini's sculpture, 1545–53; Loggia della Signoria, Florence).

As far as the second set mentioned by Hesiod is concerned, it is the offspring of the union between the above-mentioned Echidna and Typhon. It includes the Hydra of Lerna, the Chimera, and the dogs Orthos and Cerberus. According to Hesiod, Typhon, the father of these charming creatures, is himself a particularly ghastly sight. He is a protean monster in his own right, born from the primordial couple of Tartarus (hell) and Gaea (the earth); from his shoulders spring one hundred serpentine heads hissing dreadfully, with eyes flashing fire (*Theogony*, 824–30).

The Hydra of Lerna (plate 114) is a foul-smelling dragon with multiple heads (estimates range between three and twelve), which grow back as soon as they are cut off. It is ultimately killed by Heracles.

The Chimera, which was ultimately slain by Bellerophon, is a three-headed quadruped vomiting flames, with the head of a lion up front, the head of a goat in the middle, and the head of a serpent at the end of its body (others say it has a lion's head, a goat's body, and a serpent's tail). It is understandable that this hodgepodge animal was so hard to depict that it aroused little interest among artists. Nonetheless, the Chimera from Arezzo (plate 116) is one of the masterpieces of Etruscan sculpture. And the Chimera decorating the *Libro di modelli per artisti Armeni* (beginning of the sixteenth century; San Lazzaro, Mekhitarist Library, Venice), which consists of an assemblage of other animals, recalls the most audacious inventions by the Mannerist painter Arcimboldo (who himself drew dragon costumes for masked balls).

116

118. Right: Mushhushshu (fearsome snake). Detail of an enameled brick frieze from the Ishtar gate in Babylon, period of Nebuchadnezzar II (early 6th century B.C.). Baghdad Museum, Iraq

119. Opposite, top: Dragons. Cloth from Vietnam, 19th century. Musée de l'Homme, Paris

120. Opposite, bottom: Large circular plate, decorated with a feiyu (dragon-fish) and chrysanthemums. North Vietnam, Lê period (16th century). Ceramic with cobalt blue, red, and green enamel. Musée National des Arts Asiatiques–Guimet, Paris

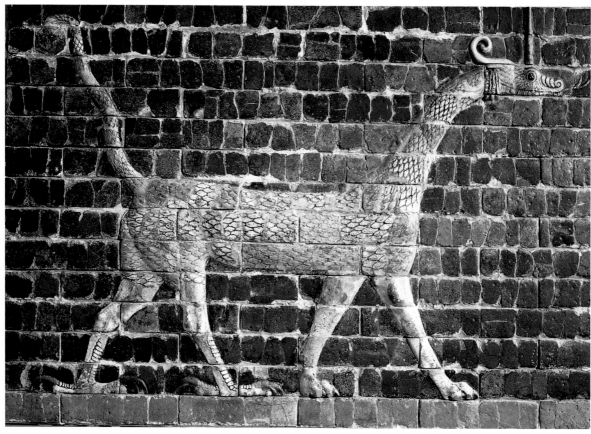

118

The two-headed dog Orthos, through its union with its sister Chimera (or its mother, Echidna, Hesiod's text being obscure on this particular point), gives birth to the female Theban sphinx and to the Nemean Lion. And finally, there is Cerberus, the ferocious fifty- or hundred-headed dog with razor-sharp teeth and a serpent tail that guards the entrance of the underworld in order to prevent the living from entering and the dead from escaping.

Shakespeare, who knew ancient art well and who was fully aware of the way Italian Mannerists of his times recycled it, rightfully observed that the appearance of dragons shared, with that of clouds, an extreme fluidity: "Sometimes we see a cloud that's dragonish" (*Anthony and Cleopatra*, 4.14). Is the dragon the polymorphic expression of our darkest reveries, our most reprehensible drives? Its reptilian nature, linked to images of the subterranean world, might induce us to think so.

The dragon may be a nightmarish animal, but nightmares are sometimes necessary to drive away evil. In any event, the dragon is ambivalent, as is the case with many other fantastic animals and with the sacred in general. As a nasty creature, it can scare innocent people, lead them into temptation, and even treacherously profit from the postmortem ceremony of weighing the soul in order to lure the righteous person into hell. In this case, there is no other solution than to kill this diabolical demon, as Saint George did, according to the Christian tradition (the heroic deed supposedly took place on the site of present-day Beirut), and as Rustam did in ancient Persian legends.

But there is also a good dragon, one that uses its strength to terrorize evil, drive away enemies, and protect princely homes and tombs as well as religious buildings. Let us not forget the Roman legions, whose emblem was the dragon; nor the Vikings' long ships with dragon figureheads; nor the dragon regiments of the armies of the ancien régime in France, whose legendary courage was unfortunately tarnished by the acts of violence, the famous "dragonnades," that they committed against the Protestants during the reign of Louis XIV.

In short, the behavior of the dragon is as unpredictable as its appearance. And it is probably

119

120

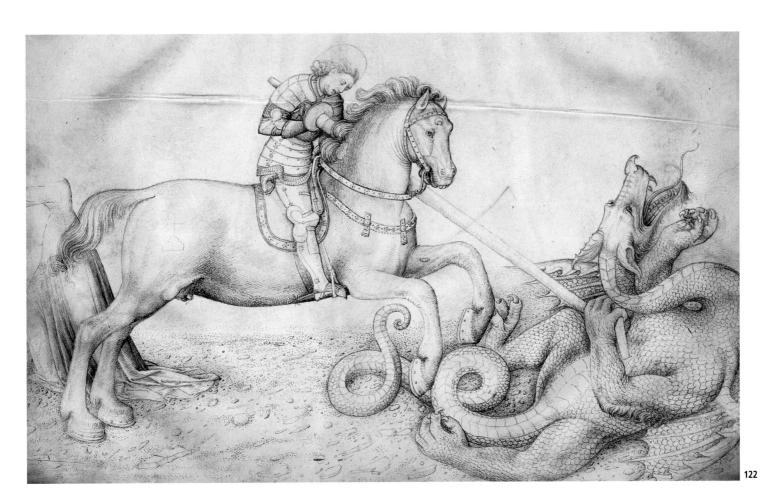

122

thanks to its shape-shifting that the dragon proliferated in all civilizations.

In Asian Art

At the time of Nebuchadnezzar II (605–562 B.C.), *mushhushshu* (fearsome snakes) decorated the Ishtar gate at the entrance to Babylon (plate 118). This horned animal—which has the head, neck, and body of a snake, the forelimbs of a lion, and the hindlimbs of a bird of prey—seems to have been associated with Marduk, Babylon's protective deity. It is vaguely reminiscent of the monster with the jaws of a crocodile, the forelimbs of a lion, and the hindquarters of a hippopotamus that, on the Papyrus of Ani (Nineteenth Dynasty; British Museum, London), awaits the wicked in hell in order to devour their hearts.

We can find other dragons (which were also entrusted with the task of fighting the forces of evil) in Achaemenid Persia (plate 135); in the Hellenic world, in particular in the form of the sea monster accompanying the Nereid Tethys on Anti-

och mosaics (third century A.D.; Baltimore Museum of Art); in the Muslim world; in India (plate 117) and in all of the region under the influence of Hinduism where *nagas* (serpent-people) proliferate; in China (plates 127 and 128); in Korea; in Vietnam (plates 119 and 120); and in Japan, where the dragon, up to this day, still inspires the creation of *netsuke*, small objects carved in wood or ivory that are highly prized by collectors.

In Christian Art

The dragon appeared very early in Christian art, derived from both Asian and Celtic models. For example, the ram-headed serpent accompanying the Celtic god Cernunnos (lord of the forest and animals) on a silver plate decorating a cauldron found in the region of Gundestrup (first century B.C.; Nationalmuseet, Copenhagen) is a type of dragon. The singularity of the Christian dragon is nevertheless undeniable, given that Christian theology equated the dragon with the devil, as shown in Byzantine, Melkite

121. Opposite: Paolo Uccello (1397–1475), *Saint George Fighting the Dragon* (detail), c. 1439–40. Tempera on wood, 20¼ x 35⅛ in. (52 x 90 cm). Musée Jacquemart-André, Paris. Uccello painted two different versions of this theme. In the second, which dates from a later period (c. 1455–60; National Gallery, London), the wings of the dragon seem to be covered with strange, colorful rosettes, perhaps inspired by oriental carpet motifs.

122. Above: Jacopo Bellini (1400–1470/71), *Saint George Fighting the Dragon*, 1461. Pen on vellum, 11⅜ x 16½ in. (29 x 42 cm). Musée du Louvre, Paris

Let us also keep in mind the continuation of this iconography into the twentieth century. For over a thousand years now, depicting Saint George or Saint Michael slaying the dragon has given Western painters and sculptors the opportunity to exercise both their imagination and their virtuosity. In the course of these exercises, many artists have distinguished themselves for the excellence of their productions, from the Limbourg brothers and Paolo Uccello to Gustave Moreau and Félix Vallotton, through Bellini, Pollaiuolo, Leonardo, Carpaccio, Raphael, Juan de Flandes, Tintoretto, Salvator Rosa, and so on (plates 121 and 122).

In the Rest of the World

In black Africa, protective spirits frequently take the form of the snake. Among the Baga in Guinea, for instance, the primordial spiritual force called Mantsho-na-Tshol ("master of all remedies") is supposed to be embodied in a brightly colored sculpture representing a huge sea serpent.

We can also find different varieties of dragons in New Zealand and in Indonesia, in particular in Borneo, Nias Island (plates 123 and 146), and Sumatra (plate 124). Carved on the beams of Batak houses (Sumatra, Lake Toba region), the *singa*—an animal associated with the great serpent holding up the earth, which is endowed with horns, the muzzle of a horse, and an undulating tongue—watches over the members of the household (or, when it is sculpted on a funerary stele, the deceased). On Nias Island, the *lasara* is a dragon whose head adorns traditional daggers and seats ritually used by noblemen during a ceremony known as "the feat of merit." The seats are also decorated with the tail of a bird, making them symbols of the union between the natural and the supernatural worlds; this motif reappears in some of the paintings made in 1939 by the Romanian Surrealist painter Victor Brauner. Finally, Quetzalcóatl—one of the oldest and most important deities of the Indians in central Mexico, whose cult reached its

123

123. Above: Osa-osa stone sculpture depicting a *lasara* dragon, erected during a "feat of merit" (*owasa*). Nias Island (Indonesia), 19th century. Musée Barbier-Mueller, Geneva

124. Opposite: House-facade ornament representing a *singa*. Batak People, Lake Toba region, Sumatra (Indonesia), 20th century. Painted wood, height 50 in. (127 cm). Musée Barbier-Mueller, Geneva

(plate 182), or Slavic icons, as well as in sculptures (gargoyles) and illuminated manuscripts (plate 56) produced throughout Roman Catholic Europe.

These works attest to the evolution of the dragon's formal image over the course of centuries. From a simple serpent without wings or legs in Romanesque art (see the cloister of Moissac), the dragon gradually acquired, in Gothic art, scales, a crest, and even the membranous wings of a bat. Most historians acknowledge today that these bat wings were borrowed from Chinese representations of evil demons (*demons* and not *dragons*, since Chinese and Asian dragons, in general, never have wings).

apex in the Aztec Empire on the eve of the Spanish conquest—is nothing else than a plumed serpent—in other words, a winged dragon.

❦

IF THE DRAGON seems to be something of a universal figure, it still owes the greater part of its existence to Chinese civilization, which has represented it for more than two thousand years as a legged serpent, covered with scales and sometimes bearing a dorsal or jagged crest. Unlike the European dragon, however, which was associated with the forces of evil, its Chinese cousin is essentially a good omen. This is why the five-clawed celestial dragon, likened to a constellation, has been considered since the Han dynasty to be the ancestor and the emblem of the emperor; in a similar manner, the phoenix, king of the birds, is viewed as an em-

blem of the empress. It should also be noted that in China, terrestrial or subterranean dragons—which are the keepers of hidden treasures—have only four claws (like Korean dragons); Japanese terrestrial dragons have only three.

The Ming dynasty (1368–1644), which was preoccupied with grounding its legitimacy in a remote past, keenly encouraged the spread of the dragon and the phoenix in decorative arts, starting with the decoration of porcelain, clothes, musical instruments, and weapons. But the dragon, thought to make the rains and hence associated with the rivers and lakes that are the source of life, is not only an emblem of power. It is also a symbol of wisdom, prosperity, and perfection. In this capacity, it plays a major role in New Year festivities (especially during the beneficial Year of the Dragon, which recurs every twelve years) and

125. Opposite: Tomb guardian—a spirit in the Buddhist religion. China, Wei period (first half of the 6th century). Terracotta sculpture with traces of polychrome, height 8¼ in. (21.5 cm). Musée National des Arts Asiatiques–Guimet, Paris

126. Below: Daniel Rabel (1578–1637), *Alizon the Cantankerous and Her Dragon*, from the *Album de Ballet de la Douairière de Billebahaut*, c. 1625. Pen, brown ink, and watercolor, heightened with silver and gold, 11 x 17¼ in. (28 x 44 cm). Musée du Louvre, Paris

125

126

127. Below: Ceramic bowl with dragons and cloud decorations. China, Ming dynasty (1368–1644), reign of Hongxi (c. 1425). Musée National des Arts Asiatiques–Guimet, Paris. After hundreds of years of evolution, the art of Chinese porcelain reached new heights during the Ming dynasty.

128. Opposite: Dragon. China, Yuan dynasty (1279–1368). Detail from a ceramic plate. Musée Adrien Dubouché, Limoges, France. The Yuan era began the classical age of Chinese porcelain. Large vases and dishes, decorated in white and blue, were mostly exported to Japan, Iran, and the Middle East.

receives propitiatory offerings in numerous sanctuaries. It is, moreover, linked to active, luminous, and salubrious values—symbolized by the yang (masculine principle) as opposed to the yin (feminine principle, to which the white tiger symmetrically corresponds).

If the Chinese dragon is frequently symbolically depicted fighting other animals (as in countless rugs and tapestries), the theme of man combating a dragon is inconceivable in the arts of the Far East. Likewise, in the Muslim regions of Central and Western Asia, where several features of Chinese civilization spread with the Mongol invasions, the dragon—in the form of the *senmurv*, which has the head of a dog and the tail of a peacock and was probably invented in Sassanid Persia (plate 137)—retained a propitious meaning.

In Christian Europe, on the contrary, the dragon was vanquished by Heracles (according to Greek mythology) and linked to the devil (in the Book of Revelation); the serpent, from which it derives, was already associated with the devil in Genesis. Defeated many times in medieval folk tales by a "solar" hero whose mission was to free a princess or recover a treasure, the dragon for the most part has been viewed as a malicious creature. It has even become faintly ridiculous in the modern era. Fairytale dragons are often more comical than terrifying, and so are the dragons in Hollywood movies jammed with special effects, like the flying dragons in *The Lord of the Rings*. Others are purposely

eroticized, like the "Dragon Lady" in *Shrek*. Neither has contributed much to the species' reputation.

Borges was thus right when he wrote in his *Book of Imaginary Beings* that the dragon is "perhaps the best known but also the least fortunate of fantastic animals" (at least in the West). Yet we should not slip into an anachronism: the fact that Europeans have long believed in the physical reality of the dragon is clear from numerous popular legends. Deeply rooted in time immemorial, these rural legends remind us of the terror induced not only by the dragon, strictly speaking, but also by animals closely related to it. The wyvern, which is the English equivalent of the French *vouivre* (from the Latin *volvere* which means "to roll," or "to roll about"), is also a two-legged creature—bird in its upper part and snake in its lower part. Central to folktales of the Jura Mountains in the east of France, the wyvern fed on human flesh and in particular on the flesh of men who vainly tried to steal its eye, a precious stone endowed with supernatural powers. The basilisk (or *basilicoq* in old French) is a cockerel with the tail of a dragon (or a snake with the head and wings of a cockerel). Capable of striking down with a single glance whoever is unfortunate enough to cross its path, it was frequently used during the ancien régime in France as a symbol of royal power. The cockatrice, finally, is a huge basilisk that, like the latter, is hatched from an egg sat on by a toad.

Such creatures no doubt inspired, for centuries, an incredible terror among travelers who had the misfortune of getting lost, at the end of the day, in deep woods or on a remote path. One can also understand—by meditating upon the strange alliance they embody between reptile and bird, underworld and sky—the fascination they exercised on the collective imagination. Like the hawk-headed crocodile of the ancient Egyptians, the dragon reconciles the most irreconcilable opposites. As a totally ambivalent animal, it is also, for this reason, the fantastic animal par excellence.

127

131

129. Pages 140–41: Dirck Bouts (c. 1420–1475), *The Fall of the Damned* (detail), c. 1450. Oil on wood, 45¼ x 27⅛ in. (115 x 69 cm). Musée des Beaux-Arts, Lille, France

130. Opposite: *Makara* (dragon). Twelfth-century sculpture in yellow sandstone found on the Thap Mâm site, Binh Dinh province (Vietnam). Musée National des Arts Asiatiques–Guimet, Paris. The sculptor rendered in minute detail the ornamental details adorning this *makara*—a dragon that heralds abundance and fertility.

131. Above: Triton and Nereid. Detail from the ceiling of the Spioncino Hall, Palazzo Vecchio, Florence. Decoration attributed to Tommaso di Battista del Verrochio.

CHAPTER FIVE

Influences or Coincidences?

I N THE PREVIOUS two chapters, we have identified a few stable structures within the profusion of fantastic animals offered by world art. Certain types among them—the griffin, for instance, one among many of the "flying quadruped" structure—seem to appear again and again, in identical form, in the most diverse civilizations and the most distant eras. Such coincidences, although undeniable, are not easy to explain. How can two artists living centuries apart, in totally different cultural contexts, produce the same forms, which are neither simple nor obvious?

In this chapter, we shall give two different, but not incompatible, answers to this question. The most immediate answer consists in demonstrating that it is not always a coincidence, but rather a direct or indirect influence exercised by one artist on the other. A second, more speculative answer would be that such recurrences are indeed a matter of coincidence in certain cases but that, far from being the result of chance, these could be perceived as the result of certain immutable, logical, or psychological laws.

THE PLAY OF INFLUENCES

When, during the half century separating the 1880s from the 1930s, Gustave Moreau sketched a

unicorn (plate 68), Fernand Khnopff a sphinx (plate 183), Antoni Gaudí a dragon (plate 132), and Pablo Picasso a minotaur (plate 133), they did not invent the animals in question. They merely borrowed them from a very ancient tradition to which they deliberately added a new chapter. Such a process is not at all exceptional. Most world art does, in fact, recycle themes and combinations of forms whose origins may go back several centuries. In most civilizations no one finds fault with such reuse and it is understood that the originality of an artist resides less in the subject than in how that subject is treated.

Going further, one could even define artistic activity as an exercise in variation on themes. Doesn't the belief that art has no other content than art—and painting, no other raw material than paintings from preceding centuries—underlie the work of several twentieth-century artists, beginning with Picasso? Picasso was not satisfied with merely reinterpreting works by Diego Velázquez, Eugène Delacroix, and Edouard Manet; he also reinterpreted Greek vase painters, Romanesque fresco masters, and African artists. Moreover, each of Picasso's exercises in rereading or rewriting gave rise not only to one or two variations but also to a series within which each variation holds a specific place, determined by an internal coherence. Thus,

Picasso rewrote Velázquez's *Las Meninas* as many times as there are characters in the painting, including the dog—each character providing a distinct point of view.

It is, however, important not to fall prey to the illusion that anything modern is new. If Picasso put the notion of series at the center of his work, in the same way that Arnold Schoenberg placed it at the heart of his theory of musical composition, and if in doing so, both did indeed help invent modernity, their modernity was not born ex nihilo. One could claim that Picasso invented serialism, that is, the systematic use of the series or the variation on a theme; however, he certainly did not invent the concept of the series nor the idea of variation, both of which had been known for a long time. Didn't the artists of the Upper Paleolithic period, when they covered the walls of the caves in the Périgord with herds of reindeer or bison in one cave after another, already demonstrate their mastery of the series?

Repeating with one small change in detail, reproducing while distorting what is being reproduced, quoting or making a pastiche just for the sheer pleasure of it or for the pleasure of not being detected: these are all common artistic practices. It should therefore be no surprise to find the creators of fantastic animals (as well as landscape or history painters, for instance) indulging in them. And, from this point of view, one can understand how futile it would be to try to re-create, through a detailed analysis of a particular fantastic animal, a comprehensive list of all animals that have served as its models or played a role in its genesis. Beneath each of Picasso's variations on the theme of the Minotaur, there is not only the whole family of minotaurs that have preceded it in the history of European painting but also the whole universe of world art, which Picasso has absorbed and recycled.

Yet if this form of recycling is common among cultured artists such as Picasso, Gaudí, and Moreau,

132. *Below:* Dragon. Detail from the Park Güell stairs in Barcelona, executed between 1900 and 1910 by Antoni Gaudí (1852–1926). The use of small mosaic pieces to cover this dragon seems to look back to the Byzantine mosaic tradition, but also ahead to the Cubist use of collage.

132

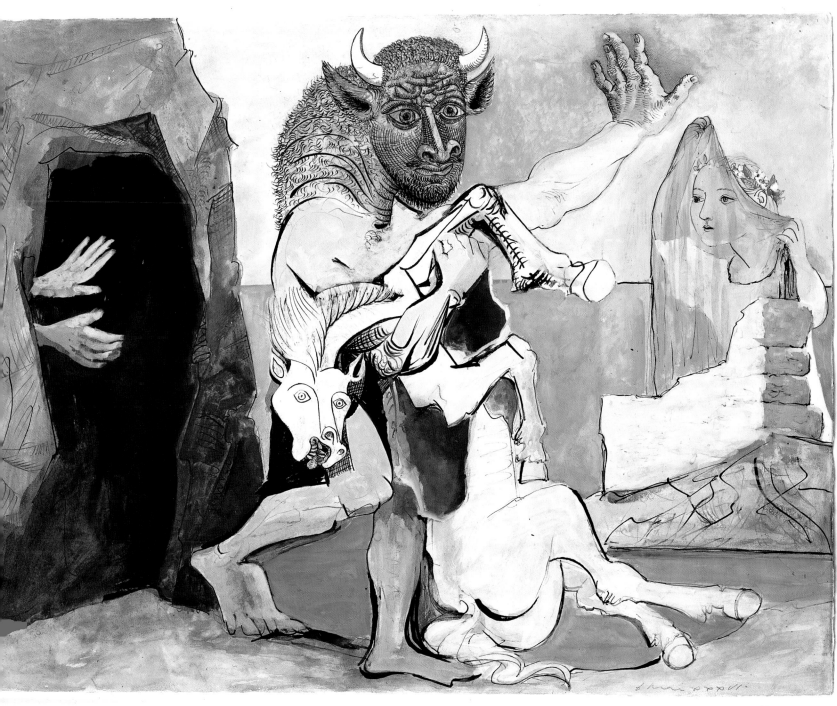

133. Above: Pablo Picasso
(1881–1973), *Minotaur and
Dead Mare Outside a Cave,
with Veiled Girl*, 1936.
Gouache and India ink,
19¾ x 25½ in. (50 x 65 cm).
Musée Picasso, Paris

134

134. Above: Walking griffin. Alexandropol Kurgan (Ukraine), 4th century B.C. Scythian perforated shaft top with hand bells. Bronze, height 6 in. (15.5 cm). State Hermitage Museum, Saint Petersburg

who had easy access to libraries and museums, isn't it confounding to encounter such recycling by artists who live in societies without either, who may not even know how to read and write, and yet who display a deep familiarity with works belonging to remote cultures?

There is unfortunately no general explanation for this perplexing phenomenon. Nevertheless, specialists in the history of art can, in some cases, piece together the chain of links by which one artist might have influenced another belonging to a different culture and era.

This concept of influence presents a major drawback because it seems to imply passivity on the part of the influenced artist in relation to the one exercising the influence. Yet this is not at all the case. One never *submits* to an influence; one *chooses* it. Moreover, no artist works in total isolation. No matter what societies they belong to, artistic creators are always interested in what their peers within the community are doing and, as much as possible, in what artists from other communities are doing as well. Curiosity, the desire for self-improvement, and the taste for emulation are enough to explain this interest. Yet the extent to which it can be satisfied remains to be determined.

In the age of the Internet this interest can be fulfilled virtually without limits, but one would be wrong, of course, to assume that artists before the Internet did not communicate with one another. Admittedly, it wasn't always so easy to gain access to the great imaginary museum of world art, later envisioned by André Malraux, but it was far from being impossible. As proof, just think about the important role played in the history of humanity by three major forces: travel, commerce, and war.

Whether nomadic by culture, or forced by circumstances to undertake vast migrations, or simply propelled by a taste for adventure, humans have always traveled—and artists especially so. Indeed, in most civilizations, artists depend on commissions from clients, and in order to expand

their network of clients they need to be constantly on the move. Although difficult to prove for the artists from antiquity whose names have been lost, it is nevertheless a well-known fact for artists of the Middle Ages. During the medieval period, most painters and sculptors were truly itinerants, going from one site to another, wherever they were hired to decorate churches and monasteries. This is one reason that from Ireland to Sicily and from Spain to Germany, we find similar characteristics and motifs executed over and over by artists taking inspiration from one another. The same goes for non-European civilizations: the Muslim, Indian, and Chinese worlds each have their itinerant artists. As for traditional societies of black Africa, even though transportation may be more difficult and journeys may take longer than elsewhere, travel among artists is no less frequent.

Moreover, artists are not the only ones to travel: objects, too, are on the move, because of commerce. This is well known within the field of decorative arts: furniture, earthenware, lamps, fabrics, rugs, and tapestries have long been bought,

sold, exchanged, or offered as gifts from one end of the planet to the other, wherever the movement of goods is possible. Finally, if migration or trade doesn't succeed in putting artists in contact with one another's work, another (unfortunately) widespread situation does so quite well: war. Although conquest or occupation is not the best way to make an acquaintance, it has for a long time been mankind's primary mixer. And if the clash of civilizations is not the ideal instrument for the dialogue between cultures, it has nevertheless played this role throughout history.

Thus, from very early on, travel, commerce, and war have created contexts favorable to artistic exchange. By way of example, we might recall that during the first millennium B.C. one motif common to the nomadic peoples of the Eurasian steppes—that of the stag with antlers ending in stylized bird heads—spread across a huge geographical area, extending from north of the Black Sea to China. An even more striking example can be found in the considerable legacy transmitted by ancient Middle Eastern civilizations to Muslim societies from the

135. Left: Fight of the phoenix and the dragon. Northwest Persia, late 16th century. Tapestry from the Collegiate Church, Mantes, France. Musée du Louvre, Paris

135

136. Right: Human-headed winged animals. Details from a decoration executed by Giacomo Rossignolo (1524–1604) for the Taparelli Castle Loggia, Lagnasco (Italy).

137. Below: Senmurv. Sogdian, middle of the 8th century. Silver plate, diameter 10⅝ in. (27.3 cm). State Hermitage Museum, Saint Petersburg. Representations of the senmurv, which was invented in Sassanid Persia, became more rare after the inhabitants of this empire (where Mazdeism had been the official religion) came under Arab domination and converted to Islam.

138. Opposite: Caricature of Louis-Antoine de Gontaut, duke of Biron (1700–1788), represented as a peacock spreading its tail. French school, Louis XVI period. Oil on canvas, 26⅜ x 20½ in. (67 x 52 cm). Castles of Versailles and Trianon

moment (in the seventh century A.D.) Islam began spreading across the regions from Iraq to Spain.

In fact, the Arab conquerors, who were initially a minority, had no other alternative than to adapt to the civilizations they took command of and to adopt their traditions. As a result, Islamic art found itself pressed (at least in places and at times where this type of representation was not forbidden) into reusing the figure of the human-headed bird (invented in pharaonic Egypt), as well as that of the griffin (depicted in the Phoenician civilization) and the winged bull (well known among the Assyrians). Once these figures were adopted by Islam, they also started to spread beyond the Muslim world, through its peaceful or warlike relationships with its neighbors, whether the populations of Central and East Asia or the Christian nations of the West.

This circulation of motifs helps us understand why the *senmurv* motif (the dog-headed winged animal with claws at the ends of its forelimbs and a curved tail, like a peacock's), used in Sassanid Persia (sixth century A.D.) as a symbol of royalty, was so easily adapted to the Muslim

137

world. It decorates the bathhouse of the Umayyad palace of Khirbat al-Mafjar (near Jericho) as well as several tenth-century Abbasid ceramic plates. Eventually, it was also found in Armenia, Byzantine Anatolia, and even in Central Asia, where it appears on a caftan found in the Moshchevaya Balka tomb (in the northern Caucasus). Likewise, the chimera, which probably originated in the Middle East, was rapidly exported along the Silk Road, resurfacing in China as early as the third or fourth century A.D. (as demonstrated by a beautiful sculpture at the Arthur M. Sackler Gallery in Washington, D.C.).

Conversely, images originating in the Far East made their way into the Muslim world very early on, fascinating for the same reasons (distance, exoticism, mystery) that they also fascinated the Christian world of that time. Numerous handwritten copies of Firdausi's *Book of Kings* (*Shahnama*) (an early-eleventh-century epic recounting in a mythical mode the exploits of Persian rulers since the country's origins), as well as copies of *Marvels of Things Created and Miraculous Aspects of Things Existing* (a popular cosmography, written in Arabic by Al-Qazwini during the thirteenth century), were illustrated for several centuries with monsters from the East. The representations of these

136

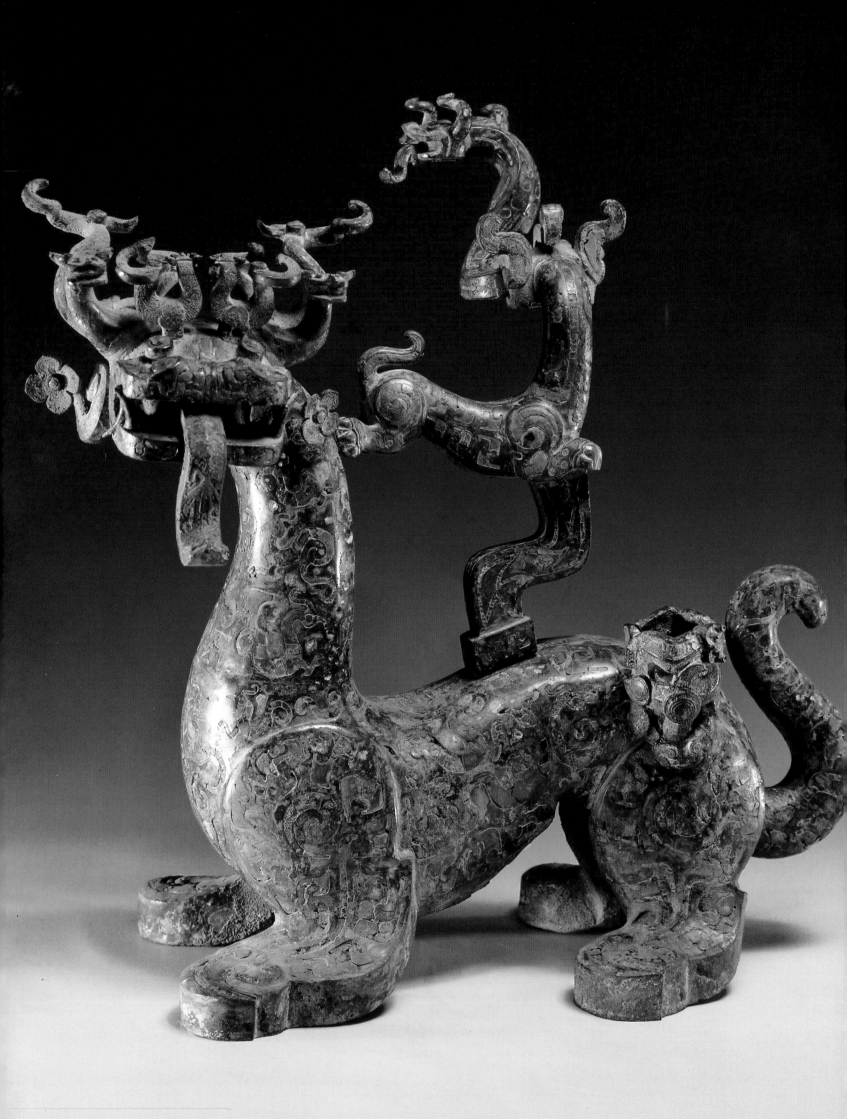

monsters took inspiration from the accounts of Muslim merchants, the memories of their travels to China, and of course, the objects they brought back from these faraway expeditions.

Equally important, the Mongol peoples expanded to the West during the thirteenth century, following the conquest of China by the fearsome Genghis Khan (who sacked Beijing in 1215). In addition to numerous massacres and brutal destruction, this expansion also resulted in the diffusion, within the Muslim world, of Chinese artistic motifs such as the dragon, the *qilin*, and the phoenix. The dragon, which appeared in twelfth-century Persian art, became very common during the thirteenth and fourteenth centuries. Retaining the positive connotations of the Chinese dragon, which is a symbol of strength and light, this Muslim dragon often also retains the serpentlike qualities of its model. It sometimes has a second head, which is smaller and planted at the end of its tail—a motif that, like the dragon itself, could have an astronomical meaning (linked specifically to what are called the "nodes" of the moon, the two points where the moon's orbit cuts the plane of the orbit of the earth around the sun).

The *qilin* appears in the fifteenth-century art of the Turkic Mongol dynasty of the Timurids. Lastly, the long, coiled feathers of the Chinese phoenix obviously influenced the representations of the *simurgh*, a magnificent bird of Persian (and probably Zoroastrian) origin. This bird, which was said to possess curative properties, should not be confused with the *senmurv*, though both were used as royal emblems in Persian art during the fifteenth and sixteenth centuries.

The links between the Muslim and Christian worlds were also characterized by numerous exchanges, in spite of recurring conflicts. In two places at least, Spain and Sicily, the Arab occupation kept Christian and Muslim artists in contact for long periods (two centuries in Sicily, more than seven in Spain). The occupation of Palestine by Europeans during the Crusades had the same effect. Moreover, this occupation had been preceded,

140

141

139. Opposite: Chimera. Chu State (China), 6th–5th century B.C. Bronze, height 18⅞ in. (48 cm). Institute of Cultural Relics and Archaeology of Henan Province, Zhengzhou, China

140. Above, top: Sphinx. Petra (Jordan), Nabatean period (1st century A.D.). Stone. Petra On-site Archaeological Museum, Jordan

141. Above, bottom: The Dog of the Seven Sleepers and the Beast of the Apocalypse (detail). Illustration from Majma' al-Ghara'ib (A collection of things strange and rare), fol. 64v. Mughal India, mid-17th century. Ink and gouache on paper. Chester Beatty Library, Dublin, MS. 9

142. *Below:* Fabulous animals. Detail of mosaic from the monastery of Ganagobie, Alpes-de-Haute-Provence (France), c. 1124. This exceptional mosaic dating back to the Romanesque period originally covered a surface of 882 square feet (82 square meters). It was executed under the direction of Pierre Trutber, a French artist well acquainted with Celtic art, Persian carpets, and Byzantine ivories.

143. *Opposite:* Giotto di Bondone (c. 1267–1337), *Saint Francis Driving Out the Devils*, c. 1297–99. Fresco, 106¼ x 90½ in. (270 x 230 cm). Upper Basilica, Saint Francis, Assisi (Italy)

during the Umayyad period, by the recruitment of Byzantine artists at the caliph's court in Damascus and was followed, during the Ottoman period, by the recruitment of Armenian artists at the sultan's court in Constantinople.

The French art historian Émile Mâle's work on medieval religious art and, even more pertinently, the work of Jurgis Baltrušaitis (*Art sumérien, art roman*, 1934; *Le Moyen Age fantastique: Antiquités et exotismes dans l'art gothique*, 1955; *Réveils et prodiges: Le gothique fantastique*, 1960) make clear the importance to both Romanesque and Gothic art of Islamic-originated motifs and of those derived from the ancient Middle East and certain regions of Central Asia. Many of these influences were in turn transmitted, around A.D. 1000, to the courts of Europe and ecclesiastical treasuries through Coptic or Sassanid textiles, Persian rugs, Arabic and Byzantine ivories, and Georgian and Armenian manuscripts.

The mosaic executed around 1124 in the church of the French monastery of Ganagobie, which is particularly rich in fantastic animals, offers proof that artists working in the great religious centers of Christianity were already able, by that time, to borrow elements from Asian imagery. This is also clearly evident in Western representations of the devil and demons. As we have already noted, artists at the end of the thirteenth century start depicting their demons with bat wings, which are Chinese in origin. And so it might be interesting to relate Giotto's *Saint Francis Driving Out the Devils* (plate 143), which he painted in Assisi c. 1297–99, to the Franciscan William of Rubruck's exploration of China, which had taken place only a few decades before the fresco was painted.

Muslim artists from India and Persia, for their part, did not hesitate to adopt motifs that were Christian in origin. For example, a seventeenth-century Indian manuscript entitled *A Collection of Things Strange and Rare* contains a superb representation of the Beast of the Apocalypse (a human-headed giraffe, with deer antlers and elephant ears), which corresponds neither to the Book of Revelation (13:1–2) nor to the Koran (27:84), and whose source most probably lies in European imagery (plate 141). And even though the study of the influences of Christian art on Islamic art is much less developed than that of Islamic influences on Christian art, we assume this is far from an isolated occurrence. In short, the play of influences may offer explanations for several "coincidences." But it does not explain them all.

THE ENIGMA OF COINCIDENCE

The fact is that some coincidences resist all attempts to consider them as the products of simple cultural transmission. We have mentioned, for instance, the Lascaux "Unicorn" (if indeed it is one)

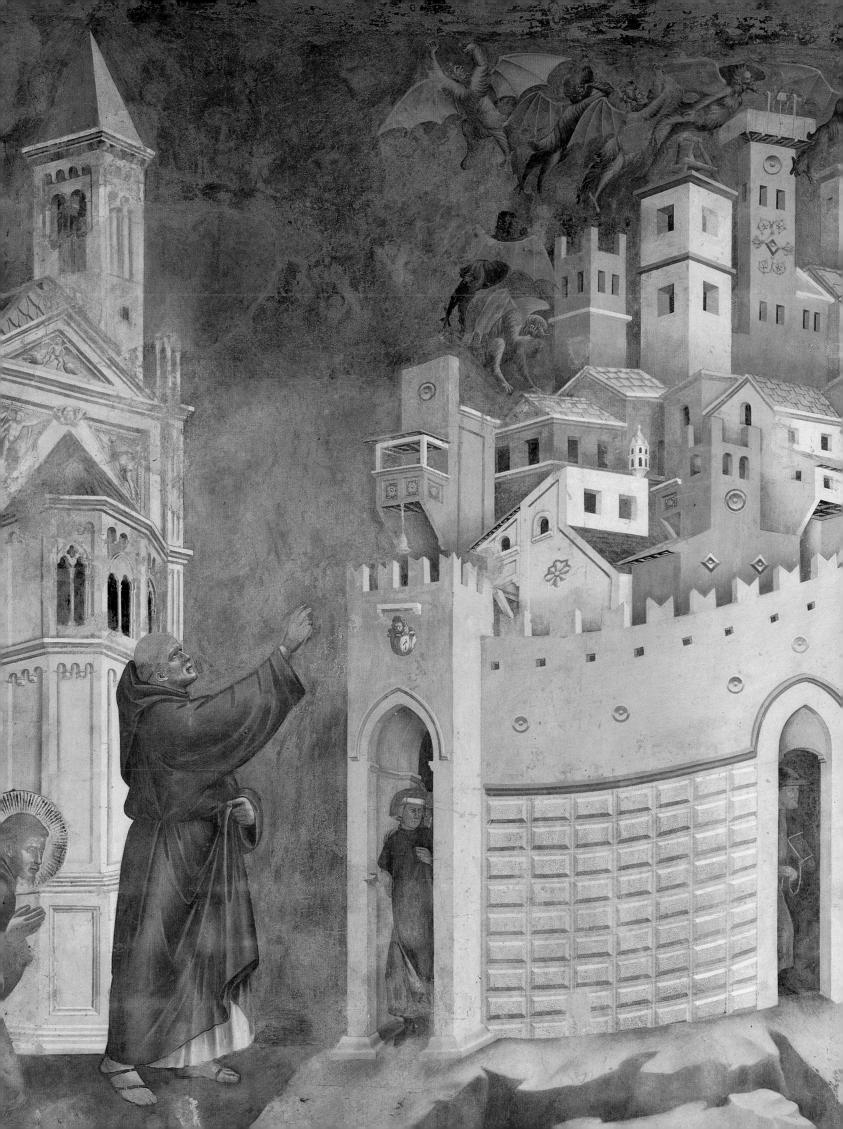

144. Opposite: Salvator Rosa (1615–1673), *The Temptations of Saint Anthony*, c. 1646–47. Oil on canvas, 48¼ x 36¼ in. (125 x 93 cm). Palazzo Pitti, Florence

and the fact that it reappeared unexpectedly thousands of years later in the Indus Valley. But it is absolutely impossible to establish a specific link between the people of Lascaux and those of Chanhu Daro, or between the fantastic in the Paleolithic era and that which sprang up again in Egyptian and Sumerian art, thousands of miles away from the caves in France. It is equally impossible to make a connection between the two-headed eagle carved on the Yazilikiya cliff in Turkey in the thirteenth century B.C. and a similar motif that resurfaced in Sassanid art (Persia) in the fourth or the fifth century A.D. and later in Xinjiang art of seventh-century China, nearly two thousand years after its initial appearance.

Let us consider again the widespread theme of the dragon. Dragons are found in the art and folklore of most Native American societies (including the Eskimos), as well as in Meso-American cultures such as the Olmec and the Aztec in Mexico and the Mochica in Peru. All those dragons bear formal resemblances to Chinese dragons. Yet who could assert that Native American dragons derive from Chinese dragons, when there is no archaeological evidence that the dragon was already known to Asian peoples when, forty thousand years ago, they started crossing the Bering Strait?

How could the amphisbaena—dating back to the Christian Middle Ages and deriving either from Pliny and the Book of Revelation (9:19) or from a Persian model—have influenced (or been influenced by) a Mayan stela at Copan, in Honduras, or by a Mochican sculpture also depicting an animal tail with a head at its extremity (Peru, first-sixth century A.D.; Museo de America, Madrid)? And finally, how can we explain the dragons at Nias Island (plates 123 and 146), given that this Indonesian culture had, until recently, very few contacts with the rest of the world?

At first glance, it is tempting to conclude that these encounters are coincidences. Coincidences, yes, but they did not happen at random. For, as far

as visual forms are concerned, coincidences are not always—and, in fact, very rarely—due to chance. It might prove more interesting and useful to attribute them to logical or psychological laws, based on the structure of the brain, that would hold true for artists separated by thousands of miles or thousands of years. This track has not really been explored so far, though searching for whatever laws govern the functioning of the brain is a legitimate ambition for cognitive sciences. But these sciences—which are subject to the institutional domination of mathematics—remain captive to quantitative models. Consequently, they look more toward computer science than toward disciplines in the humanities such as art history and philosophical aesthetics.

If this tendency could somehow evolve, researchers in cognitive sciences would discover, to their great astonishment, a truth that artists (and some philosophers) have known for a long time: since a work of art is first and foremost the product of a thought, the corpus of world art constitutes the most tremendous field of expression for the human mind, the one within which its manifestations can be most easily observed in a "pure state," to use an expression from chemistry.

From this perspective, the coincidence of structures that are visually similar in contexts that make direct influence highly improbable would allow us to establish the fundamental nature of those structures. A detailed survey of such coincidences—whether between geometrical, zoological, or human forms—would, in turn, allow us to establish an inventory of the basic formal structures that are most commonly at work while drawing. Such structures would obviously be universal ones.

Following this path, a handful of researchers, over the last half-century, have shown that there are some universal characteristics in drawings made by individuals considered marginal, such as children or the mentally ill. These researchers have thus suspected that the possible ways to depict a

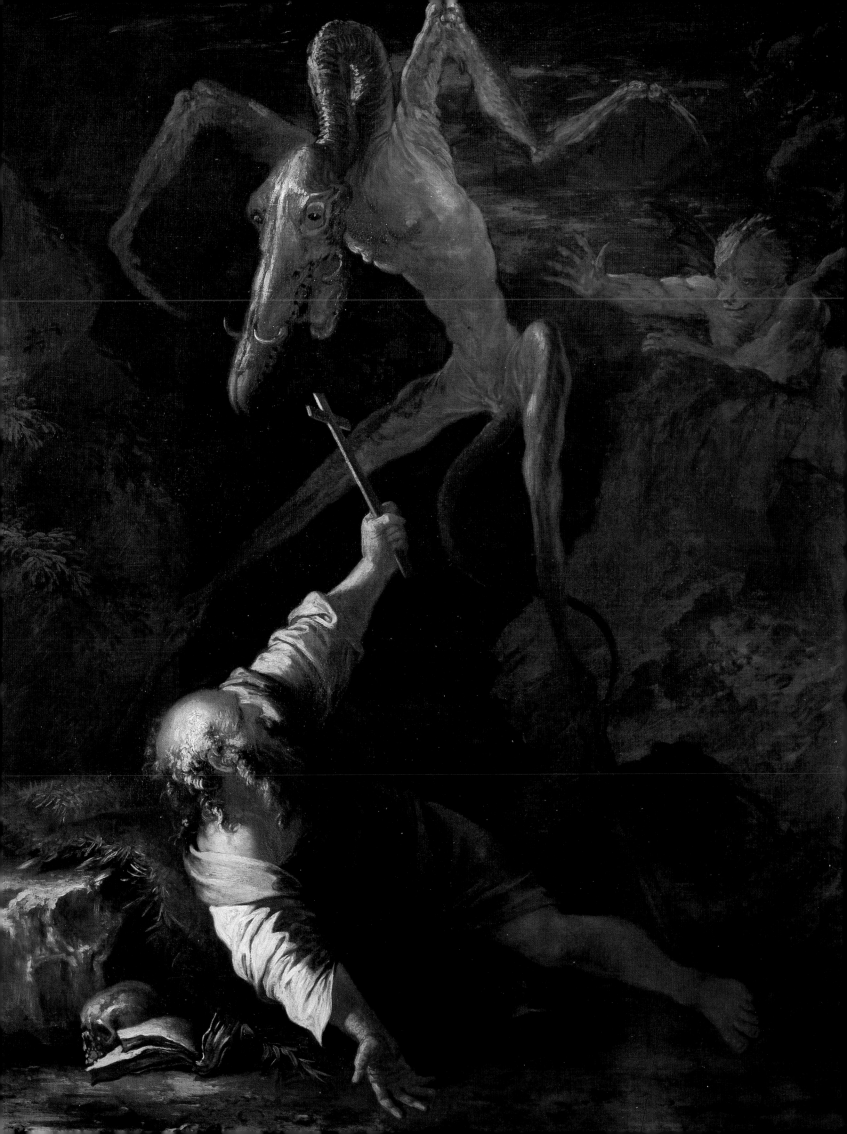

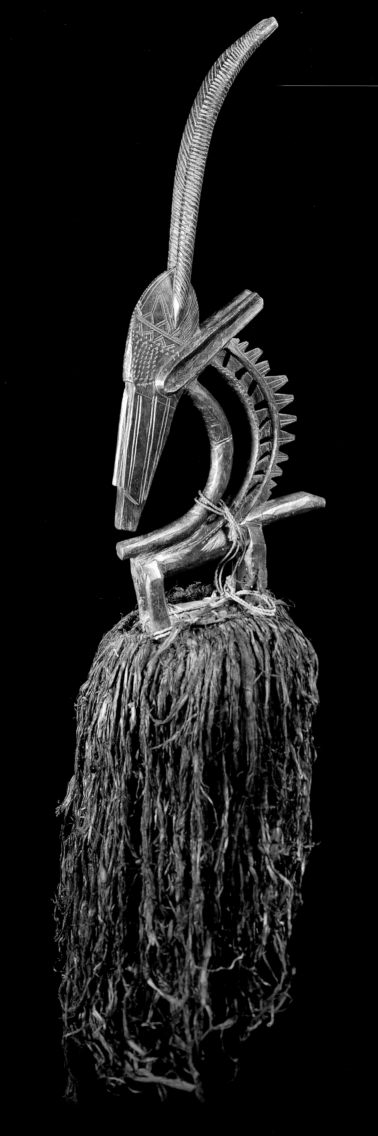

real or an imaginary being are not unlimited (any more than imaginative resources themselves are unlimited, as Baltrušaitis says in the next-to-last sentence in *Aberrations*), and that they are all inscribed in every human brain, even if each culture favors some and ignores others. The fact that each human culture retains only a limited combination of formal possibilities (which are themselves selected from a finite list) is an important discovery for understanding the link between the individual brain and the collective culture. Yet it is remarkable that this discovery was first made by artists rather than by scientists.

Let us go back to the first half of the twentieth century. In the space of a few decades, we witness the successive "discoveries" of African art by the Fauvists and Cubists (1900s), Oceanic art by the German Expressionists (1910s), and Native American art by the Surrealists (1920s and 1930s). The fact that these discoveries occurred within such a brief period continues to puzzle historians. Was the European artists' inspiration so exhausted that they needed to look for new stimulation in such faraway places? Would Picasso ever have become Picasso had he not stumbled on a collection of African masks during a visit to the dusty recesses of the Musée d'Ethnographie in Paris? Was Cubism simply the result of copying the *ci wara*—the famous headdresses of the Bamana People in Mali, worn by young people in order to attract beneficial spirits during agricultural feasts (plate 145)?

Writing the history of modernity in such a way would be misguided, in part because it fails to take into consideration the famous declaration attributed to Picasso: "L'art nègre? Connais pas" (African art? I know nothing about it). However, contrary to what has sometimes been written, this quote does not mean that Picasso, ashamed, tried to erase some kind of a debt. It means that Cubism should be understood not as merely an imitation of African art but as proceeding from certain possibilities in the realm of formal expression that are common to all

146

145. Opposite: *Ci wara.* Bamana People, circle of Kutyala (Mali), early 20th century. Upper part of a sculpted wood mask with fibers blackened with mud, whose top represents an antelope, $47\frac{1}{4} \times 10\frac{5}{8}$ in. (120 x 27 cm). Musée de l'Homme, Paris

146. Left: Warrior sword, with a *lasara*-shaped handle. Nias Island (Indonesia), early 20th century. Wood sheath with copper strips, a wicker ball, and "tiger teeth." Musée Barbier-Mueller, Geneva

humanity. These possibilities can be easily seen at work in any *ci wara*—an object born of the imaginative combination of elements borrowed from two or three real animals (antelope, pangolin, aardvark) and transformed by a powerful geometrical stylization. However, in the wake of the Renaissance's concern with optical realism, European art had opted to ignore such possibilities until Picasso decided to reactivate them in his painting beginning in 1907, thus initiating a new conception of "Cubist" space and giving rise to pictorial modernity.

Likewise, it is the encounter between a handful of European artists and certain forms of stylization

147. Opposite: Swan and white whale mask. Yup'ik People, Alaska, early 20th century. Wood, height 28¼ in. (72 cm). Musée du Quai Branly, Paris. Executed under the direction of a shaman, this mask, which represents a stylized swan coming out of the mouth of a beluga whale, was worn during ritual dances intended to ensure abundant game for the Yup'iks. The swan was considered a supernatural being, capable of guiding the hunter toward the beluga, whose meat was much appreciated by the Yup'iks. A photograph taken by Sabine Weiss in André Breton's studio in 1956 reminds us that this mask belonged to the Surrealist poet, who was among the first to develop a passion for the highly expressive Yup'ik art (then called Eskimo art).

favored by Oceanic art and Native American art—two fields where fantastic animals also play a considerable role—that contributed decisively to the elaboration first of Expressionism and then of Surrealism. And, in a more general way, the encounter between European and world cultures also contributed to an awareness of the unity of the human spirit underlying such diverse artistic manifestations—an awareness that was ultimately developed theoretically by anthropologists such as Franz Boas and Claude Lévi-Strauss (the latter always acknowledging his indebtedness, in his exploration of Indian art, to his friends Max Ernst and André Breton).

We can thus see that fantastic zoology played a crucial role, a century ago, in challenging the old Eurocentrism that had characterized Western civilization. Does this mean that there are deeper links than we have so far suspected between the image that man has of himself and the depictions he makes of other animals?

THE ANIMAL AS A MIRROR OF MAN

Among the three great monotheisms deriving from the Bible, man's superiority over animals is a basic dogma established at the beginning of Genesis (1:26) (and reinforced by the Jewish belief, subsequently confirmed by biology, in the sterility of interspecies breeding). Nevertheless, this superiority—challenged by many societies of nomads and hunters all over the world—is far from obvious.

First of all, there is hardly a single human feature (use of language or tools, social organization, prohibition of incest, and so on) that cannot also be found, at least incipiently, in the animal kingdom. Second, humans, which have never been the swiftest or the strongest of mammals, have become denatured, weakening or losing most of their instincts in the process of becoming civilized. Fi-

nally, man, this denatured being, less well adapted to the natural environment than any other animal, has so disrupted the basic equilibrium of the planet, while also developing and then losing control over weapons of mass destruction, that *Homo sapiens* has become the only species potentially capable of eliminating itself from existence in a matter of seconds. In terms of biological adaptation, such a performance can hardly be considered progress.

Let us add that humanity is aware of its frailty. The way our modern societies keep on reservations or in zoos animals that cannot be tamed reveals the fear they inspire, a fear joined by two other powerful but confused feelings within the human spirit. The first is envy. Man cannot keep from fantasizing about the innocence, the happiness, and sometimes the unbridled sexuality of animals. And he fantasizes all the more because he lives in communities where the constraints on his own sexuality are stricter. The second feeling is guilt. Man knows, deep down, that he has caused suffering among his "brothers," either by killing them in order to feed on their flesh or by inflicting all kinds of mistreatment on them (such as those once sustained by horses in wartime).

These various feelings, which are more or less irrational—fear, envy, guilt—allow us to understand why our nightmares are so often inhabited by animals. The animal world, as Freud convincingly demonstrated by analyzing several historical cases (the Wolf Man, et al.), is inextricably linked to that of our unconscious drives. For humanity, it constitutes at once a menace, a challenge, a foil, and a source of fascination. Yet it remains to be seen why *fantastic* animals occupy such an important place in our imagination, a place possibly even more important than that of *real* animals—at least judging from the artistic record.

Some recent trends in anthropology can help us formulate a hypothesis here. All human societies develop sophisticated (if not always scientific) systems for classifying animals. Several preliterate

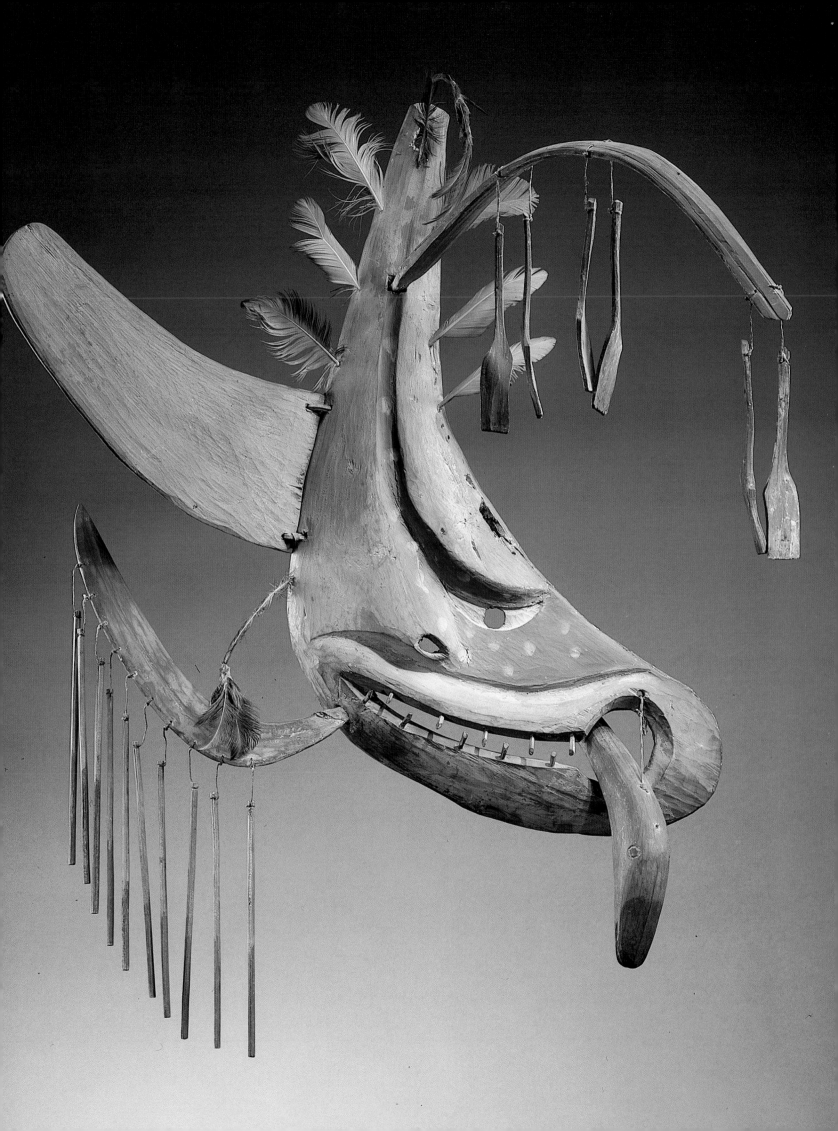

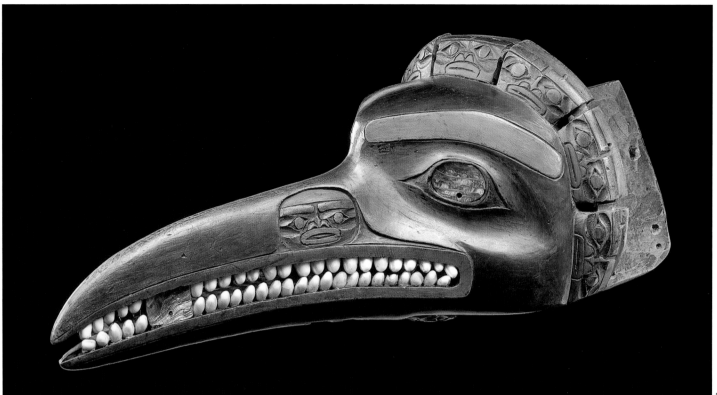

148

societies, which remain closer to a rural lifestyle, even make these classification systems the general framework of their cosmology and religion. This phenomenon is well known among anthropologists, who have been describing it for almost two centuries under the name "totemism."

Nevertheless, in prescientific classifications, that is to say in most cases (scientific zoology being a recent invention), the notions of species and genus are not merely descriptive. These are also, implicitly, normative notions. For the world to be orderly, for humanity to live in peace, it is best if the appearance of each animal matches specific cultural expectations, generally based on the group's knowledge, that is to say, on its religion. Animals that stray from the ideal type, those that combine elements that are intuitively perceived as incompatible, and of course those that are nonexistent and thus don't belong to any genus are adequate "food for symbolic thought" (as anthropologist Dan Sperber said in a famous article [1975]).

Animals that are atypical or unclassifiable are perceived as dangerous because they diverge from the standard order of the universe. This is why they are transformed into *sacred* animals, whether good or evil, pure or impure. And their role becomes all the more important since the order of the universe will become more threatened by natural or social crises, and since men perceive those crises as a source of potential danger. In that case, it often seems necessary to use the strangest animals to exorcize fears caused by these disorders. Does this hypothesis seem too abstract? To prove its validity, we will go back to the culture whose history is most familiar to us: that of Christian Europe.

FANTASTIC ANIMALS AND CULTURAL CRISIS

Rich in ancient and Eastern influences, Romanesque art was, as we saw, an exuberant, baroque, even surreal world. With the "classical" phase of Gothic art (first half of the thirteenth century), this imaginary world seemed on the verge of disappearing. A naturalist ideal, a concern for

150

moderation and clarity, shaped the work of sculptors or painters. But this phase was also transitional. Starting in the middle of the thirteenth century, we witness—to use Baltrušaitis's term—a revival of the wonders that Romanesque art was so fond of.

Yet this revival occurred precisely at the time Christianity experienced its most serious spiritual crisis to date. This crisis had undeniably objective causes: the exacerbation of class struggle, the strain of ongoing conflict with the Muslim world, the rifts within the papacy. But these factors do not, by

themselves, explain every aspect of the crisis. The continuous proliferation of heresies with a millenarian character (Cathar, Albigensian, Waldensian, Patarin, Hussite), the rise of anti-Semitism, the rapid increase in the persecution of "witches," the paranoia of the Inquisition, and finally the frenzied obsession with the Antichrist reveal that a wind of collective psychosis was blowing over Christianity.

This madness helps explain the increasing popularity, starting in the fourteenth century, of themes with a fiendish character: battling dragons, *danses macabres*, eternal punishments (see, for

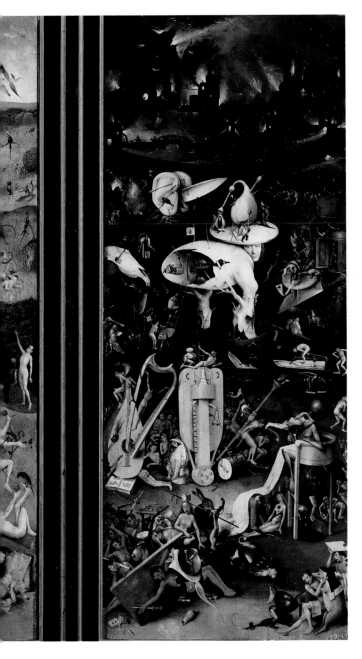

Bosch. Produced around 1500, at the end of this crisis period, Bosch's work sums up all the attractions to the supernatural—and all the anxieties—that dominated the era. This is why almost every writer exploring the fantastic has to address the enigma of Bosch's paintings, which teem with fabulous animals, monsters, and all kind of hybrids—mixtures between animals and inanimate objects, anthropomorphic or zoomorphic rocks, and so on. Nevertheless, not a single author has succeeded in proposing a comprehensive interpretation of these creatures.

Even if Bosch did not invent everything he painted, even if he largely drew from ancient traditions (including Buddhist and Chinese traditions, which were paradoxically less foreign to his contemporaries than they are to us), his imagination defies understanding. Should his work be reinterpreted in the light of gnosis or alchemy? Should it be seen as a purely formal puzzle or as a collection of heresies that only the initiated could decipher? Or is it the expression of a Catholic religiosity that dipped into mysticism, because of war and human miseries prevalent at the time? Do his most incongruous motifs illustrate familiar proverbs—as was the case, later on, in *Mad Meg (Dulle Griet)* by Pieter Bruegel the Elder (plate 151)—or the creed of some mysterious secret society?

None of these interpretations lacks justification, but none is really convincing, either, because each leaves out something essential. Even if Bosch's work appeared at a time of religious crisis, it seems to us that it unmistakably belongs to the realm of the Christian imagination. Thus, we think the most plausible interpretation is to decipher his oeuvre as a compendium of all the fears of the late Middle Ages, or (to quote the expression that is the title of Norman Cohn's beautiful book) of all its "inner demons." In other words, Bosch's work reflects a singular moment of terror and darkness that would end only when the dawn of the Renaissance, by heralding the day of reason, would temporarily free humanity. We could, in fact, say about

example, the *Triumph of Death* fresco at the Campo Santo, Pisa; and later, Luca Signorelli's *Last Judgment* in the cathedral of Orvieto), the Temptations of Saint Anthony (by Martin Schongauer [plate 149], Lucas Cranach the Elder, Matthias Grünewald, Jacques Callot, and others), and infernal loves (an erotic drawing by Hans Baldung Grien, dated 1515, reveals a decidedly explicit sex scene between a dragon and a naked young witch; Staatliche Kunsthalle, Karlsruhe, Germany).

Work by one artist in particular takes this demonology to dizzying heights: that of Hieronymus

150. Left: Hieronymus Bosch (1450/60–1516), *The Garden of Earthly Delights*, 1503–4. Museo del Prado, Madrid. The central panel in this triptych, which has a particularly esoteric symbolism, probably represents various aspects of the human adventure as it unfolds between its beginning (Creation of the World, left panel) and its end (Last Judgment, right panel). This work depicts many fantastic animals, including unicorns.

151. Pages 164–65: Pieter Bruegel the Elder (c. 1525/30–1569), *Mad Meg (Dulle Griet)*, 1561/64. Oil on wood, 45⅝ x 63⅜ in. (117 x 162 cm). Museum Mayer van der Bergh, Antwerp, Belgium. This madwoman who fiercely tries to destroy everything around her—combined with the city ravaged by war and fire in the background—could be a moral allegory of the disastrous effects of anger. Alternatively, it could be an illustration of the Book of Revelation (9:15–21), depicting the misfortunes that fall upon humanity after the opening of the seventh seal.

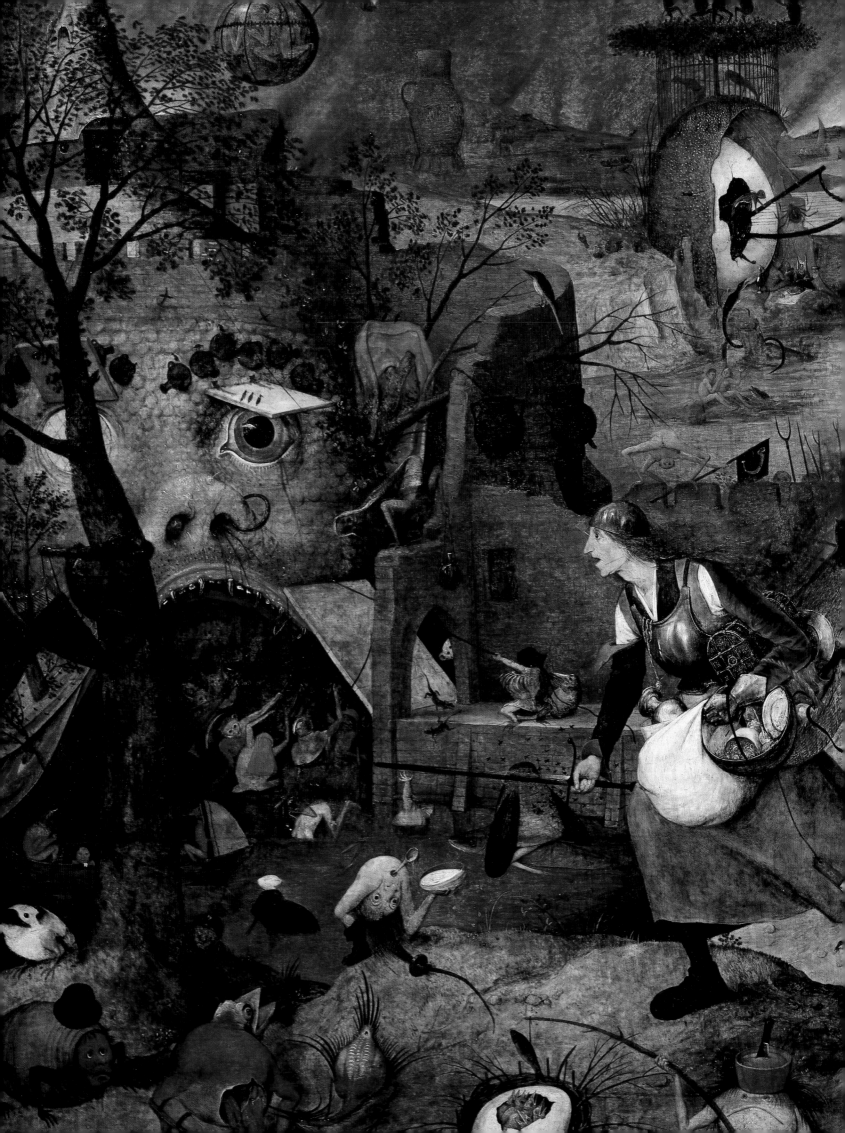

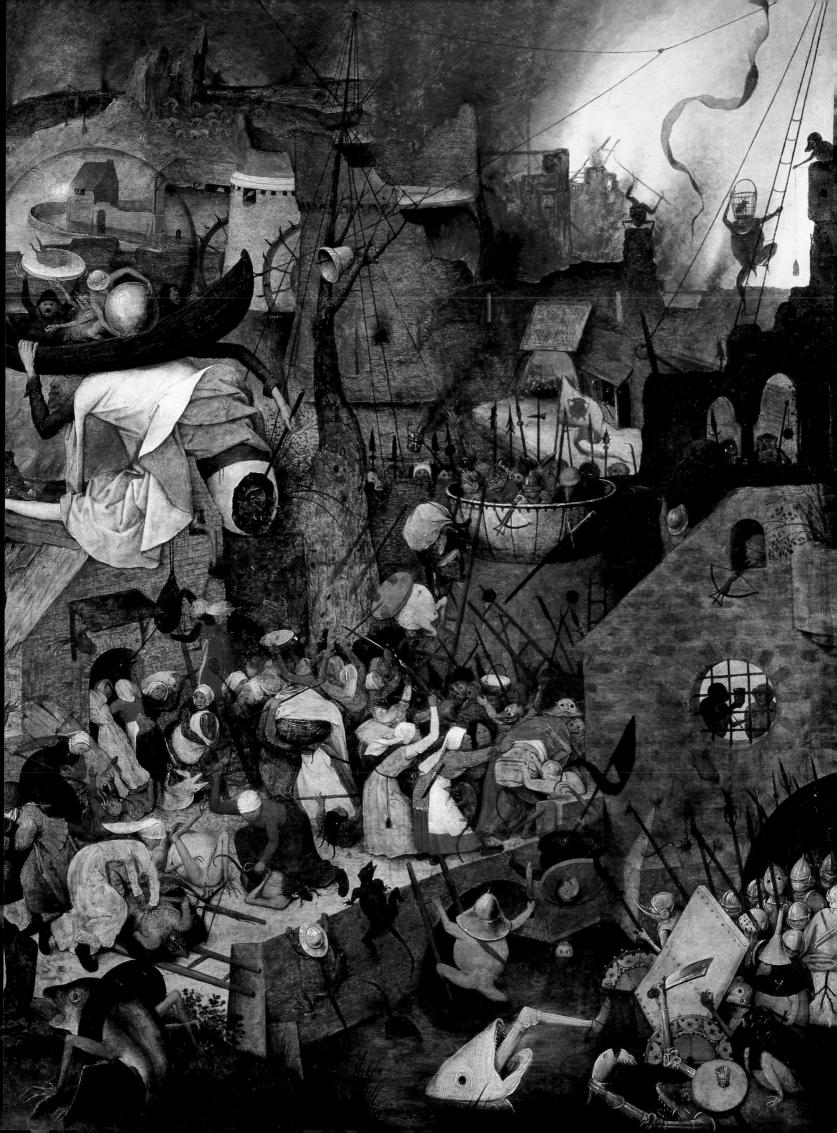

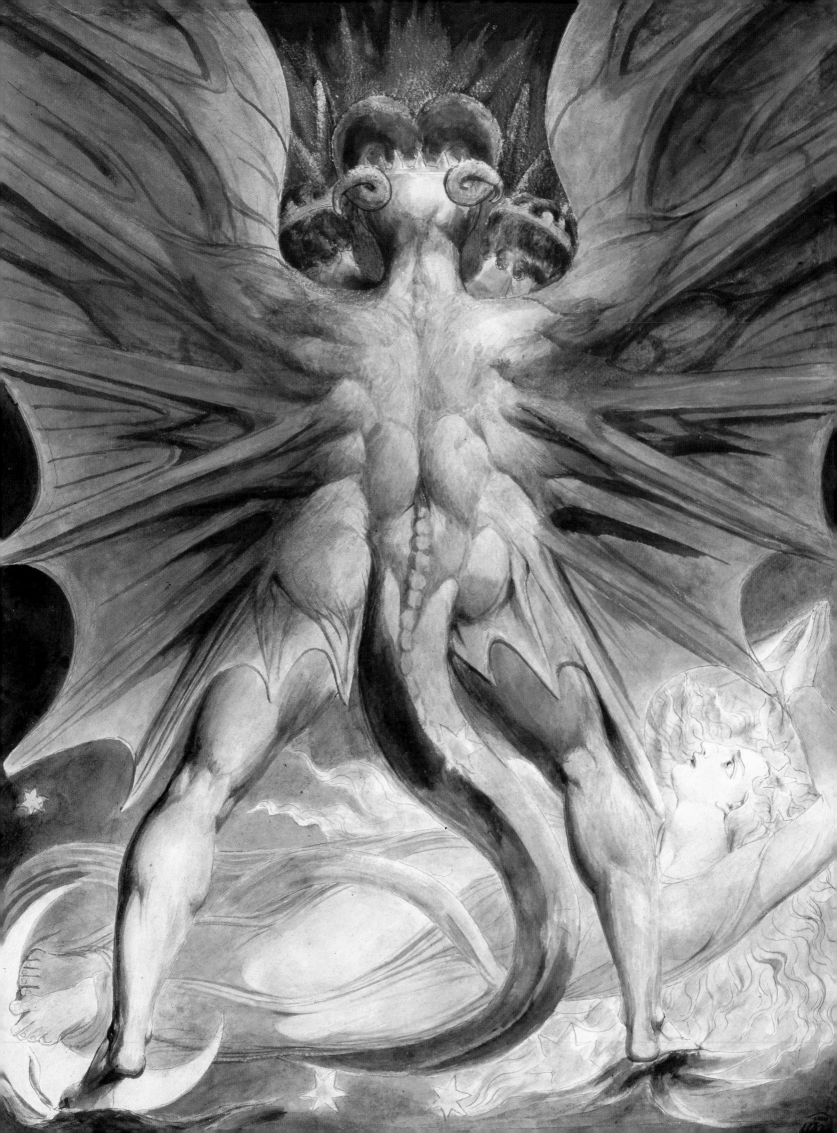

The Garden of Earthly Delights (plate 150) what Allen F. Roberts says in *Animals in African Art* (1995) about certain African masks: their main function consists of "giving fear a face" in order to exorcize it.

After Bosch, a new period began in Western culture, during which dark and shameful obsessions were forced to hide (though without ever entirely disappearing). This period lasted about three centuries, from 1500 to 1800. The Enlightenment had its dark side, too, but preferred to ignore it. It was only in the 1780s, with the emergence of another major social crisis (linked to a new crisis of religious beliefs as well as to the revolutionary tremors that were shaking Europe), that this dark side surfaced again. And with it, demons and monsters also resurfaced, in art and in literature.

For its fiercest opponents, the French Revolution itself was—like the work of the Marquis de Sade in another genre—totally diabolical. The catastrophes that accompanied it could only be attributed, according to Edmund Burke, to "harpies of France sprung from night and hell" (*Reflections on the French Revolution*, 1790). That was, of course, only a metaphor, but such dark and vivid visions became widespread by the end of the eighteenth century. This was also the age of the *roman noir*, a genre given credibility by Mary Goodwin Shelley, with *Frankenstein; or, The Modern Prometheus* (1817). At the same time there was a blossoming, in the realm of the plastic arts, of the tormented genius of Johann Heinrich Fuseli (*Thor Battering the Midgard Serpent*, 1788), William Blake (*The Red Dragon and the Woman Clothed with the Sun*; plate 152), and Francisco de Goya.

Goya's world has often been compared with Bosch's: not the world of the official portraitist of Charles IV's court, of course, but that of the mature Goya, the author of *Los Caprichos*, the *Disasters of War*, the *Disparates*, the drawings of the C and G albums, and the paintings abounding with hallucinations, bearing titles such as *The Plague, Canni-*

153

bals, and *Yard with Lunatics*. It is true that Goya's dark visions brought back to European painting this diabolical element (we would say "unconscious" nowadays), which had so diminished after Bosch and Bruegel. But one should not forget the main difference separating these two universes: for Bosch, a Christian, the devil was still dealing with a god who, on Judgment Day, would restore order; whereas, for the skeptical Goya, God had abandoned the stage, letting the devil have a free hand, in order to drive men crazy, or push them into feverish debauchery that would induce their fall (*Todos caerán*; plate 84), or incite them to unrestrained killing. In Goya's world, any hope for redemption has vanished. Man is alone, left to his own devices, abandoned to suicidal drives that, as demonstrated by the huge massacres of the nineteenth and twentieth centuries (beginning with the *Third of May*, so vividly depicted by Goya), would turn into an urge to cause death or even genocide.

152. Opposite: William Blake (1757–1827), The Red Dragon and the Woman Clothed with the Sun, 1803–5. Watercolor on paper, 21¼ x 16¾ in. (54.6 x 43.2 cm). Brooklyn Museum of Art. Gift of William Augustus White

153. Above: Harpie Femelle. Hand-colored wood engraving. Musée National des Arts et Traditions Populaires, Paris. Those odd, instructive, or amusing engravings, which were sold in villages by itinerant peddlers, were an enormous success in nineteenth-century France.

154

154. Above: Charles Méryon (1821–1868), The Ministry of the Navy, c. 1865. Etching, 6¼ x 5½ in. (16 x 14 cm). Bibliothèque Nationale de France, Paris. Formerly a lieutenant in the French navy, the engraver Méryon, whose visionary style of drawing was much appreciated by Charles Baudelaire, suffered grave mental disorders that led to repeated confinements in a mental hospital at the end of the 1850s.

155. Opposite: The Pursuit, an engraving by Jean-Ignace-Isidore Gérard, known as Grandville (1803–1847). Bibliothèque Nationale de France, Paris

It is in this sense that Goya's body of work signaled a turning point, making modern painting possible (as Malraux phrased it so well at the end of his essay *Saturn*, 1950). And as modern painting emerged during the decades following Napoleon's absurd invasion of Spain, two high points punctuated its birth. First, the convulsions of Romanticism, displayed not only in Delacroix's works but also in the bestial and extremely disquieting characters of the caricaturist Grandville (*Un autre monde*, or Another World, 1843), as well as in the monsters that were conjured out of ink blots by the "inventor" of automatic drawing, Victor Hugo. And second, the exploration of the unconscious, as expressed in painting and in literature by the Symbolist movement.

In spite of their academic workmanship and their disconcerting dependence on classical themes from Greek and Roman mythology, Symbolist

paintings by Arnold Böcklin (*The Plague*, 1898), Fernand Khnopff (plate 183; *Sleeping Medusa*, 1896), Gustav-Adolf Mossa (*Satiated Siren*, 1900), and Gustave Moreau (plate 68; *The Traveling Poet*, 1891)—not to mention the dragons used by Gaudí to adorn Park Güell in Barcelona (plate 132)—are not merely exercises in fin-de-siècle extravagance. By their dreamlike quality, they show the artist retreating back into his inner world, a mental conversion that would soon encourage the creation of Fauvism, Cubism, Expressionism, and finally the advent of the "spiritual in art" without which abstract painting (by Wassily Kandinsky and others) would never have seen the light of day. Consequently, the fact that the universe of fantastic animals became popular again during the 1880s (including in Mediumistic art, as witnessed by the drawings of the mysterious Count of Tromelin, which are today kept at the Collection de l'Art Brut, Lausanne) is not at all strange: this fact only reminds us that crisis—at once social, moral, and religious—was the cradle of modernity.

And this type of crisis—a crisis whose intensity reached new heights during the absurd and monstrous slaughter of World War I—also relates to the two latest waves of modernity, starting in 1916: the Dadaist wave, which soon crashed because of the suicide (or the artistic suicide) of its main representatives, and the Surrealist wave, which, because it engaged with figurative art while flirting with psychoanalysis, achieved popular success until World War II, in turn, brutally put an end to it.

As testimonies to those unsettling times, paintings by Max Ernst (plate 176), Dorothea Tanning, Victor Brauner (plate 177), Salvador Dalí, René Magritte, André Masson, Roberto Matta, Otto Pankok (plate 156), Jacques Prévert's collages (plate 157), and José Clemente Orozco's murals reverted to some of the main themes of medieval art, of Bosch and of Goya. In order to illustrate the workings of the unconscious, they revived a fantastic fauna

LA POURSUITE.

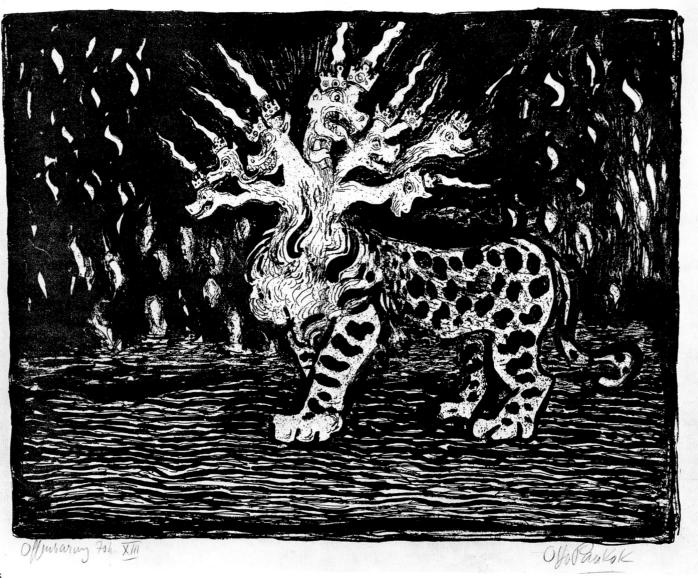

156

156. Above: The Beast of the Apocalypse, 1942, lithograph by Otto Pankok (1893–1966). Otto-Pankok-Museum, Hünxe-Drevenack, Germany

156. Above: The Beast of the Apocalypse, 1942, lithograph by Otto Pankok (1893–1966). Otto-Pankok-Museum, Hünxe-Drevenack, Germany

157. Opposite: Jacques Prévert (1900–1977), The Desert of Retz, 1940. Collage on paper, 10⅝ x 8⅛ in. (27.5 x 21 cm). Private collection. The garden known as the Desert of Retz was a favorite spot for the Surrealists. The deer-headed man is a reference to both Actaeon and the Cardinal de Retz, a seventeenth-century writer.

that, even in Moreau's time, would already have seemed outmoded. The same tendency affected Picasso's work, starting in the 1930s, when the return of the Minotaur (a monster that also gave its name to the most famous Surrealist review) betrayed the increasing obsession of the author of *Guernica* (1937) with themes pertaining to rape and war.

But looking back on the twentieth century, during which reality often exceeded fiction in terms of horrors, does this Surrealism, which also pretended (according to Breton) to be a witness to its time, still have anything to tell us? Does it still reflect a form of sensitivity in which we could recognize ourselves? In short, is fantastic art still possible in the contemporary world?

This is a question we can no longer avoid asking.

LE DRAGON 2 LA JEUNE FEMME. H·D·R·98·BD·

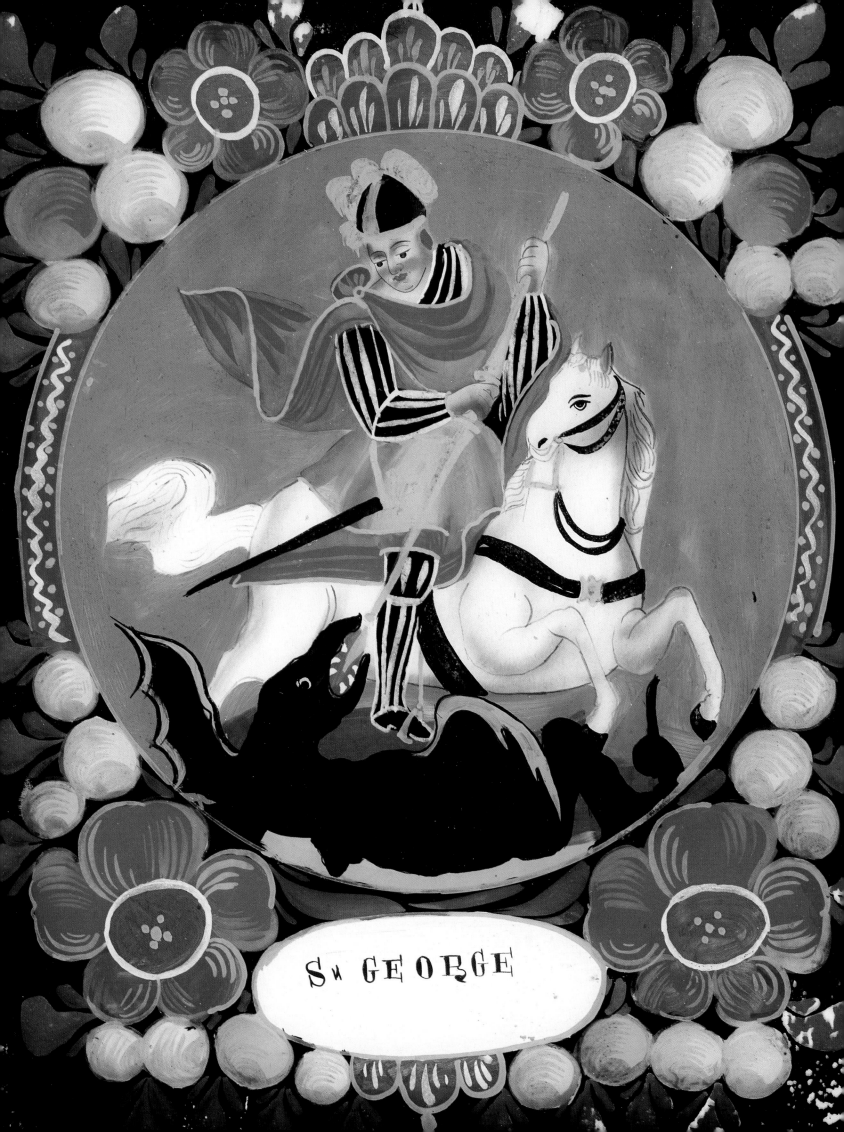

Sⁿ GEORGE

158. Pages 172–73: The Dragon and the Maiden, 1998, by Hervé Di Rosa (born 1959). Lacquer, mother-of-pearl, and eggshell on wood, 23¾ x 36½ in. (61 x 93.5 cm). Private collection. This work was executed by the French artist during a long stay in Binh Duong, Vietnam.

159. Opposite: Saint George Fighting the Dragon. Alsace (France), 19th century. Painting under glass, 12⅝ x 9⅜ in. (32 x 24 cm). Musée National des Arts et Traditions Populaires, Paris

160. Above: Alebrije, a figurine of a dragon, made in a village in Oaxaca (Mexico), in 2002. Papier-mâché, 5½ x 7 in. (14 x 18 cm). Private collection

CHAPTER SIX

The Fantastic Today

IN *THE ACCURSED SHARE* (1949), a prophetic book in many respects, Georges Bataille observes that the "proletarians"—the workers who constitute the majority of the employed labor force in industrial countries—no longer have well-defined spiritual aspirations. Living in a consumer society, in a world of things in which they themselves are reduced by exploitation to the status of things, they no longer manage to look beyond the mundane realities that obstruct their horizon. And even if they vaguely aspire to liberate themselves from this condition by envisioning a "Future Man," they do not really know what form to give him. "They do not involve him in ambitious projects;

they do not construct a rich and variegated world, modeled on the ancient mythologies or the medieval theologies. Their attention is apt to be limited to *what is here*" (Bataille's emphasis).

There could be no better formulation of modern humankind's alienation, which Karl Marx had foreseen and which Herbert Marcuse, a few years after Bataille, analyzed so grippingly in his *One-Dimensional Man* (1964). This alienated individual, who is not even aware of the extent of his own alienation, proves incapable of imagining a reality that is truly different from the one he lives in. Even his rare rebellions or his pitiful dreams (about escape or romance) conform to the

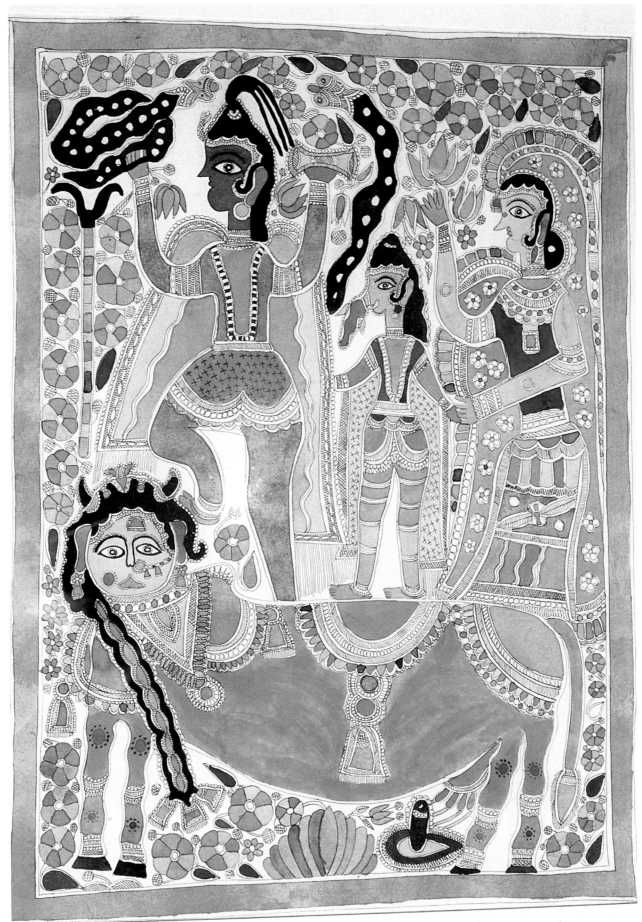

models that are forced upon him by the entertainment industry: the media and the movies. It is most unlikely that an original work of art arousing the feeling of the fantastic will appear in this convention-bound universe, which has been so eroded by mass culture.

As a matter of fact, in spite of the unprecedented turmoil that tore it apart, the twentieth century seems not to have been one of the most prolific in terms of inventing fabulous creatures. However, it is important to qualify this first impression. It's not that there is a total absence of fantastic creatures from all artistic productions made since 1900. Instead, in looking carefully, one discovers curious traces, unexpected transformations, and even some significant innovations. They all seem to be linked to the most recent shapes taken by what might be called the malaise of the contemporary world, and perhaps also to a feeling of nostalgia for the marvelous—a yearning intensified by the standardization of our daily lives, from one end of the globe to the other. This demonstrates that even in these down-to-earth times we are witnessing, fantastic art certainly has a future.

TRACES

In the age of mass leisure, the "rich and variegated" world—to quote Bataille—of ancient, medieval, and traditional mythologies continues to offer a formidable set of images and symbols that can fire the imagination. Clearly, we no longer believe in these mythologies the way our ancestors did. They no longer frighten us; in fact, they often make us smile. Moreover, they do not help us invent, for our own future, a world different from the one in which our daily activities take place. But they continue to fascinate us, because their very existence reminds us that, in the past, there were worlds different from our own. And, within those worlds, there were individuals who, when asked about the meaning of existence, gave clear and irrefutable an-

162

163

swers. Even now, and in spite of our apparent rationalism, we are not sure we are willing (or able) to do without such answers.

This explains the fascination (widely exploited by travel agents) that the inhabitants of developed countries continue to feel for the Sphinx of Giza, the dragons of the Forbidden City in Beijing, or Quetzalcóatl's bloody altars. Egypt, China, and Mexico, some of today's most popular "getaway" destinations, seem to offer strangely comforting answers to the mystery of death, answers that humankind has sincerely and quietly believed in for centuries, answers that we too might like to believe in again. But it is not necessary to travel thousands of miles to indulge in nostalgia. Throughout Europe and the Americas, local traditions that sometimes date back to the pre-Christian era have recently demonstrated remarkable resilience, after

161. Opposite, left to right: Shiva, his son, Ganesh (recognizable thanks to his elephant head, symbolizing wisdom), and his consort, Parvati; below them is Shiva's mount, the human-headed bull, Nandi. Painting on paper made by young girls from the Madhubani village, Mithila district, Bihar, India, 1970s. Private collection. Before being executed on paper for sale, these traditional paintings were made on sand or on house walls.

162. Above, top: Lion and dragon dancers in a Chinese New Year parade, Chinatown, New York, February 2003.

163. Above, bottom: Dragon-shaped pedal boats in Inner Harbor, Baltimore, April 2002.

having been temporarily pushed aside by modern life. In many areas, carnivals and village celebrations, with their traditional processions of masks and symbolic animals, have shown an increased vitality that local administrations, enticed by tourist revenues, are trying to keep alive.

For instance, in Poitiers, France, the Grand'Goule (a winged serpent with claws and a scorpion's tail) continues to be at the heart of legends linked to Saint Radegunde, protectress of Poitiers (plate 164). Even better, in the small city of Tarascon, France, there is still an annual procession, much to the tourists' delight, of the colorful body of the Tarasque (plate 165). A lion-headed dragon with the tail of a snake, the Tarasque was, according to tradition, vanquished during the first century A.D. by Saint Martha, said to be the sister of Mary and Lazarus in the Gospel of Saint Luke.

French regional folklore has thus helped ensure the survival of many beautiful examples of fantastic animals, whose continued existence recalls that of the Chinese dragons. And even if the latter inspire less awe since communism's attempts to suppress formal religion, dragons are still paraded in Chinese and Vietnamese streets during the celebration of the New Year (plate 162) and used abundantly to deco-

rate (because one never knows . . .) paper lanterns, boats, plates, and robes sporting the label "Made in Shanghai."

TRANSFORMATIONS

The transformations of fantastic animals are especially visible in certain domains: popular art, decorative art and architecture, advertising, body art, and even the fine arts—at least in post-Surrealist art.

Like popular celebrations and folklore in general, for the last twenty-five years or so, popular art has been experiencing a revival not only in the industrialized countries of Europe and the United States (where dozens of specialized museums and journals have begun to celebrate all possible aspects of folk art), but also in Africa, Latin America, India, and Indonesia. But whereas popular celebrations follow an unchanging seasonal cycle and replicate certain traditions each year, popular art offers much greater scope for renewal, which dar-

164. Below: The Grand'Goule. Wood sculpture, 22¼ x 68¼ in. (57 x 175 cm), by Jean Gargot, an artist active in Poitiers, France, during the last quarter of the 17th century. Musée Sainte-Croix, Poitiers. From the seventeenth century until 1789, this sculpture was carried in an annual procession through the city streets to appease this monster, which, according to legend, once devoured the nuns who ventured into the underground chambers of the local monastery.

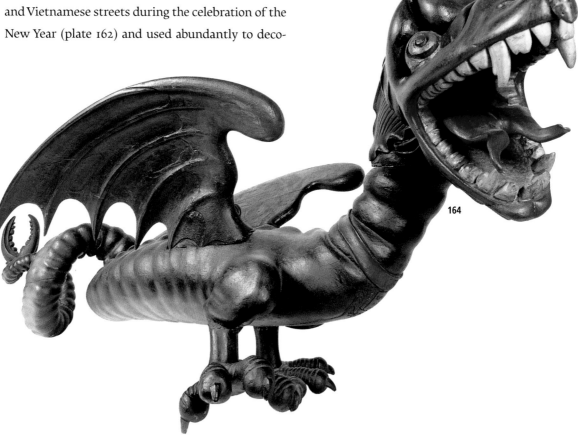

164

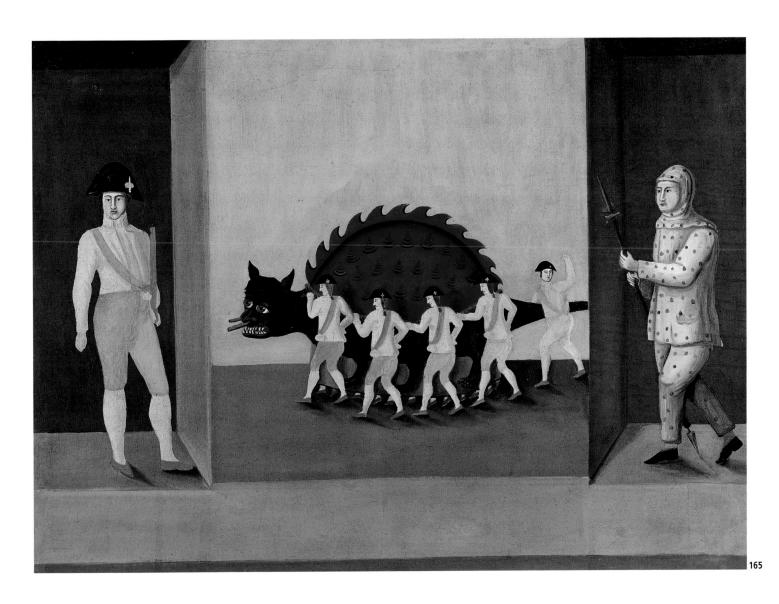

ing artists and artisans are not reluctant to exploit. And, in recent times, audacious artists have become more and more numerous.

We have already mentioned parenthetically the work of Spanish contemporary ceramists. Thanks to them and in particular thanks to the master Domingo Punter, of Teruel, the fantastic fauna originating from Persia, which had been introduced in the Iberian peninsula in the eighth century by the Arab invaders, has experienced a rebirth on glazed earthenware that has become a prized object for tourists and collectors alike (plate 170). This unexpected "revival" of Islamic pottery, in which the imitation of an ancient model does not preclude a certain freedom of interpretation by the contemporary artists, mirrors other revivals. Most carnivals, for instance, have abandoned the sideshows of living monsters (mermaids or bearded women) that, for a long time, had ensured their success. However, they allot an increasing amount of space on their carousels to the most unbridled fantastic animals (plate 168). The revival of papier-mâché folk sculpture is equally remarkable, as the production of *alebrijes* in the Oaxaca region of Mexico confirms (plate 160). There, the traditional demonology of the local Indians inspires the dragons that are sold as toys to tourists' children.

In the field of decorative arts and architecture, certain fantastic animals that had fallen into oblivion have been resurrected in urban design and advertising. The trend of embellishing the austere facades of New York skyscrapers with gargoyles and other fabulous animals may no longer be as prevalent as it was in the Art Deco age, but the preoccupation with reinterpreting symbols of the past

165. Above: The Tarasque and Her Knights. Provence (France), mid-19th century. Oil on wood, 29¼ x 37⅛ in. (75 x 95 cm). Musée National des Arts et Traditions Populaires, Paris

166. Above, top: Gargoyle. Stone, c. 1900. Cathedral of Saint John the Divine, New York

167. Left: Painting of a fabulous animal (or a masked shaman), signed "Gorras" and executed in 1988 on the wall of an abandoned Indian trading post. Tierra Amarilla, New Mexico.

168. Above, bottom: Cabin in the shape of a fabulous animal from a carousel in Segovia, Spain.

continues to haunt urban designers. Thus, the United Nations esplanade in New York has a statue representing Saint George and the dragon, and the Security Council Hall is decorated with a fresco by Per Krohg (1952) celebrating the slaying of another evil monster. On a more modest scale, the small French city of Niort, which claims to have been ravaged by a terrible dragon in the middle of the eighteenth century, has installed a group of modern sculptures in one of its squares, reminding passersby of the story of this beast.

Along the same lines, graphic designers have long been aware, in designing logos for particular brands and products, of the value of using a figure recalling mythical animals, however stylized, especially when these images ring a bell in the minds of consumers. This is the case of Mobil Oil's Pegasus; the unicorn transporting the Japanese beer Kirin; the six-legged salamander of the Agip oil company in Italy; the dragons that are the emblems of several sports teams in America (such as the San Antonio Dragons for hockey and the Portland Forest Dragons for football); and, more recently, the friendly big-jawed monster who invites little Americans to stuff themselves with Ben & Jerry's. In November 2002 a white unicorn—this time, rather European in its inspiration—made an appearance in a commercial, singing the praises of Volvo's most recent car.

Body art, which goes back to the human desire to transform the body into a work of art, also constitutes a vast field of action for the amateurs of fantastic zoology. Flying dragons, serpents with multiple coils, butterflies with strange shapes, and all kinds of other monsters have long been part of the basic vocabulary of tattooing, an ancient practice now popular again. Along with piercing and other forms of body modification, tattooing reminds us that, in spite of the increasing standardization in clothing styles, certain people are ready to self-inflict a little suffering in order to stand out.

169

170

169. Above, top: Monster.com advertisement on a plastic bag.

170. Above, bottom: Fabulous animal. An original Persian motif reinterpreted by Domingo Punter for a ceramic plate. Teruel (Spain), 1980s. Private collection

171

171. Above: Roland Topor (1938–1997), *Kill Death*, 1978. China ink and watercolor on paper, 33½ x 51⅛ in. (85 x 130 cm). MNAM–Centre Georges Pompidou, Paris. The "panic" drawings by Roland Topor seem to prolong the Surrealist tradition, but without literary affectation. They reflect this artist's obsessive nightmares, which he liked to hide, along with his deepest anxieties, behind a sometimes ferocious sense of humor.

Finally, even in the world of fine arts, in the traditional sense of the word, the interest in fabulous animals continues. But it rarely comes from the "avant-garde" artists who have abandoned painting and sculpture. Instead, fabulous animals are more often created by artists who—consciously or not—relate to a Surrealist tradition and ethos. These include anguished drawings by Roland Topor (plate 171); composite sculptures by César (plate 172) and Niki de Saint-Phalle (plate 173); paintings from the champions of the Italian "Transavantguardia" and the French "Free Figuration," such as Francesco Clemente (*Spider King Obscuring the Sun*, 1980) and Hervé Di Rosa (plate 158); and creations by non-Western twentieth-century artists such as the Haitian Hector Hyppolite (plate 175) and the Congolese Chéri Samba (b. 1956). Their works are among the most recent formal mutations of the great family of fantastic animals.

Last but not least, it is important to add the works of self-taught artists, whose imaginations are often inflamed by madness or other forms of social marginalization. Among these representatives of what Jean Dubuffet once called "art brut" (raw or outsider art) we would like to mention at least two major artists. The first, Henry Darger (1892–1973), is an American. The claustrophobic body of work by this loner with pedophiliac obsessions was the subject of a major retrospective in 2001–2 at the American Folk Art Museum in New York. Yet his watercolors and gouache-enhanced collages take their inspiration from pop culture (illustrations of magazines and encyclopedias, comic books, and so on) only in order to subvert it. The

172

second is Friedrich Schröder-Sonnenstern (plate 180), a German adventurer who made crayon drawings of psychoanalytic images dominated by the fearsome figure of a castrating mother. We are indebted to both artists for some picturesque, colorful, and disquieting monsters, which medieval artists would probably have appreciated.

Nevertheless, it is not in the realm of fine arts that the bestiary of fantastic animals most radically renewed itself during the twentieth century,

173

172. Above: César (1921–1998), *Centaur*, 1984. Bronze, 61⅞ x 63 in. (157 x 160 cm). Collection du Fonds Régional d'Art Contemporain Provence-Alpes-Côte d'Azur. This is a study for César's *Centaur* monument, located in Red Cross Square in Paris's sixth arrondissement, which was intended as a tribute to Picasso.

173. Right: Niki de Saint-Phalle (1930–2002), *The Bird*, 1971. Painted polyester. Private collection

174. Below: Tintin and the Yeti (Tibetan name for the Abominable Snowman). Illustration by Hergé for his book Tintin in Tibet (originally published in French as Tintin au Tibet in 1960, translated into English in 1975).

175. Opposite: Loa-Boa (voodoo spirit depicted as a human-headed serpent). Painting by Hector Hyppolite (1894–1948). Private collection. Discovered by André Breton, celebrated by André Malraux, and studied by Jean-Marie Drot, Hector Hyppolite is the "master" of the school of naive painting that has been developing for almost a century in Haiti. For these painters, voodoo (originally an African religion dear to the slaves who were deported to the Americas) constitutes a source of inspiration, as well as a testimony to their spiritual resistance to Western influences.

but within two more popular forms of artistic expressions that are, in a way, peculiar to this century (even though both were, in fact, born during the preceding one): we are referring to comic strips and the cinema.

INNOVATIONS

Throughout the twentieth century, the world of comic books abounded with monsters. It may have inherited this feature from French popular imagery of the nineteenth century, including the prints known as *images d'Epinal*. In particular, the figures of the werewolf and other human-animal hybrids (also found in Russia in popular wood engravings called *lubok*) were familiar to this imagery.

Such an interest in monsters was also present in the universe of the caricature, and especially political caricature, that blossomed during the nineteenth and twentieth centuries after the rapid development of the popular daily or weekly press. (Grandville was a precursor in this respect; his etching entitled *Impôts suceurs* [Sucking taxes, 1833] depicts taxes as monstrous and gluttonous dwarfs.) Let us add that most comic strips were published in high-circulation newspapers before they were issued as comic books. But however mass-market the audience, most popular artists were still in hot pursuit of originality.

This is attested to by many of the fantastic animals that are easily recognizable to French-speaking comic-strip lovers. For example, there is the friendly Marsupilami (a kind of monkey whose long tail

174

can tie itself into a lasso, in a way that recalls the second head of the amphisbaena serpent), created by Belgian artists Batem, Greg, and Franquin. The Belgian author and illustrator Hergé created an Abominable Snowman in *Tintin in Tibet* (plate 174); the French comic-book artist Jean-Claude Forest invented a "synthocère" for the *Barbarella* strip; and Jacques Tardi made up various monsters that proliferate in *The Most Extraordinary Adventures of Adèle Blanc-Sec* (*Adèle and the Beast*, *The Demon of the Eiffel Tower*, and so on).

None of these fabulous creatures is particularly frightening. Many, including the Marsupilami, are likeable; and some, such as the "Dragz" family dragons, invented by O'Groj and Corcal for the Franco-Belgian *Spirou* comic magazine, are even hilarious. In the same spirit as the likeable monsters in the U.S. films *Shrek*, *The Ice Age*, and *Monsters, Inc.*, and the magical creatures populating the *Harry Potter* cycle, they remind the adult of the closeness between the child that he once was and the animal. This identification mechanism partly explains their huge success. But this popularity is also due to the inventiveness of the comics' illustrators, who are, in many instances, true artists.

On the other hand, monsters deriving from the Japanese comic strip *Godzilla* and its many emulators are more frightening. Popularized by animated films and then by both video games and role-playing games (such as "Dungeons and Dragons") intended for young people worldwide, these monsters find themselves today in a very crowded market. The most interesting ones find their original source in the fantastic stories of the American writer H. P. Lovecraft, one of the masters of the genre. Such is the case of the terrifying (and unpronounceable) "Cthulhu," which its creator described as combining the appearance of an octopus and a winged dragon, with a vaguely anthropoid silhouette. Others come from best-sellers in science fiction or fantasy literature (a kind of reverse science fiction set in an indefinite past, such as J. R. R. Tolkien's cult favorite, *The Lord of the Rings*).

175

Hundreds of Internet sites, used by tens of thousands of aficionados, guarantee that this abundant though unequal (in terms of quality) graphic production is widely diffused to a market eager to buy.

We cannot shift from comic strips to cinema without first recalling that movies began to a certain extent as comic strips in motion, and that the links between the two forms of expression were for a long time quite close. Indeed, in the works of the first important filmmaker, George Méliès (who directed a theater for a Parisian carnival), the scenery, often consisting of no more than a painted canvas backdrop, played an essential role. Méliès used the scenery to do all kinds of special effects—from the most simple to the quite ingenious—to

176

176. Above: Max Ernst (1891–1976), Chimera, 1928. Oil on canvas, 44⅞ x 57 in. (114 x 145 cm). MNAM–Centre Georges Pompidou, Paris. Chimera seems to be intended here not in its literal sense but in the more general sense of an illusion.

177. Opposite: Victor Brauner (1903–1966), Totem of the Wounded Subjectivity—II, 1948. Oil on canvas, 35⅞ x 28¼ in. (91 x 72 cm). MNAM–Centre Georges Pompidou, Paris

make his spectators laugh and dream. Like the magic-lantern show of which it is the heir and like the carnival sideshows that constitute its background, early cinema first and foremost intended to entertain: its aim was surrealism, not realism; its audience was more popular than intellectual; and the filmmaker perceived himself less as an author than as a magician. This is why Méliès's films (to which André Breton attached great value) teem with eccentric and improbable creatures. In his *Trip to the Moon* (1902), "a big extravaganza in thirty scenes," the Selenites, reddish giants with bird beaks, spiked heads, claws for hands, and giant feet, lurk near the woods, awaiting the arrival of the mad scientists from Earth.

Later, well after Méliès, filmmakers turned their cameras toward the real world, and cinema became a mirror of reality. But the temptation to go back to its carnival origins never ceased; illusion and the surreal were never far away. One should not be surprised that the increased insecurity caused by the Great Depression and by the specter of world war gave rise, in the early 1930s, to a revival of fantastic cinema. Among this sudden explosion of films filled with the most horrible monsters (*Frankenstein*, 1931; *Freaks*, 1932; *The Hounds of Zaroff*, 1932; *The Island of Dr. Moreau*, 1933), perhaps the most memorable is Merian C. Cooper and Ernest B. Schoedsack's admirable *King Kong* (plate 178).

178

179

178. Above, top: King Kong, from the film King Kong (1933), directed by Merian C. Cooper and Ernest B. Schoedsack.

179. Above, bottom: The Beast, from Jean Cocteau's film Beauty and the Beast (1946).

A reflection of unsettled times, the film is itself highly disturbing. First of all, it is more than just another variation on the theme of beauty and the beast (which Jean Cocteau was to revisit in a more lyrical mode in 1946—plate 179); it is also a sad fable about the fate of cinematic art in the age of rampant capitalism. An American filmmaker organizes an expedition to shoot a documentary about the world's last-known "savages" (the inhabitants of a small, unspoiled Indonesian island, ominously called Skull Island). When his film project falls apart, he decides to capture a monstrous ape discovered on the island in the hopes of displaying it publicly, and profitably, at a New York music hall.

Second, the hero of this pathetic parable, the ape himself, is troubling not only because of his gigantic size, almost as large as the dinosaurs that survive on Skull Island, but also because of his quasi-human behavior, his sensitivity to the female protagonist of the film (the blond and beautiful Ann Darrow, played by Fay Wray), his need for tenderness, and his unsettling loneliness. And finally, King Kong is also so effectively disturbing because it is the first talking film to use special effects that, as Jacques Lourcelles wrote in his *Dictionnaire du Cinéma*, would be "used for decades: the animation frame by frame of small-scale models, the back projection in life-size and in miniature, glass shots, the 'matte' technique (superposition of several frames within the same shot)." In short, with its deliberately romantic aesthetics (recalling, even in the interplay between

black and white, the tempestuous atmospheres created by Honoré Daumier and Gustave Doré), with the moody ambiance in which it is constantly shrouded, and especially with the threat of destruction posed by this primeval monster to the civilized world, *King Kong* represents a kind of allegory of modern humanity's anxieties. It is not surprising that this film has continued to fascinate generations of viewers for seventy years.

It goes without saying that *King Kong* inevitably gave rise to numerous remakes and adaptations, which possess none of the charm of the original. It also goes without saying that *King Kong*'s special effects, invented in 1933 by the first special effects master, Willis O'Brien, were soon perfected by his successors, as fantastic cinema became a genre in its own right. But contrary to what Hollywood currently seems to believe, sophisticated technology is not, in itself, sufficient to create beauty. And even though, among the stereotypical products of the American fantastic cinema (which is sometimes difficult to distinguish from horror or science-fiction movies), a few successes do stand out—for example, the image of the man-fly in Kurt Neumann's *The Fly* in 1958, remade by David Cronenberg in 1986—most of these movies aimed solely at entertaining the crowds have little hope of going down in history.

One would be tempted to say the same thing about some of Hollywood's greatest commercial successes since the end of the Cold War—*Jurassic Park, Independence Day, Men in Black, Spiderman*—in which special effects have achieved, thanks to technological innovation, an unprecedented virtuosity. However, these movies, in which the supernatural continues to play a significant role, betray the same anxieties about the future of the world that were evident in their predecessors in the distant 1930s. Threatened at times by extraterrestrials, at others by dinosaurs or crazy terrorists, isn't our world going to miss the old communist villains, who at least were rational beings?

Far from being as fanciful as they may have seemed, these anxieties about catastrophic destruction finally connected to reality in the criminal attacks against the United States on September 11, 2001. In fact, one can't help wondering if these movies in which Hollywood seems to have relished putting America's destruction on-screen might have played a role, however minor, in the elaboration of terrorist fantasies. In any case, whatever force the fantastic creatures imagined by Hollywood today exert over the moviegoers' unconscious, they have far less power to make us dream than do the creations of the great medieval, Aztec, Persian, Chinese, or African artists.

180. Above: Friedrich Schröder-Sonnenstern (1892–1982), *The Enchanted Fish*, 1954. Colored pen on cardboard, 19¼ x 27⅞ in. (49 x 69 cm). MNAM–Centre Georges Pompidou, Paris

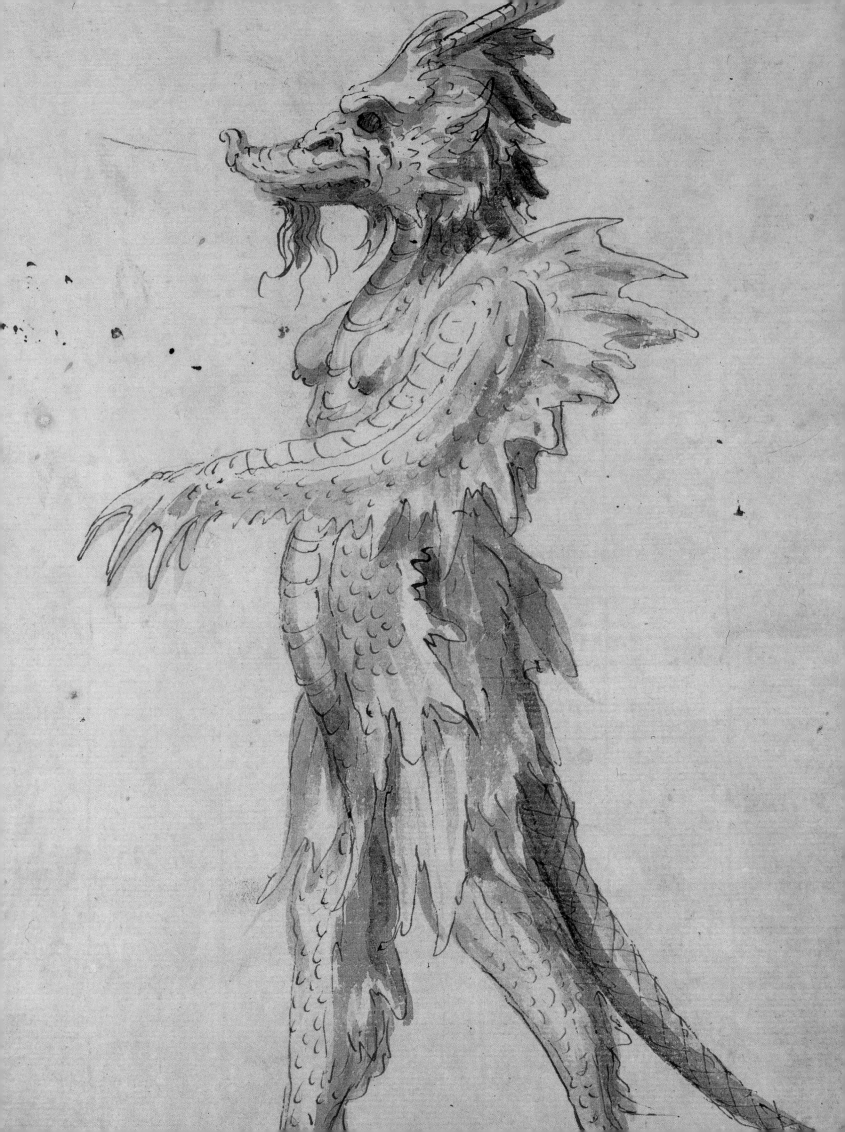

182

CONCLUSION

WE HAVE SEEN that all fantastic animals originate from the combination, in varying proportions, of two distinct elements: on one hand, a creator's individual dream, and on the other, the set of norms that the creator's culture imposes on the modes of artistic representation. It follows that fabulous animals take on more inventive forms whenever the pressure of culture is less, and more stereotyped forms whenever pressure is more.

These two factors are nevertheless so intricately interwoven that it is impossible to separate them. Even a journey as swift as the one we have just taken through world art has allowed us to re-alize, albeit intuitively, that certain civilizations have been richer in fantastic animals than others. They proliferate in ancient Middle Eastern societies, China, the Turko-Persian world, and in the Christian Middle Ages, as well as Pre-Columbian America; they are less numerous (and less diversified) in the Greek world during the Classical period, in European art starting from the Renaissance (with the exception of the Romantic period, during which they make a brief return), and in the art of Muslim countries, at least during the last two or three centuries.

How can such variations be explained? Are they due to blocks in the artists' imagination, or

81

do they correspond to phases of cultural history during which one particular style of representation (realism at one time, for instance, or abstraction at another) overshadows all others? Both answers are probably partly true. Let us not try to choose between them.

One thing, however, is certain: even if the representation of fantastic animals languished, or was even proscribed, within certain societies and at certain periods, there is no artistic universe that is totally devoid of these types of animals. They often have a marginal place; they may be represented in such a stylized form as to be hardly recognizable; they may even temporarily escape from the realm of fine arts to take refuge in the decorative arts, popular art, or mass culture—but they cannot disappear altogether, any more than humankind can refrain from populating the world with supernatural beings, whether religious or heroic, that transcend the individual's own existence.

Having arrived at the conclusion of this book, how can we resist wondering about how fantastic animals will be represented in the future? All prediction in this domain is obviously risky. Judging by the less than exciting visuals offered by the twenty-first century so far, it seems that fabulous animals, though neglected by most in the artistic "avant-garde," are present in comic strips, cinema, and games aimed at entertaining the young. It also seems that such animals—especially in the movies and in role-playing games—are more and more perceived as threatening, as fiendishly clever as they are wicked, and that they consequently pose a lethal danger for the future of our species.

If such an evolution is confirmed, it would mean that our era is no more liberated from religious superstitions or from the obsession with monsters than previous eras (whether the Romantic period or the end of the Middle Ages). But, unable to find a way of calming our anxieties in

183. Left: Fernand Khnopff (1858–1921), *The Art* (or *The Caresses*, or *The Sphinx*), 1896. Oil on canvas, 19¾ x 59⅜ in. (50 x 151 cm). Musées Royaux des Beaux-Arts de Belgique, Brussels

184. *Page 194:* Fantastic animal. France, 16th century. Fragment from a stained-glass window, 5⅞ x 5⅛ in. (15 x 13 cm). Musée de la Renaissance, Ecouen, Paris

183

traditional religions, we henceforth entrust the entertainment industry with the task of helping us exorcize them. Nevertheless, traditional religions—we can see this mostly by examining some regions like the Muslim world, the Hindu world, and the black African world—have not said their last word. They have even been witnessing, for the last quarter century, a surprising revival. It is thus possible that the coming century will be marked by a more and more radical confrontation between two types of imaginary worlds: an imaginary world that could be called (by oversimplifying) Hollywoodian, in which a shoddy supernatural—half frightening, half entertaining—has supplanted religion, and an imaginary world inspired by the great historical religions, whose power of attraction, though waning within the Western world, seems to be benefiting elsewhere from renewed vigor. There is no possible compromise between these two imaginary worlds as is attested to by the paradoxical hatred that many developing countries harbor against America, even as their inhabitants daily watch American movies and television.

This is why, if the worse is never certain, it is in our interest to look directly at things. In the cultural but also political and military shock to which this confrontation will probably lead, the destiny of all humanity is at stake.

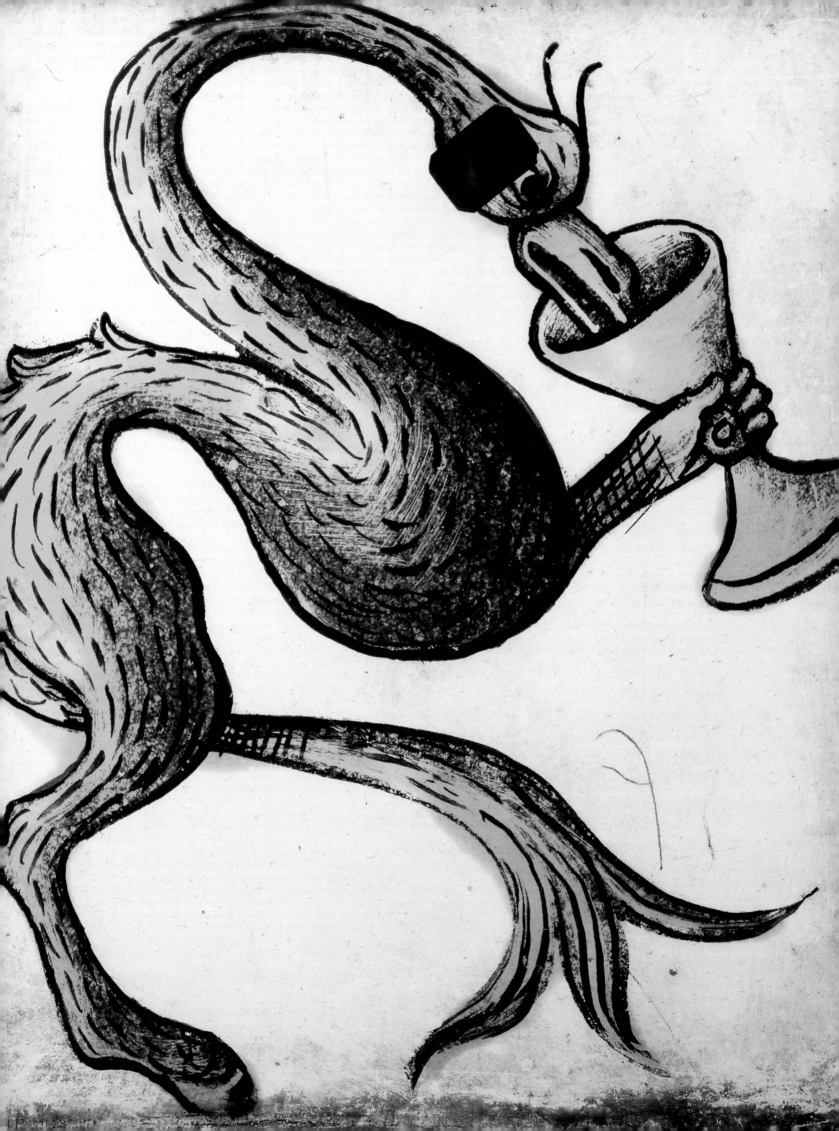

BIBLIOGRAPHY

Aelianus. *On the Characteristics of Animals.* 3 vols. Trans. A. F. Scholfield. Cambridge, Mass.: Harvard University Press, 1958–59.

Alamichel, Marie-Françoise, and Josseline Bidard. *Des animaux et des hommes.* Paris: Presses de l'Université de Paris-Sorbonne, 1998.

Alleau, René, ed. *Guide de la France mystérieuse.* Paris: Tchou, 1964.

Aristotle. *History of Animals.* Trans. A. L. Peck. 1965. Reprint, Cambridge, Mass.: Harvard University Press, 1993.

Art papou: Austronésiens et Papous de Nouvelle-Guinée. Exh. cat. Paris: Editions de la Réunion des Musées Nationaux, 2000.

Baltrušaitis, Jurgis. *Art sumérien, art roman.* Paris: Ernest Leroux, 1934.

———. *Réveils et prodiges: Le Gothique fantastique.* Paris: Armand Colin, 1960.

———. *Le Moyen Age fantastique: Antiquités et exotismes dans l'art gothique.* 1955. Rev. ed., Paris: Flammarion, 1981.

———. *Aberrations: Les Perspectives dépravées.* Vol. 1. 1957. Rev. ed., Paris: Flammarion, 1983.

Barr, Alfred H., Jr., ed. *Fantastic Art, Dada, Surrealism.* With essays by Georges Hugnet. 1947. Reprint, New York: Museum of Modern Art, 1968.

Bataille, Georges. *The Accursed Share: An Essay on General Economy.* Trans. Robert Hurley. New York: Zone Books, 1988–91.

Barber, R., and A. Riches. *A Dictionary of Fabulous Beasts.* London: MacMillan, 1971.

Bianciotto, Gabriel. *Bestiaires du Moyen Age.* Paris: Stock, 1980.

Borges, Jorge Luis, with Margarita Guerrero. *The Book of Imaginary Beings.* Trans. Norman Thomas di Giovanni, in collaboration with the author. New York: Dutton, 1969.

Boschère, Jean de. *Jérôme Bosch et le fantastique.* Paris: Albin-Michel, 1962.

Breton, André. *Surrealism and Painting.* Trans. Simon Watson Taylor, with a new introduction by Mark Polizzotti. Boston: MFA Publications, 2002.

Bunker, Emma C. *Nomadic Art of the Eastern Eurasian Steppes: The Eugene V. Thaw and Other New York Collections.* New York: Metropolitan Museum of Art, 2001.

Carr Grant, Sandra, and Catherine Coleman Brawer. *The Auspicious Dragon in Chinese Decorative Art.* Exh. cat. Katonah, N.Y.: Katonah Gallery, 1978.

Castelli, Enrico. *Il Demoniaco nell'arte.* Milan: Electa, 1952.

Cavallo, Adolfo S. *The Unicorn Tapestries at the Metropolitan Museum of Art.* New York: Metropolitan Museum of Art, 1998.

Champeaux, Gérard de, and dom Sébastien Sterckx. *Introduction au monde des symboles.* Paris: Zodiaque, 1972.

Clark, Kenneth. *Animals and Men: Their Relationship as Reflected in Western Art, from Prehistory to the Present Day.* New York: William Morrow, 1977.

Clébert, Jean-Paul. *Bestiaire fabuleux.* Paris: Albin-Michel, 1971.

Cohn, Norman. *Europe's Inner Demons: An Inquiry Inspired by the Great Witch Hunt.* New York: Basic Books, 1975.

Ctesias of Cnidus. *Ancient India as Described by Ktesias the Knidian.* Trans. J. W. Crindle. 1882. Reprint, Amsterdam: Philo Press, 1973.

Davidson, Jane P. *The Witch in Northern European Art.* Freren, Germany: Luca, 1987.

Debidour, V. H. *Le Bestiaire sculpté du Moyen Age en France.* Paris: Arthaud, 1961.

Delacampagne, Christian. *L'Aventure de la peinture moderne, de Cézanne à nos jours.* Paris: Mengès, 1988.

———. *Outsiders: Fous, naïfs et voyants dans la peinture moderne, 1880–1960.* Paris: Mengès, 1989.

Delacampagne, Christian, and Erich Lessing. *Immortelle Egypte.* Paris: Nathan, 1990.

Diény, Jean-Pierre. *Le Symbolisme du dragon dans la Chine antique.* Paris: Collège de France, 1987.

Dieux et démons de l'Himalaya: Art du bouddhisme lamaïque. Exh. cat. Paris: Editions de la Réunion des Musées Nationaux, 1977.

L'Étrange et le merveilleux en terre d'Islam. Exh. cat. Paris: Editions de la Réunion des Musées Nationaux, 2001.

Fienup-Riordan, Ann. *The Living Tradition of Yup'ik Masks*. Seattle: University of Washington Press, 1996.

Fontenay, Elisabeth de. *Le Silence des bêtes*. Paris: Fayard, 1998.

Germond, Philippe. *An Egyptian Bestiary: Animals in Life and Religion in the Land of the Pharaohs*. With photographs by Jacques Livet. London: Thames and Hudson, 2001.

Goens, Jean. *Loups-garous, vampires et autres monstres: Enquêtes médicales et littéraires*. Paris: Editions du CNRS, 1993.

Gougaud, Henri. *Les Animaux magiques de notre univers*. Paris: Solar, 1973.

Grandville. *Un Autre Monde: Transformations, visions, incarnations . . . et autres choses*. 1843. Rev. ed., Paris: H. Fournier, 1963.

Guibert, Jean-Claude. *Le Réalisme fantastique: 40 Peintres européens de l'imaginaire*. Paris: Opta, 1973.

Guillaume, le Clerc de Normandie. *The Bestiary of Guillaume le Clerc*. Trans. George Claridge Druce. Ashford, UK: Invicta Press, 1936.

Hahner-Herzog, I., L. Kecskési, and L. Vajda. *African Masks from the Barbier-Mueller Collection*. Munich: Prestel-Verlag, 1998.

Harf-Lancner, Laurence, ed. *Métamorphose et bestiaire fantastique au Moyen Age*. Paris: Ecole Normale Supérieure de Jeunes Filles, 1985.

Hassig, Debra, ed. *The Mark of the Beast: The Medieval Bestiary in Art, Life, and Literature*. New York: Garland, 1999.

Hesiod. *Theogony*. Trans. with an introduction and notes by M. L. West. Oxford, UK: Oxford University Press, 1988.

Hicks, Carola. *Animals in Early Medieval Art*. Edinburgh: Edinburgh University Press, 1993.

Hippeau, C. *Le Bestiaire divin de Guillaume, clerc de Normandie*. Caen, France: 1852.

Houwen, L. A. J. R. *Animals and the Symbolic in Medieval Art and Literature*. Groningen, the Netherlands: Egbert Forsten, 1997.

Icônes grecques, melkites, russes: Collection Georges Abu Adal. Exh. cat. Geneva: Skira, 1993.

Jones, David E. *An Instinct for Dragons*. New York: Routledge, 2000.

Kappler, C. *Monstres, démons et merveilles à la fin du Moyen Age*. Paris: Payot, 1980.

Klingender, Francis D. *Animals in Art and Thought to the End of the Middle Ages*. Cambridge, Mass.: MIT Press, 1971.

Kruta, Venceslas, and Erich Lessing. *Les Celtes*. Paris: Hatier, 1978.

Lascault, Gilbert. *Le Monstre dans l'art occidental*. Paris: Klincksieck, 1973.

Lecouteux, Claude. *Les Monstres dans la pensée médiévale européenne*. Paris: Presses de l'Université de Paris-Sorbonne, 1993.

Lehner, Ernst, and Johanna Lehner, eds. *Picture Books of Devils, Demons, and Witchcraft*. New York: Dover, 1971.

Lévi-Strauss, Claude. *Totemism*. Trans. R. Needham. Boston: Beacon Press, 1963.

Mabille, Pierre. *Le Miroir du merveilleux*. Paris: Minuit, 1962.

Magana, Edmundo. *Les Monstres dans l'imaginaire des Indiens d'Amérique latine*. Paris: Lettres Modernes, 1988.

Magiciens de la terre. Exh. cat. Paris: Editions du Centre Georges Pompidou, 1989.

Mâle, Emile. *L'Art religieux du XII° siècle en France*. 6th ed. Paris: Armand Colin, 1948.

———. *L'Art religieux du XIII° siècle en France*. 8th ed. Paris: Armand Colin, 1948.

Malraux, André. *Saturn*. Trans. C. W. Chilton. London: Phaidon Press, 1957.

Mame, Fierens P. *Le Fantastique dans l'art flamand*. Brussels: Editions du Cercle d'Art, 1947.

The Manchu Dragon: Costumes of the Ch'ing Dynasty, 1644–1912. Exh. cat. New York: Metropolitan Museum of Art, 1981.

Milin, Gaël. *Les Chiens de Dieu: La Représentation du loup-garou en Occident (XI°–XX° siècle)*. Brest, France: Centre de Recherche Bretonne et Celtique, Université de Bretagne Occidentale, 1993.

Milne, Tom, and Paul Willemen, eds. *The Encyclopedia of Horror Movies*. New York: Harper and Row, 1986.

Monroe, Michael W. *The Animal Image: Contemporary Objects and the Beast*. Washington, D.C.: National Museum of American Art, 1981.

Muchembled, Robert. *Une Histoire du diable: XII°–XX° siècle*. Paris: Seuil, 2000.

The New King James Bible: New Testament. Rev. ed. Nashville, Tenn.: Thomas Nelson, 1982.

Paré, Ambroise. *Des Monstres et prodiges*. Ed. Jean Céard. Geneva: Droz, 1971.

Pastoureau, Michel. *Traité d'héraldique*. 2nd ed. Paris: A. et J. Picard, 1993.

Pliny the Elder. *Natural History*. Trans. H. Rackham. 1940. Reprint, Cambridge, Mass.: Harvard University Press, 1997.

Poirion, Daniel. *Le Merveilleux dans la littérature française du Moyen Age*. Paris: Presses Universitaires de France, 1982.

Pseudo Callisthenes. *Historia Alexander Magni/The Greek Alexander Romance*. Trans. and with an introduction and notes by Richard Stoneman. London: Penguin Books, 1991.

Renonciat, Annie. *La Vie et l'œuvre de J.-J. Grandville*. Paris: ACR Éditions, 1985.

Roberts, Allen F. *Animals in African Art: From the Familiar to the Marvelous*. New York: Museum for African Art, 1995.

Rombauts, E., and A. Welkenhuysen, eds. *Aspects of the Medieval Animal Epic*. Louvain, France: Louvain University Press, 1975.

Rose, Carol. *Giants, Monsters and Dragons: An Encyclopedia of Folklore, Legend, and Myth*. New York: W. W. Norton, 2000.

Rowland, B. *Animals with Human Faces*. Knoxville: University of Tennessee Press, 1973.

Schrader, J.-L. *A Medieval Bestiary*. New York: Metropolitan Museum of Art, 1986.

Sperber, Dan. "Pourquoi les animaux parfaits, les hybrides et les monstres sont-ils bons à penser symboliquement?" *L'Homme* 15, no. 2 (Apr.–June 1975).

———. "Why Are Perfect Animals, Hybrids, and Monsters Food for Symbolic Thought?" *Method and Theory in the Study of Religion* 8, no. 2 (1996): 143–69.

Stephens, Walter. *Demon Lovers: Witchcraft, Sex, and the Crisis of Belief.* Chicago: University of Chicago Press, 2002.

Sumer, Assur, Babylone: Chefs d'oeuvre du Musée de Bagdad. Exh. cat. Paris: Petit Palais, 1981.

Todorov, Tzvetan. *The Fantastic: A Structural Approach to a Literary Genre.* Trans. Richard Howard. Cleveland: Press of Case Western Reserve University, 1973.

Whitlark, James. *Illuminated Fantasy: From Blake's Visions to Recent Graphic Fiction.* Rutherford, N.J.: Fairleigh Dickinson University Press, 1988.

Willemin, Véronique. *Monstres et démons.* Paris: Alternatives, 1999.

Willemin, Véronique, and Joëlle Rodoreda. *Les animaux fantastiques.* Paris: Editions de la Réunion des Musées Nationaux, 1999.

Wittkower, Rudolf. *Allegory and the Migration of Symbols.* Boulder, Colo.: Westview Press, 1977.

Wolff-Quenot, Marie-Josèphe. *Des monstres aux mythes.* Paris: G. Trédaniel, 1996.

Yang Xin, Li Yihua, and Xu Naixiang, eds. *Art of the Dragon.* London: Studio Vista, 1989.

ACKNOWLEDGMENTS

WHILE WRITING this book, we have benefited from advice and suggestions made by many people, all of whom we cannot possibly name. However, we do wish to thank, in particular, Freddy Abou Adal, Sylvia Agémian, Shane Agin, Hagop Atéshian, Jacqueline and Hubert Comte, Isabelle and Jean-François Delacampagne, Manuel Delacampagne Crespo, Marcel Detienne, Jean-Marie Drot, Arthur Goldhammer, François Laroque, David Mimran, Alan Shapiro, Walter Stephens, and Professor Zhu Hui, for their valuable help. We are also indebted to Agnès de Gorter, who was the first to suggest the idea of this book, allowing it to see the light, and to Béatrice Coti, whose mastery in the field of iconography has been indispensable.

INDEX

PHOTOGRAPHY CREDITS

The photographers and the sources of visual material other than those indicated in the captions are as follows (numerals refer to plates):

ABM Archives Barbier-Mueller: Pierre-Alain Ferrazzini (123–24); Christian Poite (37, 42, 46–47); Studio Ferrazzini Bouchet (9, 49, 97, 146)

Raffaello Bencini (34)

© Bibliothèque Nationale de France (6, 18, 21–22, 35, 38–40, 45, 50–51, 55–57, 59–60, 72, 94–95, 154–55)

BIFI—Bibliothèque du Film (178–79)

Bridgeman Art Library (152)

China Cultural Relics Promotion Center (139)

CNAC/MNAM dist. RMN (176); Béatrice Hatala (180); Philippe Migeat (171, 177)

Cussac (183)

Ariane Delacampagne (41, 87–88, 108, 160–63, 166–70, 175, 182)

Hugues Dubois (147–48)

J. Y. Dubois—A.R.A.A. (125)

Fatras/Succession Prévert (157)

Guy Ferrandis (140)

Ferrante Ferranti (48, 132, 142)

Dominique Genet (15, 65, 99, 102)

Béatrice Hatala (29–30, 119)

© Hergé/Moulinsart, 2003 (174)

Walter Klein (156)

J. Larivière (11)

Joseph Martin (150)

Jean Mazenod (10, 16, 28, 113, 118)

Photograph © 1983 The Metropolitan Museum of Art, New York (112)

Philippe Morel (page 3, plates 54, 63, 131, 137)

Musées de Poitiers: Ch. Vignaud (164)

Giovanni Dagli Orti (44, 62, 96, 151)

P. Pleynet (page 2)

Antonio Quattrone (143)

Rabatti & Domingie (93, 115, 144, 181)

RMN: (67, 111, 130, 133, 135, 138, 165); Arnaudet (3, 85, 107); M. Beck-Coppola (128); Michèle Bellot (149); J. G. Berizzi (page 1, plates 32, 66, 80, 90–91, 126, 129, 159); P. Bernard (89); Gérard Blot (58, 78, 81, 106, 122, 153); Bulloz (52–53); Chuzeville (14); Quecq d'Henripret (33); John Golding (13); Richard Lambert (127); Ch. Larrieu (12, 74); Hervé Lewandowski (1, 2, 5, 20, 24, 82, 101, 103); J. L'Hoir (114); R. G. Ojeda (7, 36, 68, 70, 100, 109–10, 184); Thierry Ollivier (75, 83, 120); Franck Raux (69); Matthieu Ravaux (25–26); Rudolf Schrimpff (27); Guy Vivien (98)

Benoît Roland (86, 172–73)

Scala, Florence (61, 116, 121)

Pierre Schwartz (158)

Thomas Stephan (71)

Vladimir Terebenine (19, 104–5, 134, 136)

Jean Vertut (64, 73)

All rights reserved for artists not yet in the public domain. © 2003 ADAGP for their members.